ON THE
EDGE OF YOUR SEAT

ON THE
EDGE OF YOUR SEAT

POPULAR THEATER AND FILM
IN EARLY TWENTIETH-CENTURY

AMERICAN ART

PATRICIA McDONNELL

With contributions by
ROBERT C. ALLEN, C. LANCE BROCKMAN, LEO CHARNEY,
WALTER MURCH, DAVID NASAW, ROBERT SILBERMAN,
LAURAL WEINTRAUB, SYLVIA YOUNT, AND REBECCA ZURIER

YALE UNIVERSITY PRESS, NEW HAVEN AND LONDON
IN ASSOCIATION WITH
FREDERICK R. WEISMAN ART MUSEUM, UNIVERSITY OF MINNESOTA

This book is published in conjunction with the exhibition *On the Edge of Your Seat: Popular Theater and Film in Early Twentieth-Century American Art*, organized by the Frederick R. Weisman Art Museum, University of Minnesota, Minneapolis.

Exhibition itinerary
April 20–August 4, 2002 Frederick R. Weisman Art Museum, University of Minnesota, Minneapolis
September 15, 2002–January 5, 2003 Montclair Art Museum, Montclair, New Jersey
February 22–May 18, 2003 Pennsylvania Academy of the Fine Arts, Philadelphia

Frederick R. Weisman Art Museum
University of Minnesota
333 East River Road
Minneapolis, Minnesota 55455

Designer: Jean Wilcox
Editor: Phil Freshman, Minneapolis
Printed in Singapore by CS Graphics

Published with assistance from the Louis Stern Memorial Fund.

This exhibition and book have been made possible in part by a major grant from the National Endowment for the Humanities, expanding our understanding of the world. Additional generous project funding comes from the National Endowment for the Arts, Target Stores, Marshall Field's, and Mervyn's California with support from the Target Foundation, and the B. J. O. Nordfeldt Fund for American Art. The Institute of Museum and Library Services, a federal agency that fosters innovation, leadership, and a lifetime of learning, supports the Frederick R. Weisman Art Museum at the University of Minnesota. Additional operating support is provided by the Chadwick Foundation; the Boss Foundation; the Dorsey and Whitney Foundation; the General Mills Foundation; HRK Foundation; the R. C. Lilly Foundation; Target Stores, Marshall Field's, and Mervyn's California with support from the Target Foundation; Minnesota State Arts Board; the Colleagues of the Weisman Art Museum; and the University of Minnesota.

Library of Congress Cataloging-in-Publication Data

McDonnell, Patricia, 1956–
On the edge of your seat : popular theater and film in early twentieth-century
American art / Patricia McDonnell; with contributions by Robert C. Allen
 . . . [et al.].
 p. cm.
"This book is published in conjunction with the exhibition, On the edge of your
seat: Popular theater and film in early twentieth-century American art, organized
by the Frederick R. Weisman Art Museum, University of Minnesota,
Minneapolis." Includes bibliographical references and index.
ISBN 0-300-09240-7 (alk. paper)
ISBN 1-885116-11-X (pbk. : alk. paper)
1. Art, American—20th century—Exhibitions. 2. Theater in art—Exhibitions.
3. Art and motion pictures—Exhibitions. I. Allen, Robert Clyde, 1950—.
II. Frederick R. Weisman Art Museum. III. Title.
N6512 .M363 2002
760'.0449792'0973—dc21
2001005109

Cover illustrations: *front*, Everett Shinn, *Girl in Red on Stage*, c. 1905 (Private col-
lection, courtesy Berry-Hill Galleries); *back*, illustrated song slide from song dated
c. 1910 (Marnan collection, Minneapolis)

CONTENTS

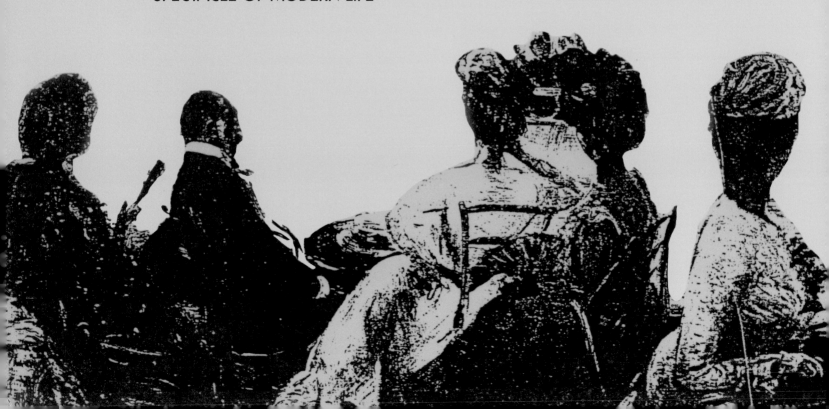

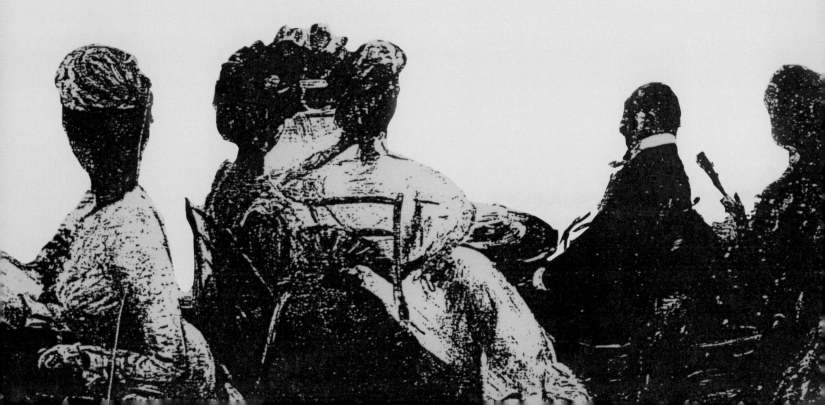

DIRECTOR'S FOREWORD

It is with great pride that the Frederick R. Weisman Art Museum presents *On the Edge of Your Seat: Popular Theater and Film in Early Twentieth-Century American Art*, the first major exhibition and book devoted to art inspired by mass-culture entertainment media in this country during the period 1890 to 1930. The project is the brainchild of the Weisman's talented curator, Patricia McDonnell, and it benefits from her deep knowledge of American modern art—an area that is a particular strength of the museum's collection. It was fueled by her abiding desire to examine how some of the radical shifts that occurred in the visual arts early in the twentieth century could be linked to the technological and social transformations that were then taking place.

American theater saw tremendous change at the turn of the past century. A resolutely modern, intensely visual outlook emerged that was partly the result of dramatic technological advances. Electrical lighting of the stage, for example, opened up a vast range of creative possibilities. Motion pictures were invented, were projected in public, and became wildly popular. These and other spectacular attractions captured the attention of many artists and ignited their imaginations. Progressive artists, particularly in New York City, conveyed the highly charged experience of attending vaudeville and early moving-picture shows in paintings, drawings, and prints that formulated new, sometimes radical aesthetic vocabularies. *On the Edge of Your Seat* examines these artists' achievements within the stimulating, and often bewildering, cultural setting of which they were a part.

The exhibition includes paintings, drawings, and prints by an immensely communicative group of American artists, shown side by side with vintage posters, playbills, sheet music covers, postcards, illuminated song slides, and photographs. These artifacts help bring alive the urban visual environment of the period 1890–1930, and they shed light on some of the sources artists drew upon when producing their works.

Like the early twentieth century, the dawn of the twenty-first century is marked by breakneck technological development. The Internet, digital technologies, and the interactivity they encourage are having a profound impact on the world in which we live and work. Artists are investigating this new technology as a fresh means of expression—interpreting its implications for our society and culture. As a new millennium begins, we find ourselves on the edges of our seats once again.

I want to recognize Patricia McDonnell not only for her ideas but also for her hard work, commitment, and persistence. Those qualities are shared in full measure by her curatorial assistants, Theresa Downing-Davis and Jackie Starbird. Former Weisman curatorial staff members Mary Kalish-Johnson, Lara Roy, and Susan Weir devoted themselves to this project in its early stages. We are lucky to have such a great team at the Weisman, and although I can't name all those who deserve thanks here, I will mention Karen Duncan, our registrar, and Mark Kramer, our exhibition designer and crew chief, both of whom always make sure all the details are handled and that our exhibitions look great.

Yale University Press has collaborated in producing this book, and we thank the members of its staff for their high-quality efforts. I also would like to acknowledge the National Endowment for the Humanities, the National Endowment for the Arts, the Target Foundation, and the B. J. O. Nordfeldt Fund for American Art. These organizations have invested in the Weisman Art Museum as an institution dedicated to education, and we appreciate their confidence in us. Finally, I thank the many museums, archives, and individuals who have lent their treasures to make *On the Edge of Your Seat* a reality. Without their trust, this project would have remained only a great idea.

Lyndel King

ACKNOWLEDGMENTS

On the Edge of Your Seat: Popular Theater and Film in Early Twentieth-Century American Art has been an extraordinary project, enriched at every turn by the many people who over several years contributed to it—at every level.

The National Endowment for the Humanities gave support for early planning and implementation. Clay Lewis of the NEH staff believed in the project's potential and brought his wisdom and good humor to its organization. NEH funding allowed the Weisman Art Museum to assemble a committee of advisers. This group pushed me to have good reasons for all the steps I took along the way, and they freely offered many ideas of their own. I greatly appreciate the sharper intelligence brought to *On the Edge of Your Seat* by Robert C. Allen, C. Lance Brockman, Wanda M. Corn, Lary May, Virginia M. Mecklenburg, Robert Silberman, and Robert W. Snyder. I owe special additional thanks to colleagues and friends who prodded and inspired me as I formulated the exhibition and the book. They include Robert Allen, Kathleen Motes Bennewitz, Wanda Corn, Anne Dawson, Phil Freshman, Lyndel King, Virginia Mecklenburg, Colleen Sheehy, Robert Silberman, and Rebecca Zurier. Smithsonian Institution curators Dwight Blocker Bowers and Virginia Mecklenburg assisted incalculably by sponsoring the research fellowship that enabled me to plumb the archives and collections of their institution.

The authors who contributed to this book helped focus attention on key subjects in American early modernism and the culture that informed it. They illuminate corners of a large and complex area of inquiry. I hope this volume and their essays inspire more study and future related publications. I could not hope for a more capable and intelligent editor than Phil Freshman. His efforts turned rough manuscripts into polished statements, and he offered important analysis and insight along the way. As well, Susan C. Jones proved to be one of the ablest editorial pinch hitters around.

I spent countless hours in remarkable archives and was always impressed by the objects I saw and by the able, friendly staff people I encountered. This project owes an immense debt to many people who aided my search. I especially thank Maricia Battle, Donna R. Braden, David Haberstich, Rosemary Hanes, Marty Jacobs, Ron Magliozzi, Madeline F. Matz, Elena Millie, Eileen K. Morales, Dana Sergent Nemeth, Bob Shamis, David H. Shayt, Zoran Sinobad, Susan Strange, Robert N. Taylor, and Patricia Willis. Lenders have been extraordinary, entrusting us with their cherished possessions for a worthy cause; we thank them heartily. We also extend gratitude to those who permitted us to reproduce their artworks and artifacts.

Yale University Press became a partner with the Weisman Art Museum on this publication because of the relationship we formed with former senior editor Judy Metro. I have enjoyed working with her successor, Patricia Fidler, with Dan Heaton on the editorial staff, and with other Press staff. Designer Jean Wilcox found graceful solutions to presenting the prose and images in this volume.

At the Weisman Art Museum, I work with a team of talented, smart, and witty people. All the members of the staff earned my gratitude and respect for embracing this project and collaborating to make it happen in the best way possible. Director Lyndel King gave me what every curator craves—the encouragement to think big and persevere. My two indefatigable assistants did much of the heavy lifting that an enterprise such as this one entails. Special projects coordinator Theresa Downing-Davis and curatorial assistant Jackie Starbird came through again and again. Former curatorial staff and interns also aided greatly in the early research and planning stages. They include Kathleen Motes Bennewitz, Alison Crossley, Heather Felty, Mary Kalish-Johnson, Dara Kiese, Andrea Nelson, Lara Roy, and Susan Weir.

Inevitably, it is one's family who contribute the most to any scholarly undertaking: they suffer routine absences and cold dinners and nonetheless provide essential moral encouragement. Greg and Kate Pluth, my husband and daughter, deserve my deepest thanks.

Patricia McDonnell

ON THE
EDGE OF YOUR SEAT

CHAPTER 1

AMERICAN EARLY MODERN ARTISTS, VAUDEVILLE, AND FILM

PATRICIA MCDONNELL

"Where are you going, my pretty maid?" asks the gent in the 1905 poster that would have been liberally displayed about New York City (fig. 1.1). "I'm going to Keith's, sir," is the fetching young lady's reply. The poster concentrates, within a single image, characteristics central to early twentieth-century experience in American cities that were entirely new and pervasive. Everyone would have known that the young woman's answer referred to a leading vaudeville house, B. F. Keith's New Union Square Theatre, near the junction of Broadway and Fourth Avenue. In 1905, when the poster was made, vaudeville was the single most popular form of entertainment for Americans, and B. F. Keith and his partner E. F. Albee reigned over a syndicate of theaters and a booking circuit that spanned the country. Motion pictures were originally shown in vaudeville, one "act" among nine on the standard bill. In 1905 motion pictures were just beginning to stand alone as an entertainment form when the first movie houses, called nickelodeons, appeared. Far more democratic than previous popular entertainments, vaudeville and film reached out to all classes and age groups by making tickets cheap and by strictly sanitizing content to create an enjoyable theatrical diversion for the whole family. Even respectable young women, single or married, could now venture forth alone and unescorted through city streets to attend these popular entertainments—just one sign of how quickly American society was becoming transformed.

Vaudeville rocketed to immense popularity largely because it was thrilling, stimulated the senses, and pulled on fans' heartstrings and funny bones. As a spectator later recalled, "It moved fast, had a wide range that kept you always absorbed—no one act was long enough so that you lost interest—the evening shifted from excitement to excitement, but on different levels high comedy, sophistication, slapstick, dancing, singing—sentimental—jazz—acrobats—animals—a panorama that was gorgeous, funny, tearful, each in

turn—a kind of entertainment audiences could lose themselves in, individually and collectively."[1] In short, it presented intoxicating sensation and spectacle within an atmosphere of levity and community.

Historians in recent years have confirmed that vaudeville and early moving pictures also provided means for audiences to make sense of the furiously changing world outside the theater. The two media echoed the tone of contemporary experience, particularly the pace, sights, and sounds in cities. Persistent industrial modernization was altering the basic ways Americans led their lives and related to one another. Each new decade in the late nineteenth and early twentieth centuries brought radical transformations wholly unanticipated in the past, transformations often prompted by social accommodations to new technologies—railways, electrification, mass transit, telephones, and automobiles, to name a few. The German sociologist Georg Simmel famously characterized metropolitan experience in 1903 as "the rapid crowding of changing images, the sharp discontinuity in the grasp of a single glance,

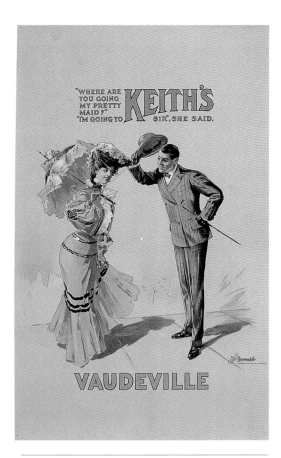

1.1 "Where are you going, my pretty maid?" "I'm going to Keith's, sir," c. 1905. Lithograph (poster). Prints and Photographs Division, Library of Congress

and the unexpectedness of onrushing sensations." Vaudeville performance and early movies mirrored these central characteristics of urban modernity. The hurried pace, barrage of agitating interruptions, rigorous competition of diverse stimuli, shifts in focus of attention, irregular and unpredictable quick movements—these elements of life on the streets could be found in concentrated form on the vaudeville stage and silent screen. As the historian Gunther Barth put it, vaudeville "brought the momentum of the modern city from the sphere of work into that of amusement."[2]

American visual artists did not ignore this stimulating environment. Many turned to it for their own amusement, as did countless Americans. Others found in it a rich resource for their work. *On the Edge of Your Seat: Popular Theater and Film in Early Twentieth-Century American Art* examines the art that sprang from this fascinating intersection of historical forces from 1890 to 1930. This book and the exhibition it accompanies explore both *why* visual artists chose vaudeville theaters, revue halls, and early motion picture houses as subjects and *how* they developed formal languages to communicate what they experienced. The paintings, drawings, and prints explored here are extraordinarily revealing. From them, we can learn much about the complicated beginnings of modernity in the United States and about American artists' search to express their life experience in the first decades of the twentieth century. In particular, a heightened stress on visual sensation materialized during this period, especially in cities, and American artists took up new subjects and fashioned new pictorial means to characterize that crucial development.

In turning to popular theater as fuel for their work and, therefore, to common experiences within the transforming metropolis, American artists followed a trend to depict the contemporary world that had been under way for some time. The French poet Charles Baudelaire, in a famous 1863 essay, was the first to urge artists to "paint modern life," by which he meant city experience. During the late nineteenth century, French impressionist painters chronicled numerous cultural changes. Their work represented a paradigm shift—a move from the depiction of classical narratives, lofty allegorical themes, and dramatic historical events in an academically mannered, precise, and polished artistic language to a comparatively disordered pictorial presentation of the activities and sensations found in urban streets, new railway stations, cafés, and vacation spots. The art historian Thomas Crow articulated the dilemma impressionists faced: "Almost every conventional order, tech-

nique, and motif which had made painting possible in the past had, by [the 1870s], been fatally appropriated and compromised by academicism. And this presented immediate practical difficulties for the simple making of pictures: how do you compose, that is, construct a pictorial order with evident coherence and closure without resorting to any prefabricated solutions?"[3]

Across the cultural and geographic landscape, progressive artists responded to this challenge. Surely, they saw the art academies as offering few appealing options. Simultaneously, the immense changes and dislocations wrought by industrialization served as captivating stimuli. We can rightly speak of *impressionisms* in the plural, because artists in a number of Western countries quickly adopted and adapted the style and conceptual thematics begun in France for their own purposes and context.[4]

Explaining the new thinking in 1892, the American impressionist Childe Hassam said: "The painter was always depicting the manners, customs, dress, and life of an epoch of which he knew nothing. A true historical painter, it seems to me, is one who paints the life he sees about him, and so makes a record of his own epoch." Years later, the Parisian-based sculptor Jacques Lipchitz more colorfully remarked, "One cannot live on a visual diet of skyscrapers and produce the same sort of art as one who fed visually on the Acropolis."[5] Arguably, the artistic result Lipchitz avers would not only include new subjects; it necessarily would look very different, too. Skewed points of view, asymmetrical compositions, cropped subjects, bright and often garish colors, fast brushwork, innovative paint handling, and other formal devices were taken up to yield a novel and unmannered image that would imaginatively evoke modern life.

Depicting American popular-theater performers, Max Weber's *Vaudeville* (1909, fig. 1.2) and Walt Kuhn's *The Tragic Comedians* (c. 1916, fig. 1.3) offer variations on this theme of pictorial experimentation. They are aggressively flattened images with little to no shading for volume. Their massing of forms is stylized, so simplified that it appears crude. Vivid color in both works fits the contemporary milieu of American show business. The paintings' frontal, head-on view offers a bold, direct address not typical in either Victorian conduct or Victorian art. Such pictorial effects were new and conveyed a highly modern sense of the immediacy that was increasingly common in cities.

Throughout the past two centuries, modernization in the metropolis involved rapid industrialization, unceasing technological innovation that

PATRICIA MCDONNELL

1.2 Max Weber, *Vaudeville*, 1909. Oil on canvas, 20 x 14 in. (50.8 x 35.6 cm). The Farber Collection, New York

1.3 Walt Kuhn, *The Tragic Comedians*, c. 1916. Oil on canvas, 96 x 45 in. (243.8 x 114.3 cm). Hirshhorn Museum and Sculpture Garden, Smithsonian Institution, Washington, D.C., Gift of Joseph H. Hirshhorn, 1966

included new modes of transportation and communication, urbanization, and the advent of a mass culture centered on consumers. The United States absorbed these changes and massive waves of immigration, population growth nationwide but especially in urban centers, and a redefinition of social conventions related to class, gender, and race.

The aggregation of people in cities brought marked changes once factories and industrial plants began drawing workers into the cities. In the United States, people were commenting about a new atmosphere of city life as early as the 1840s. "Faces and coats of all patterns," one new arrival to Manhattan remarked in 1846, "bright eyes, whiskers, spectacles, hats, bonnets, caps, all hurrying along in the most apparently inextricable confusion. . . . And it's

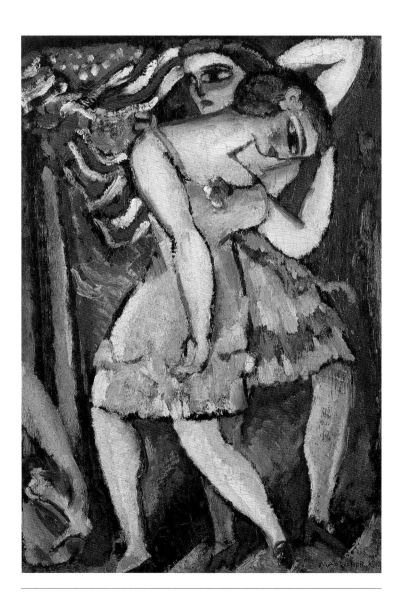

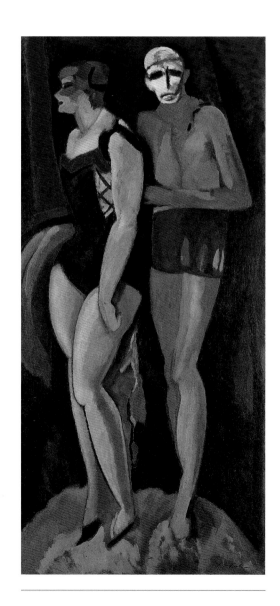

rather overpowering to think of that rush and whirl being their regular every-day life." By 1900 the population of the five boroughs of New York City had increased almost tenfold, from 391,114 in 1840 to 3,437,202 in 1900. A mere twenty years later, the city's population bulged to 5,620,048. Other American cities experienced comparable growth. The daily comings and goings of these multitudes went on at a fevered pitch. Urban modernity's principal charac-ter—"the intensification of nervous stimulation," as Simmel put it—was powerfully obvious to all. It attracted the keen notice of novelists, journalists, sociologists, and, not least, visual artists.[6]

The frenetic and disjointed turn-of-the-century American city had, as noted, an intensely visual aspect, one that derived largely from the culture of consumption that now seemed to pervade every facet of urban life. Consumer culture relied on the mobile urban denizen, one who assimilated the display of products and attractions through his or her eyes. In the larger city market-place, a commotion of shop signs, dazzling electrical billboards, advertising posters on kiosks, immense plate-glass shop windows framing alluring dis-plays, fashionable wares in encyclopedic department stores—all jostled for attention (figs. 1.4, 1.5). This kind of visual display was novel and resolutely modern, part of "a culture marked by an accelerated proliferation . . . of sen-sations, fashion, and styles." As the historian William R. Taylor observes, "each new genre of commercial culture compressed a representation of city life into its format. These new genres had in common a seemingly random, potpourri organization that continued to dramatize the discontinuity, the kaleidoscopic variety, and the quick tempo of city life, as in the vaudeville revue."[7]

To appreciate how mass entertainment, particularly vaudeville and film, figured in the emerging modern metropolitan culture, it is important first for today's readers to know something of the contours of these immensely popu-lar media. Vaudeville's heyday spanned, roughly, the years 1890 to 1930. Edward F. Albee (1857–1930), Benjamin F. Keith (1846–1914), Tony Pastor (1834–1908), and Frederick F. Proctor (1851–1929) are the names chiefly associated with the beginnings and rise of American vaudeville. They all got their start as entertainers, working as circus performers, variety acrobats, singers, and blackface minstrel artists before becoming theater operators. With experience on both sides of the stage in Manhattan Bowery theaters during the 1860s and early 1870s, Tony Pastor opened the first vaudeville the-ater, the Metropolitan, at 585 Broadway in 1875. His formula, soon to be fol-

lowed by others, was to cater to an ever wider and larger audience by cleaning up the boisterous male atmosphere, raunchy humor, and seedy setting of popular entertainment haunts. Respectable theater offering enjoyable family entertainment would swell ticket sales, entrepreneurs such as Pastor realized. And "if women could also be induced to attend," Pastor recalled in an 1890s interview, "patronage could be materially extended" (fig. 1.6).[8] The words "refined entertainment" and "high-class performance" appeared on the facades of many vaudeville houses drawing in crowds across the social spectrum (fig. 1.7). (Robert C. Allen elaborates on vaudeville's history and discusses B. F. Keith's cultivation of variety entertainment in his essay in this volume.)

Vaudeville's popularity also needs to be understood against the backdrop of social transformations that allowed it to grow. In the mid-nineteenth century, the choices for an evening's entertainment outside the home were limited to upper-class opera and legitimate theater or male-oriented concert saloons. But starting in the 1870s, that range of options expanded greatly, in part due to forces that had little to do with show business. As the cultural historian David Nasaw clarifies:

Between 1870 and 1920, American cities flourished as never before. The urban population of the nation increased from under ten to over fifty-four million people. Per capita income and free time expanded as well. Between 1870 and 1900, real income for nonfarm employees increased by more than fifty percent, while the cost of living, as mea-

1.4 West side of Broadway, between Forty-seventh and Forty-eighth streets, 1917. Silver gelatin print. The New-York Historical Society

1.5 John Marin, *Pertaining to Fifth Avenue and Forty-second Street*, 1933. Oil on canvas, 28 x 36 in. (71.1 x 91.4 cm). The Phillips Collection, Washington, D.C.

sured by the consumer price index, decreased by fifty percent. This increase in wages was accompanied by a steady decrease in work hours. The average manufacturing worker worked three and a half hours less in 1910 than in 1890; for many blue-collar workers, unionized employees, and white-collar workers, the decrease in the workweek was even more dramatic.[9]

As cities enlarged, and as increasing numbers of Americans found themselves with more money and more leisure time than in the recent past, "going out," on a regular basis, whether for an evening's or an afternoon's diversion, grew as never before. And new forms of urban entertainment—not only vaudeville but also amusement parks, national and international expositions, variety revues, and motion picture shows—began to blossom.[10] Going out inspired a wealth of popular songs, a few of which, such as "Take Me Out to the Ballgame" (1906) and George M. Cohan's "Give My Regards to Broadway" (1904), are still ingrained in the American memory.

William Glackens celebrated this passion for newfound pastimes by depicting the summer joviality of attending variety entertainment at one of New York's leading roof gardens. In the era before air-conditioning, theater interiors were stifling in the summer. Clever managers staged light amusements under the stars or in glassed structures on theater rooftops, a popular diversion from the 1880s to the 1920s. *Hammerstein's Roof Garden* (c. 1901, fig. 1.8) shows city dwellers at leisure, watching a high-wire act; most roof gardens simply transferred the vaudeville lineup shown downstairs and inside at other times of the year to the cooler outdoor "garden" for the summer.[11] The number of women in the audience—in fact, only one man is shown in the foreground—is a distinct marker of this painting's modernity. So, too, is the multiplicity of gazes Glackens depicts. Each spectator seen in the foreground casts his or her vision in a different direction. Experience was disjunctive, not coherent, in popular theater, and Glackens demonstrates that by showing people responding to various attractions taking place around them simultaneously. The imprecise brushwork, daubed on speedily, contributes to the desired effect, helping to evoke the charged environment.

For our purposes, vaudeville's prominence in the array of entertainment choices matters for two essential reasons. First, because vaudeville was so popular, toured on circuits nationwide, and drew spectators from across the social

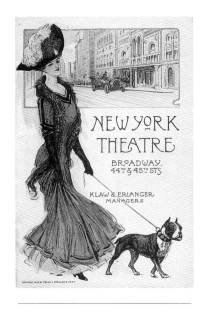

1.6 Program, New York Theatre, October 19, 1911. Warshaw Collection of Business Americana, Archives Center, National Museum of American History, Smithsonian Institution, Washington, D.C. Formerly Hammerstein's Olympia theater, the New York Theatre was among the first on Times Square. This program depicts theatergoing as a fashionable activity, even for an unescorted lady.

1.7 Theatre Comique, New York, c. 1900–1920. Silver gelatin print. Prints and Photographs Division, Library of Congress. This vaudeville theater advertised itself as offering "high class performance."

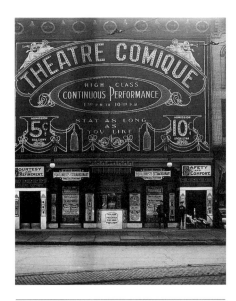

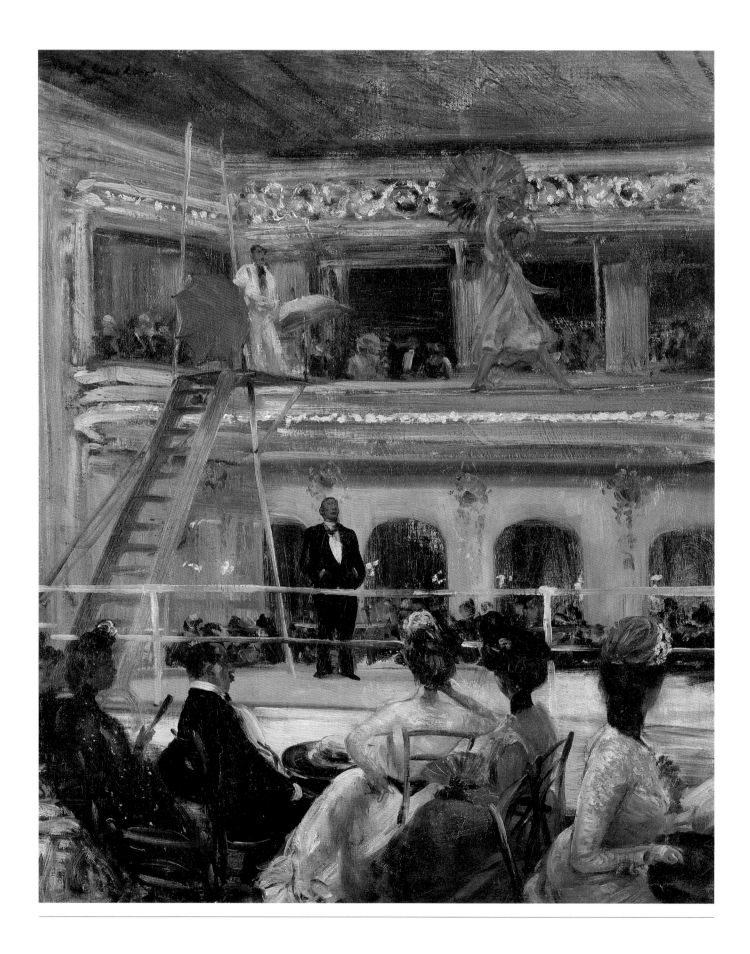

and economic spectrum (as well as women and children), it helped form America's first mass audience. Later the movies eclipsed vaudeville and, along with radio in the 1920s, generated a truly national mass culture.[12] Second, vaudeville pursued tantalizing visual sensations. In contrast to relatively genteel Victorian-era amusements, vaudeville offered spunk. It was fast-paced, saucy, and irreverent, and it staged every thrill in its reach. Its punch and spectacle meant that it recast the stimulating energy of the city streets within its theaters.

A vaudeville bill consisted of a string of unrelated acts. Discontinuity reigned, intensified by quick pacing and the compelling energy of performers. An anything-and-everything range of routines appeared. Singers, "cooch" and jazz dancers, animal acts, bicycle stuntmen, monologuists, magicians, acrobats, slapstick comics, dramatic skits, jugglers, puppeteers, rope skippers, lines of chorus girls, strongmen—all these and more took the stage. The driving force, according to a 1914 book on vaudeville, was "novelty, more novelty, and always novelty" (fig. 1.9). Charles Demuth, more than any other artist,

1.8 William J. Glackens, *Hammerstein's Roof Garden*, c. 1901. Oil on canvas, 30 x 25 in. (76.2 x 63.5 cm). Whitney Museum of American Art, New York, Museum purchase

1.9 Program, Hammerstein's Olympia theater, week of February 24, 1896. Warshaw Collection of Business Americana, Archives Center, National Museum of American History, Smithsonian Institution, Washington, D.C. William Glackens depicted a vaudeville high-wire act in his 1901 painting: a trapeze artist and tightrope walker are featured on this program.

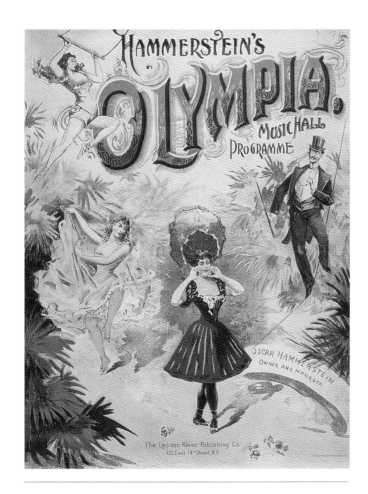

1.10 Paradise Roof Garden, atop Hammerstein's Victoria Theatre, 1901–2. Silver gelatin print. The Byron Collection, Museum of the City of New York. This photograph shows the same roof garden depicted in Glackens's painting.

1.11 Hammerstein's Victoria Theatre, northwest corner of Seventh Avenue and Forty-second Street, 1904. Silver gelatin print. The Byron Collection, Museum of the City of New York

1.12 American Theatre Roof Garden, New York, 1898. Silver gelatin print. The Byron Collection, Museum of the City of New York

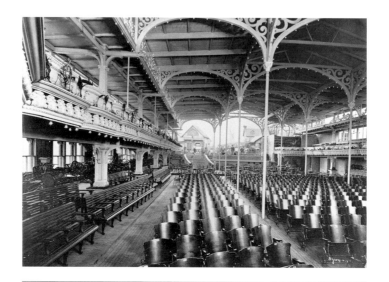

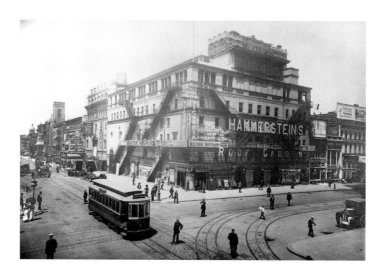

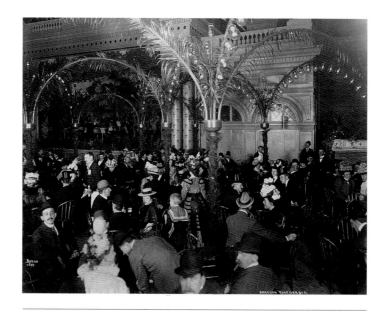

documented vaudeville's zany range in a series of watercolors he made in the mid- and late 1910s. He pictured the song-and-dance routines and comics but also bicycle stuntmen, tumblers, acrobats, acrobat musicians, and odd novelty acts. His bright hues and diaphanous washes register the liveliness of performances presented in the glow of electrical lighting, which had been recently introduced (figs. 1.14, 1.15).[13]

In this novelty-driven environment, every visual gimmick was given a try. Magic-lantern shows, illustrated song slides, magical-illusion acts, shadowgraphy, and living pictures were all highly popular. Emerging technologies of the day were quickly adapted to the theatrical setting and exploited to arouse audiences. As the film historian Ben Singer has noted, "The demand for thrills escalated as the blasé perception required increasingly intense impressions."[14]

Theater electrification and the birth of moving pictures occurred at a time when theater managers were aggressively seeking to showcase each new spectacle. In his essay in this book, David Nasaw perceptively assesses the immense impact that electricity had as it began spreading across the country late in the nineteenth century. The historian David E. Nye explains that electricity during this period quickly came to epitomize innovation and progress in the popular imagination.[15]

Nowhere was electricity more celebrated or exploited than in the Manhattan theater district. In the 1890s people started calling the Broadway theater row the Great White Way for its alluring light display; by 1910 more than twenty blocks were lit to the hilt (fig. 1.16). As towns across the United States began to electrify, they were sold systems promoted as the Great White Way, a trend that showed up in fiction as well as in fact. The townsfolk of Gopher Prairie in Sinclair Lewis's 1920 novel *Main Street* "put in a White Way," thereby certifying that they were up-to-date. In the literature of the era—from tourist guidebooks to newspaper stories—one finds adulation for the spectacle that nightly shone along Broadway. The novelist Theodore Dreiser in *Sister Carrie* (1900) aptly equated New York's wattage with amorous seduction, writing that the "gleam of a thousand lights is often as effective as the persuasive light in a wooing and fascinating eye."[16] John Marin and Joseph Stella, among other artists, developed formal devices to depict this seductive quality as well as to convey the drama of the blazing night sky and inventively signal its energy and strident newness. A syncopation of geometries and hues captures these features in Marin's *Broadway Night* (1929, fig. 1.17) and Stella's

1.13 The Sandow Trocadero Vaudevilles, c. 1894. Lithograph (poster). Billy Rose Theatre Collection, The New York Public Library for the Performing Arts, Astor, Lenox, and Tilden Foundations. This poster emphasizes the sort of variety that was typical of a vaudeville bill.

1.14 Charles Demuth, *In Vaudeville: Columbia*, 1919. Watercolor and graphite, 11¹⁵/₁₆ x 8 in. (30.3 x 20.3 cm). Columbus Museum of Art, Ohio, Gift of Ferdinand Howald

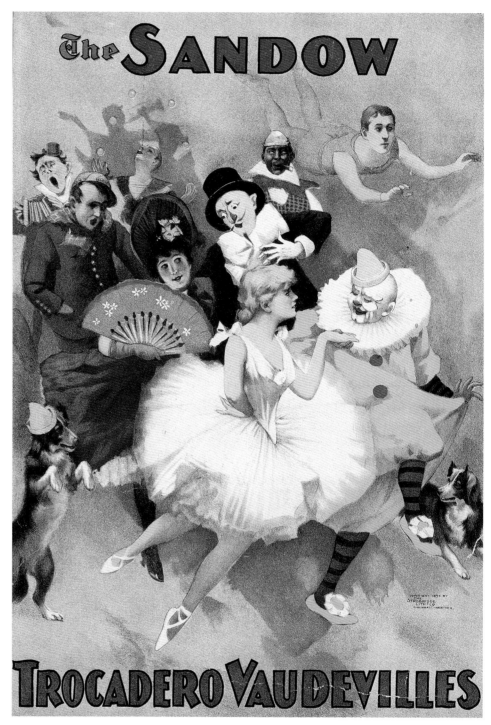

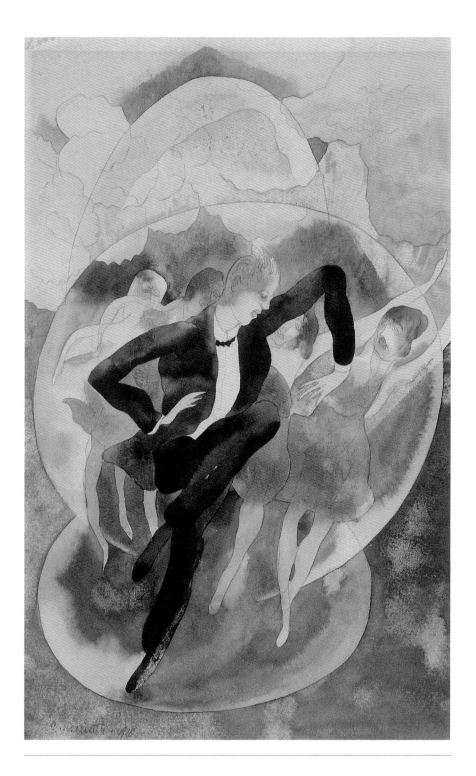

1.15 Charles Demuth, *In Vaudeville: Dancer with Chorus*, 1918. Watercolor on paper, 12³/₄ x 8 in. (32.4 x 20.3 cm). Philadelphia Museum of Art, A. E. Gallatin Collection

1.16 John Sloan, *The White Way*, 1926. Oil on canvas, 30 x 32 in. (76.2 x 81.3 cm). Philadelphia Museum of Art, Gift of Mrs. Cyrus McCormick

1.17 John Marin, *Broadway Night*, 1929. Watercolor, graphite, and black crayon on paper, 21 3/8 x 26 5/8 in. (54.3 x 67.6 cm). The Metropolitan Museum of Art, New York, The Alfred Stieglitz Collection, 1949

1.18 Joseph Stella, *The Voice of the City of New York Interpreted: The White Way*, 1920–22. Oil on canvas, 88¹/₂ x 54 in. (224.8 x 137.2 cm). The Newark Museum, New Jersey

The Voice of the City of New York Interpreted: The White Way (1920–22, fig. 1.18), to take just two examples.

Between the 1880s and the 1910s, incandescent electrical-lighting systems gradually replaced gaslight and electric carbon arc lighting inside theaters, too. This development yielded a level of spectacle that was far greater than had previously been conceivable. Illusory lighting effects had of course been part of the theater experience for centuries (as C. Lance Brockman details in his essay for this book). But the power, efficiency, and special effects that incandescent

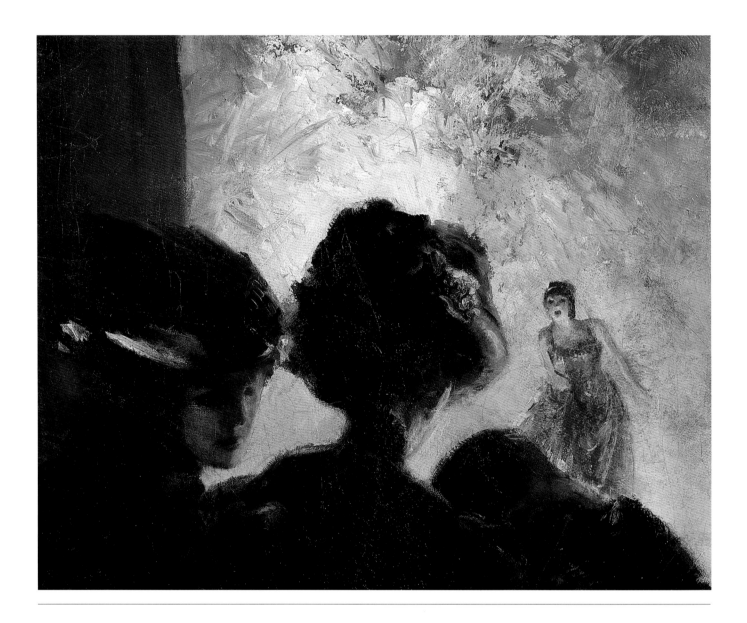

1.19 Everett Shinn, *Girl in Red on Stage*, c. 1905. Oil on canvas, 17 1/2 x 20 in. (44.5 x 50.8 cm). Private collection, courtesy Berry-Hill Galleries

lighting made possible motivated theaters to install and experiment with it during these decades. Gas and carbon arc lights had open flames, needed to be individually lit and monitored throughout the performance, and had limited intensity when contrasted with the focusing power of incandescent lights.

In the United States, the influential producer and playwright David Belasco was a leading theatrical-lighting innovator. He considered it "as essential to every work of dramatic art as blood is to life." His devotion to creating the perfect lighting is reflected in the fact that he would begin working out light settings and changes before rehearsing actors, wanting them to respond dramatically to the mood established by the lighting. The Ashcan school

artist Everett Shinn painted eighteen interior murals for Belasco's Stuyvesant Theatre, which opened in 1907. Shinn, who had met Belasco in 1900, clearly absorbed the importance that the producer ascribed to lighting, incorporating it into key paintings. *Girl in Red on Stage* (c. 1905, fig. 1.19), for example, exhibits a forceful contrast of hue and value. The stage backdrop is saturated with vivid color, conveying the intensity of electrical lighting. The muted hues and asymmetrical area of the foreground, inhabited by spectators, contrasts sharply with the glare of the background. The unresolved tension between these compositional zones characterizes the new lights, while it also expressively evokes the jarring energies of vaudeville.[17]

Vaudeville's ceaseless pursuit of any form that promised a fresh type of spectacle made it a natural medium for the introduction of film. During 1896, the year film was first projected in public in the United States, living-picture acts were a particular rage on the vaudeville stage. The incongruous juxtaposition of these two entertainment modes—lovely ladies who struck frozen poses emulating the figures in famous paintings, contrasted with spectral film images that captured and replayed real-life scenes and activities—offers a compelling example of the sort of sharp contrasts Americans experienced in this period. The quaint, "refined" living-picture act elicited approving oohs minutes before viewers were catapulted into the dazzling but frequently jarring new realm of moving pictures. Cherished legend has it that at some early screenings, first-time viewers ran from their seats when they saw a film of the Black Diamond Express train barreling toward them.[18]

Of course, by 1896 moving picture images had been around for several years. In 1894 the first Kinetoscopes were installed in arcades. Before long, they were to be found in hotel and vaudeville-theater lobbies (fig 1.20). Kinetoscopes were hand-crank peep shows—boxes into which one peered to see a one-minute or shorter film sequence for a penny. John Sloan immortalized the merry scene in a penny arcade in his 1905 print *Fun, One Cent* (fig. 1.21). Amazing as these devices must have seemed, their impact paled when, two years after their introduction, moving pictures were projected at large scale on theater drop curtains.[19]

Early film took its cues about what to present and how to present it from vaudeville. Its broad diversity, the fragmentary nature of the short unrelated pieces screened together, the absence of an informing narrative or theme, and the emphasis on captivating viewers tie early film to its origins in vaudeville

and, at the same time, to the tenor of modern urban experience. Films were grouped, yet projectionists were free to sequence them in any way they wished, making the presentation random and disjointed. Couple this casual, provisional approach with the fact that vaudeville audiences were a mobile, sociable crowd. The continuous-performance mode, unreserved seating, and interesting activities available elsewhere in some of the grander vaudeville houses—for example, the library, barbershop, Turkish bath, café, and roof garden that were part of Proctor's Pleasure Palace in New York—encouraged people to come and go as they pleased. Easy movement and chatter around the theater continued into the first decades of moviegoing as well (figs. 1.22, 1.23).[20]

Motion pictures eventually began to develop as an independent entertainment medium. Nickelodeons were the first places dedicated to a night (or afternoon) at the picture show. They caught on in 1905 and spread quickly across the country as shoestring operations that generally attracted people who could afford the nickel admission—in those days the price of a beer. Just a few years later, picture shows attracted audiences from many social levels in settings that were distinctly grander.[21]

The actual experience of viewers changed only by degrees as film took steps toward independence. Live acts remained a regular feature in nickelodeons and, even later, in more glamorous picture palaces. Vaudeville turns

1.20 Automatic Vaudeville, c. 1904. Silver gelatin print. The Byron Collection, Museum of the City of New York

1.21 John Sloan, *Fun, One Cent*, 1905. Etching on paper, 9⁷/₈ x 12¹/₂ in. (25.1 x 31.8 cm). Frederick R. Weisman Art Museum, University of Minnesota, Minneapolis, Gift of Ione and Hudson Walker

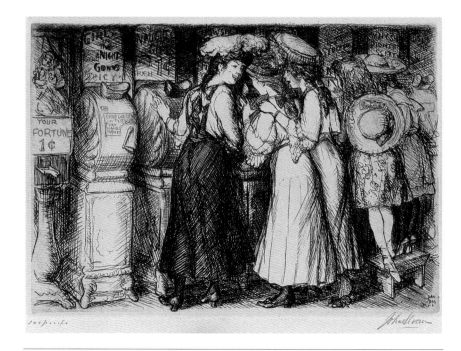

were peppered throughout a program—before, after, and between films. Popular slide-illustrated sing-alongs might fill the gap when film reels were being changed. In fact, the serial variety format stuck with film exhibition throughout and even after the Golden Age of Hollywood, for newsreels, cartoons, organ music, and short subjects were regular features of this later filmgoing experience. During the first decades of cinema, when an act was not performed live, viewers could see it on the silver screen. Edison's film team actually turned to Koster and Bial's Music Hall "and came back with Annabelle the dancer, Madame Bertholdi the contortionist, Sandow the strongman, performing animals, and jugglers."[22]

In his essay for this book, Robert C. Allen acknowledges that vaudeville "favored display and spectacle over narrative." One reason for this, he suggests, was that vaudeville performers had to captivate their audiences quickly because they were given only a few minutes on stage. The need to "put the act over," in the vaudevillian's parlance, fostered a climate in which actors needed to be "a sensation." The captivating performances, fragmented variety format, swift sequencing of acts, blazing new electric lights and their special effects, amazing stunts and tricks, movement and chat about the theater—all these stimuli combined to create a performance mode based upon arousal. This applies to vaudeville *and* early film, whose histories at the dawn of the twentieth century are so closely linked.

The film scholar Miriam Hansen has characterized early cinema as an "unabashed display of visuality." She and a number of other scholars have recently offered reappraisals of early film and the experience of its audiences. Their evaluations root film presentation in vaudeville and emphasize the aim, in both media, of visual provocation. Tom Gunning has termed this type of address "the cinema of attraction."[23]

The first filmmakers were content simply to exploit the marvel of the seductive new medium. The scenes, activities, and presentation style all derived from "an aesthetic of astonishment." The earliest projected films were bits of spectacle only one to five minutes long, gradually lengthening as technology and production methods improved. Originally, films directly acknowledged viewers; there was no "fourth wall" separating them from the scene on the screen. As story lines began to appear, filmmakers continued to rely on this initial mode of engagement, and it persisted long after narrative came to dominate the medium.[24]

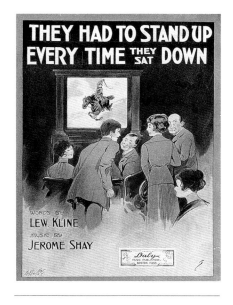

1.22 "They Had to Stand Up Every Time They Sat Down," 1914. Sheet music cover. The Museum of Modern Art, New York, Celeste Bartos International Film Study Center Special Collections. The circulation of audience members that was typical in early movie houses and vaudeville theaters inspired this irreverent song.

1.23 Mabel Dwight, *The Clinch*, 1928. Lithograph, 9 x 11¹¹/₁₆ in. (22.8 x 29.7 cm). Fogg Art Museum, Harvard University Art Museums, Cambridge, Massachusetts, Gift of Paul J. Sachs. Notice the patrons here finding their seats during the film. Such entrances—and exits—were common in popular theaters in the century's early decades.

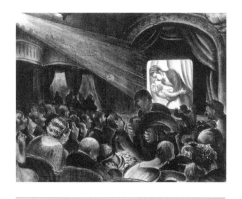

PATRICIA MCDONNELL

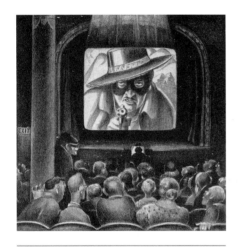

1.24 *The Great Train Robbery*, 1903. Film Stills Archive, The Museum of Modern Art, New York

1.25 Mabel Dwight, *Stick 'Em Up*, 1928. Lithograph, 11 9/16 x 14 15/16 in. (29.4 x 37.9 cm). Yale University Art Gallery, New Haven, The John P. Axelrod, B.A. 1968, Collection of American Art

Not only the presentation style but also the content of film offered visual titillation—tricks that shocked, exotic scenes that piqued curiosity, suggestive display of the body that whetted arousal, views from moving trains. Gunning has defined the cinema of attraction as one "that displays its visibility, willing to rupture a self-enclosed fictional world for a chance to solicit the attention of the spectator."[25] In many films, actors look right at the audience. In *The Great Train Robbery* (1903), a bandit sneers at the camera, draws his gun, and fires at the viewers (fig. 1.24). Mabel Dwight later evoked this famous sequence in her print *Stick 'Em Up* (1928, fig. 1.25): agitated viewers crane their necks for a better view as Dwight's masked thief points his pistol. In the film *Burlesque Suicide* (1902) a man sits alone at a table, drinking and looking forlornly out at the audience. He picks up a gun and holds it to his head. Then he laughs, pointing his finger at the viewers, whom he has duped into thinking he was about to kill himself. *The Comet* (1910) is all about looking. A man's face fills the moon's circle, while the faces of a bevy of attractive ladies scatter across the form of a comet. They exchange glances, gazes, and kisses sent on the wind as the comet slowly travels past the moon. Occasionally, the actors look at the camera. John Sloan emphasizes looking as well in *Movies, Five Cents* (1907, fig. 1.26). The central figure has just turned to look straight at us, echoing the actor-to-viewer engagement of early films.

Films that surprised and shocked were also part of this mode. The beloved trick movies of the Frenchman Georges Méliès, such as *A Trip to the Moon* (1902), fall within this category. Through the marvel of editing, costumes change in an instant, birds turn into ladies, and various other illusions delight the eye. The American Edwin S. Porter also capitalized on such alluring sleight of hand. In *The Artist's Dilemma* (1902), a painter is making a portrait of an attractive young woman when, suddenly, the image on the canvas comes to life, steps to the floor, and begins dancing. The portrait sitter joins her frolic. In such films, of course, narrative is peripheral. As Gunning writes, "The story simply provides the frame upon which to string a demonstration of the magical possibilities of the cinema."[26]

So-called actuality films in this period brought sights from the Spanish-American War in 1898 and images of the devastation wrought by the Galveston hurricane of September 1900, not to mention shots of local fires. The exotic and the mundane claimed equal time. Scenes of everyday metropolitan life afforded rural moviegoers a glimpse of city bustle and urban film

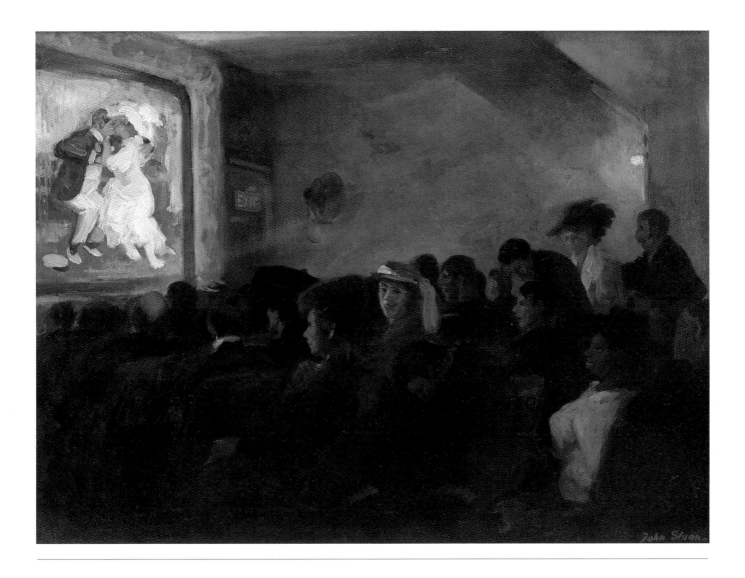

1.26 John Sloan, *Movies, Five Cents*, 1907. Oil on canvas, 23½ x 31½ in. (59.7 x 80 cm). Private collection

fans the pleasure of recognition or awe at views shot from typically inaccessible vantage points. *Interior, New York Subway, 14th Street to 42nd Street* (1905) showed the then new experience of underground transport shortly after the first stretch of the New York subway opened for business; the film ends with the car's arrival at Grand Central Station. In this category, too, were films that overtly reached for strong reactions. In *Railroad Smashup* (1904), two locomotives hurtle toward one another and collide with great force. *A Mighty Tumble* (1901) records the dramatic explosion of a building demolition.

The essential point about this aspect of early film is the medium's "fascination with novelty and its foregrounding of the act of display." This mode dominated in the first ten years of film, was heavily employed in the years that followed, and persists to this day in movies whose appeal centers on staggering

special effects. Additionally, a consciousness about vision—gazes exchanged and new windows opened onto enticing scenes—permeated these films. Emerging from the setting of vaudeville and live performance, early movies played to spectators and, in doing so, created a heightened awareness of the sights to be consumed in a rapidly changing world.[27]

The clear attention to the visual in early film and vaudeville is connected in the period to a far wider phenomenon. An intricate system of display practices helped define metropolitan modernity. In recent years, a number of scholars have explored some of the ways in which the new amusement realm greatly elevated visual attractions in order to entice ticket buyers. Amusement parks, world's fairs, urban theater districts and their White Ways, and circus extravaganzas—impresarios in all these arenas sought ways to intensify visual stimulation, knowing that the lure of extraordinary sights loosened change from people's pockets. Cultural historians, urban geographers, and others have made clear that the world of commerce and consumption also contributed vitally to the new stress upon visual sensations during these years.

The rise in the late nineteenth century of the department store, for example, had a crucial impact on the shopping experience, shifting it from directly handling desired goods to encountering them, initially, on bright display. Large plate-glass windows, cheaply manufactured for the first time in the 1890s, "dramatically altered the appearance of city streets" and encouraged browsing. Store windows suddenly made American abundance visible to all. When wares were creatively arranged and electrically lit, the allure and sense of novelty were magnified. Writing about the new mode of shopping, the historian William R. Leach has emphasized retailers' growing "desire to show things off," a trend, he argues, that "marked a critical moment in the formation of a new culture of consumption. The concept of show invaded the domain of culture, whether in the shape of a theatrical show, a baby show, a show girl, a show place, or a show room." Leach's research confirms that many elements of shopping we now take for granted—from plate glass and spotlighting to the use of mannequins, bold colors, and inventive arrangements—all emerged for the first time in the 1890s. By about 1912 the term *trimmer* was no longer applied to the people who designed store displays; they were now called "display managers."[28]

Elaborating upon the "concept of show," William R. Taylor has suggested that the emergence of American commercial culture in the late nineteenth

and early twentieth centuries was part of an image culture that "helped different groups within the population make sense of the new urban environment." Taylor points to the jostling of classes and genders in the ferry boats, streetcars, and, after 1904, the subway. But to these he also adds the new department stores, large new office buildings and their elevators, and new entertainments as sites where there were "opportunities for mutual observation up and down the social scale." He characterizes the city experience of movement and display and new social interactions as a "culture of pastiche . . . especially in their miscellaneousness, the strident pitch of their promoters, and their emphasis on consumption as 'show.'" The German cultural critics Walter Benjamin and Siegfried Kracauer also commented perceptively on the intensity of display in modern cities. Writing in the 1920s, they offered department stores and opulent picture palaces as paradigms for the new emphasis on show and fragmentary experience.[29]

Certain defining aspects of the multifaceted history of modern urban culture informed the realities that American early modern artists encountered: the visual became key. Disjunctiveness—variously referred to as miscellaneousness, fragmentation, and discontinuity—reigned. The pace of experience revved to high speed. The sweep of changes within a short span of years made some observers wary. In his 1903 essay "The Metropolis and Mental Life," Georg Simmel worried about what "the intensity of nervous stimulation" would bring, and, a few years earlier, the American Thorstein Veblen voiced strong criticism of the "show" at the heart of the burgeoning consumer capitalism.[30] Many others at the turn of the century, however—intellectuals and common citizens alike—accepted these cultural transformations as givens (and sometimes as progress) and celebrated their effervescent newness.

————————

Numerous artists found ways to tap the complex onrush of urban modernity. In their rebellion against the stultifying ways of traditional academies, they seized upon the animation of contemporary life. They were pioneers, sometimes stumbling and groping toward pictorial forms that could represent what they were seeing, hearing, and feeling. Changed social realities as well as transformed perceptions are reflected in their works. The art historian Jeffrey Weiss poses "peculiar confoundedness" as a term for modern experience and argues that Pablo Picasso and Marcel Duchamp built incomprehension into their art to mark it as a product of their orbit and time.[31]

Propelling this book and exhibition is the notion that the visual culture of early twentieth-century popular entertainment—chiefly vaudeville and film—provided a source that various American artists used to make art that was distinctly modern. Admittedly, art historians have disregarded much of the work included here when discussing modern art in the conventional histories. Michael Leja, for one, recently asserted that, "Among the most modernized countries in industrial, demographic, economic, and technological terms, the United States was slow to accommodate art committed to discerning forms and visual practices characteristic of modernity." Conforming to the pressures of the art world and its market in turn-of-the-century America, artists looked especially to Paris, which was seen as the unrivaled art capital on both sides of the Atlantic. Any American artist with ambition knew that a stint abroad, particularly in France, was essential. Henry James accurately analyzed the situation in 1887: "When today we look for 'American art' we find it mainly in Paris. When we find it out of Paris, we at least find a great deal of Paris in it."[32] The formal inventions of the Barbizon, impressionists, fauvists, and other modernists found their way onto American canvases.

Nonetheless, modern art should not principally be appreciated as a footrace, with prizes awarded only for pioneering firsts. Like any evolving artistic form, it incorporated continuities as well as new tendencies and jarring breaks. Also, modern art should not be seen as a monolithic entity. The ways in which it found expression naturally depended upon the particular moment and place and upon the social, political, and economic realities of a given incubation. If we value art as a creative and culturally constructed expression in visual form, we can learn about the richness of shifting, culturally specific practices by carefully assessing the works of American artists that stem from early twentieth-century popular theaters.

It is also critical to point up a distinction: *Modernist* or avant-garde art pioneered radical visual vocabularies that formally embodied the fractured experiential mode of modernity. *Modern* art stretched pictorial conventions, but its progressiveness rests more significantly in its portrayal of new, contemporary subjects and exchanges. Both strains of modernism are abundantly evident in the American art made to capture the essence of early twentieth-century entertainment. American artists' responses to vaudeville and early film—modernist and modern—yielded significant creative statements, reflecting and interpreting what it meant to be alive in a time of radical transformation.

To borrow a phrase from the art historian Lisa Tickner's recent study of modern British art, it is helpful to "expand the frame" and more carefully examine the precise language of American early modernism.[33]

Ultimately, American artists' images of popular theaters were bound to differ from those of their European contemporaries, such as Edgar Degas, Georges Seurat, and Henri Toulouse-Lautrec. The wholesomeness of vaudeville—despite its brash and colorful stance—opened it to a far larger portion of the population than the pervasive but typically seedy music halls of Paris, where respectable ladies and children dared not go. Additionally, by the early 1900s many popular theaters in the United States were electrified and screened movies, vital ingredients of their visual appeal for American artists—ingredients to which French artists of the 1880s had not been exposed. As one consequence, the imagery of American artists leans toward depictions of rapt viewers more than it does to stage performances or impassive orchestra members, as we see, for instance, in the music-hall posters of Toulouse-Lautrec or the ballet images of Degas.

It was not simply a daring few among the progressive artists in the United States who attended vaudeville and "the flickers." Many loved them and went often, and more than a handful even found employment in these theaters and got to know them well. Alfred Stieglitz, the photographer and impresario who single-mindedly promoted modern art in America, was an inveterate, and catholic, theater- and concertgoer. From 1877 until 1902 he kept a scrapbook documenting his nightlife. In between visits to Carnegie Hall or the Metropolitan Opera, Stieglitz went to vaudeville—to Hammerstein's Victoria, to the Bijou, and to the Casino (figs. 1.27, 1.28). In 1896 he went to Koster and Bial's Music Hall, where he heard the chanteuse Yvette Guilbert and watched a program of fifteen films produced by the American Biograph Company.[34] The record of his theater attendance meaningfully demonstrates that a well-heeled gentleman went regularly to hear Wagner and see Eleanor Duse but also loved the zest of vaudeville.

Marsden Hartley and Charles Demuth, two artists intimately connected with Stieglitz and his circle, also were big vaudeville fans and theater lovers. The two met in Paris in 1912, when Hartley was using the studio of his stage-designer friend Lee Simonson. Over the years, Hartley and Demuth counted many theater people among their friends, such as the stage designer Robert Edmund Jones and the playwright Eugene O'Neill. Although Hartley did not

1.27 Program, Casino Theatre, from Alfred Stieglitz's 1888–1902 theater scrapbook. Stieglitz/Georgia O'Keeffe Archive, Yale Collection of American Literature, Beinecke Rare Book and Manuscript Library, Yale University, New Haven

1.28 Illustrated song slide for song dated 1905, featuring the Casino Theatre. Marnan collection, Minneapolis

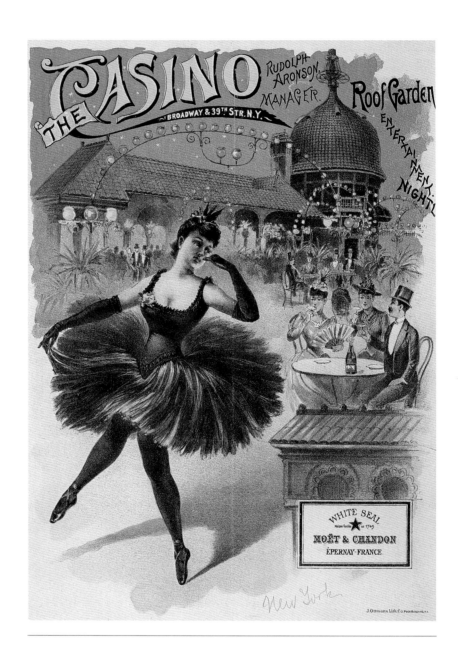

treat theater subjects in his work, Demuth did. In the 1910s he made a series of vaudeville and cabaret watercolors (discussed in Laural Weintraub's essay in this book), and in the 1920s he produced what he called "poster portraits" of three theater-related subjects: O'Neill (1926), the vaudeville star Bert Savoy (1926), and the enigmatic still life of theater scripts, programs, and masks entitled *Longhi on Broadway* (1928). In about 1922 the two artists apparently were at work on a book that would pair writing about vaudeville by Hartley with illustrations by Demuth.[35] They might have felt impelled to take on this project because Marius de Zayas had illustrated Caroline Caffin's

1914 book *Vaudeville* (fig. 1.29); she was married to the influential New York art critic Charles Caffin, and de Zayas and the Caffins also were part of the extensive Stieglitz network.

Members of the Ashcan group also frequented the popular theater. The group's leader, Robert Henri, urged them to connect with contemporary experience and make their keen, direct observations the focus of their art. Getting their start in newspaper and magazine illustration, these artists received assignments that enabled them to roam New York, depicting crowded ghettos, fires and street accidents, Fifth Avenue shopping, and Central Park picnics. They also ventured to vaudeville. In her essay in this book Rebecca Zurier writes about how John Sloan went out often and describes how vaudeville and movies were part of his routine. William Glackens similarly paid regular visits to New York's popular entertainments. Between 1889 and 1901 more than two dozen illustration drawings by William Glackens of vaudeville and popular-theater scenes appeared in the periodicals of the day—ostensibly derived from his prowls in these pleasure palaces.[36]

The Ashcan artist Everett Shinn had an especially strong affinity for the theater. While still living in Philadelphia, he performed in the parlor theatricals put on by such friends as Glackens, Henri, and John Sloan. In New York, Shinn built a small theater in his home on Waverly Place to continue the amateur fun. Photographs from these productions make clear, through the obvious care given to costumes and sets, that the members of this group took their fun quite seriously. In 1899 Shinn came to know three New York theater people who would help him further his career: the actress (and later interior designer) Elsie de Wolfe, the actress Julia Marlowe, and the playwright and producer Clyde Fitch. Through them, Shinn met the architect Stanford White and the theater impresario David Belasco; these two, in turn, led him to important contacts and commissions, including, as noted, the eighteen decorative panels he painted for Belasco's Stuyvesant Theatre in 1907. Shinn later sidelined his paint and brushes temporarily when, from 1917 to 1923, he worked as a movie set designer and art director.[37]

Walt Kuhn and Edward Hopper are two others who made unique contributions to the art focused on popular theater and early film, contributions based on their familiarity with this environment. Kuhn, like Shinn, stepped over conventional professional boundaries and kept himself busy at several occupations simultaneously. He first whetted his lifelong appetite for the

1.29 Marius de Zayas, caricature of Will Rogers in Caroline Caffin's 1914 book *Vaudeville*

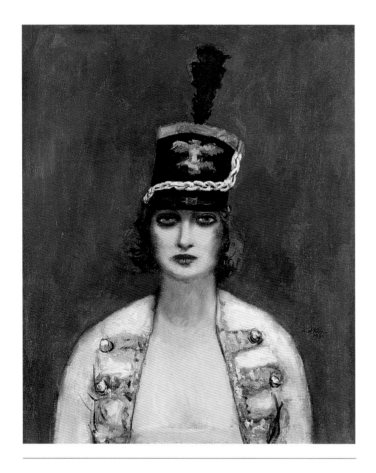

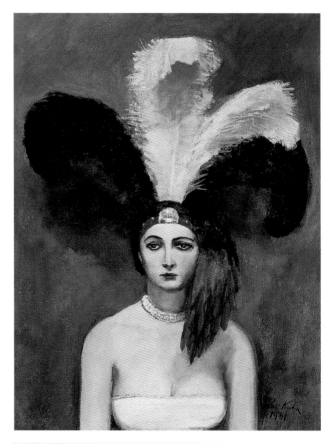

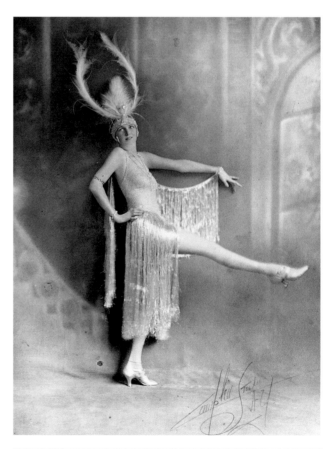

1.30 (above) Walt Kuhn, *Girl in Shako*, 1930. Oil on canvas, 30¹/₈ x 25 in. (76.5 x 63.5 cm). Wichita Art Museum, Kansas, The Roland P. Murdock Collection

1.31 (above right) Walt Kuhn, *Plumes*, 1931. Oil on canvas, 40 x 30 in. (101.6 x 76.2 cm). The Phillips Collection, Washington, D.C.

1.32 Irene Castle, 1900s. Silver gelatin print. Theatre Collection, Museum of the City of New York

theater by working as a delivery boy, taking rental costumes to New York theaters. In the early 1910s he produced annual costume balls for various social clubs, often bringing in vaudeville entertainers for these gala events. From the late 1910s through 1925 he worked in musical revues and vaudeville, designing sets and costumes, writing, and directing. As one Kuhn scholar noted of this intense period, "It is hard to say whether he regarded himself primarily as a painter who made a little extra money dabbling in the theater, or as an aspiring director-producer who had some talent in painting."[38] The colorful showgirls and male clowns are now considered Kuhn's best work from his varied career (figs. 1.30, 1.31).

Edward Hopper was married to the painter Jo Nivinson, a former actress; the couple shared a passion for going out. They attended legitimate-stage performances, popular theater, and movies. Because Hopper habitually saved ticket stubs during the 1920s and 1930s and wrote on them the titles of the productions he and Nivinson saw, we have a detailed record of their active theatergoing in those decades. The closest he came to working in show business was his design of movie posters.[39]

The list of artists who were attracted to popular theater in the early twentieth century is long. These few have been called out here to demonstrate the degree to which artists looked to the theater world and, in important cases, were drawn directly into it. Visual artists intently followed vaudeville's flowering and film's development and understood the ways in which these media projected the newly amplified qualities of city life; they made their perceptions clearly evident in their art. The essays that follow on Charles Demuth, Edward Hopper, Everett Shinn, and John Sloan offer careful analyses of the varied ways in which those artists chose to address modernity by interpreting the climate of popular theater.

Two examples stand out as exceptional illustrations of this point—the vaudeville paintings of Shinn and Demuth. As Sylvia Yount makes clear in her essay on Shinn, spectacle in its various incarnations in big-city life greatly attracted this artist. High drama as an engine of spectacle dominates the street scenes he produced—images of horrid accidents and fires. In some of his vaudeville paintings he treats the performance itself; yet more often he focuses on the lively atmosphere—spectators responding to activities on stage and in the house. He represents vaudeville's permeable membrane between stage and spectators, and he creatively records the animated visual environment

1.33 Everett Shinn, *The Orchestra Pit, Old Proctor's Fifth Avenue Theatre*, c. 1906–7. Oil on canvas, 17⁷/₁₆ x 19¹/₂ in. (44.3 x 49.5 cm). Mr. and Mrs. Arthur G. Altschul, New York

1.34 Everett Shinn, *Magician*, 1906. Pastel, 12¹/₈ x 17¹/₄ in. (30.8 x 43.8 cm). The Saint Louis Art Museum, Gift of F. Lee Hawes and Richard S. Hawes III

1.35 Illustrated song slide for song dated 1913. Marnan collection, Minneapolis. Actors in many early movies played directly to the audience, just as vaudeville performers did. In this song slide, a woman reaches out toward the hero onscreen.

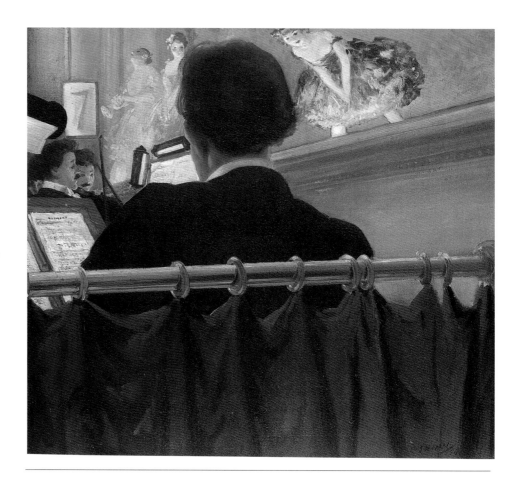

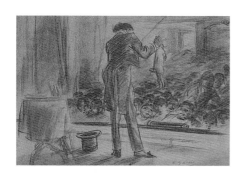

as audience members shift in their seats, their eyes drawn in various directions by assorted stimuli.

The Orchestra Pit, Old Proctor's Fifth Avenue Theatre (c. 1906–7, fig. 1.33) clearly demonstrates the feeling of modern experience that vaudeville exemplified. One of Shinn's major paintings from a long career, it offers an unconventional vantage point: just behind the orchestra and up to the edge of the stage. This skewed perspective unbalances the composition and suggests the unsettled electricity of the scene. Three female dancers, two of them on the left holding brass instruments, look out into the audience. The one on the far left lifts her head up high, looking toward an upper balcony. The dancer at the far right stoops low to look at the pit musician, who is seated just in front of us; her lively expression leads us to think that the two are communicating in some way. Shinn's *Magician* (1906, fig. 1.34) conveys the kind of direct appeal that vaudeville performers made to the audience.[40] The performer beckons to the audience. His presentation of the rabbit pulled from the hat is exaggerated by the unconventional viewpoint: we are positioned backstage, looking

past the gesturing performer and toward the audience. In *The Orchestra Pit, Old Proctor's Fifth Avenue Theatre*, intense stage lighting transforms the dancers into garishly colored caricatures. This effect results, in part, from the stark difference between the vibrant stage and the more muted hues of the offstage areas. Strong graphic contrast, bright versus subdued colors, asymmetrical tensions, a skewed perspective, a novel and curious viewpoint—these pictorial elements combine to transmit the agitated energy and splintered attention of a night at Proctor's.

Shinn offers a more penetrating analysis in *Concert Stage* (1905, fig. 1.36) and *The Vaudeville Act* (1902–3, fig. 1.37). Both works place the implied viewer of the painting in the audience. In these and many more Shinn images, other audience members fill the immediate foreground and look about in various directions. Each figure reacts to different stimuli—whether to the general movement of people in the house, to a man two rows back who laughs too loudly, to a sudden turn or dazzling light change onstage, to a friend's wink across the hall, or to a neighbor who has just given a nudge acknowledging mutual enjoyment. In *Concert Stage*, a woman standing on the left looks out from the canvas, her gaze meeting ours. Through the shifting glances, Shinn concentrates attention on the act of looking and on an awareness of seeing and being seen. His pictorial formulation underscores the fractured spontaneity that was at the heart of the vaudeville audience's experience. At the same time, the image reflects a fundamental aspect of modernity—"show." Shinn's paintings characterize the urban consumer's stepped-up alertness. Very much like early film, they present vaudeville as (to paraphrase Tom Gunning) a theater of attraction, centered on novelty and the act of display. We can speak of Shinn's vaudeville images and those of other Ashcan artists as definitively modern in that they realized their aim "to create an art that spoke to contemporary viewers and to make images that gave transitory experience of the city memorable form."[41]

Charles Demuth, from another progressive sector of America's art world, also analyzed and celebrated vaudeville. He made many vaudeville watercolors between roughly 1915 and 1919. As Laural Weintraub observes in her essay here, Demuth's dancers in popular theaters exude a primal energy. The art historian Barbara Haskell has additionally suggested that a vibrant sensuality runs throughout his vaudeville images.[42] Demuth depicted the energetic movements of performers through fluid curves, undulations, and bulges. The

1.36 Everett Shinn, *Concert Stage*, 1905. Oil on canvas, 16½ x 20 in. (41.9 x 50.8 cm). Norton Museum of Art, West Palm Beach, Florida, Bequest of R. H. Norton

1.37 Everett Shinn, *The Vaudeville Act*, 1902–3. Oil on canvas, 19½ x 23½ in. (49.5 x 59.7 cm). Palmer Museum of Art, Pennsylvania State University, University Park

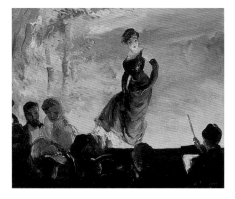

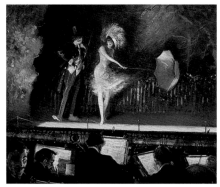

awkward, bumpy line of the female performer's limbs in *Acrobats* (1916, fig. 1.38), for example, communicates the extraordinary movement as the duo enact their feats.

Significantly, Demuth's vaudeville and cabaret works and drama illustrations preceded the precisionist paintings for which he is better known. In many of the vaudeville watercolors, one can detect the first elements of the vocabulary that later matured in those works, in which he reformulated the cubist geometries that had originated in Europe. For example, he rendered the compositional rudiments of *Vaudeville Musicians* (1917, fig. 1.39) in light pencil. He sketched the stage setting in pencil, tracing in elements of the curtains, scenic imagery, stage props, and floorboards, then completed the work by carefully watercoloring in the actors and dynamic atmosphere. The background line is spare and reductive as well as angular and geometric. Demuth creates a pictorial tension by contrasting clean, spare, graphic geometry with luminous washes of diaphanous color. Looking closely at *Vaudeville Musicians*, one can see penciled floorboards and the faint outlines of building forms that would have been painted on the stage backdrop. To evoke powerful electrical lighting, Demuth muted the painted scenery to faint background outlines. The contrast between structural, sharp angles and fluid, colorful figures communicates the disjunctive verve of the vaudeville moment depicted.

Electric spotlighting is another central element in Demuth's vaudeville images. He experiments with various pictorial formulas to convey his excitement about this new tool of theatrical spectacle. In many, such as *Vaudeville Musicians, Two Acrobats* (1918, fig. 1.40), *Acrobats* (1919, fig. 1.41), and *Vaudeville Dancers* (1918, fig. 1.44), spotlights are pictured through successive concentric rings of deepening golds. The final band of the spot's reach is a rich orange. The evenness of touch and color value that pervade the spotlit zones mimic the wash of glaring electrical light Demuth would have seen. The expanding bands of light and color recall the French artist Robert Delaunay's famous orphic circles and the American modernist Arthur Dove's pulsing solar orbs. But in Demuth's lexicon, these glowing rings convey the animated spectacle that was on view any day or night in vaudeville.

Demuth experimented with watercolor to record the moods that electric stage lighting created. In *Vaudeville* (1917, fig. 1.45), for instance, he painted sweeping, billowing skeins of light that read as shifting gray and brown stripes in front of which the performers appear. This effect renders the stage space as

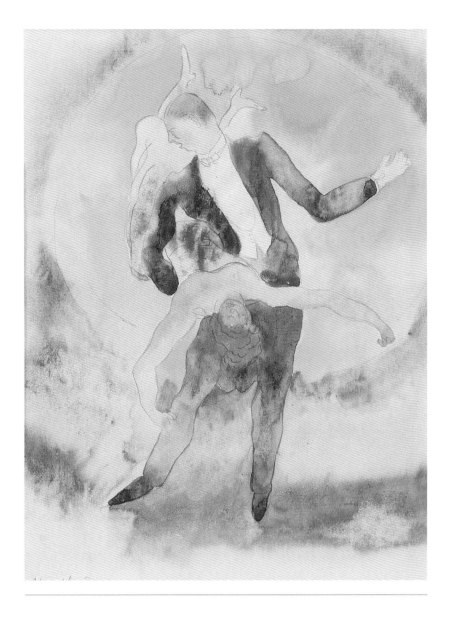

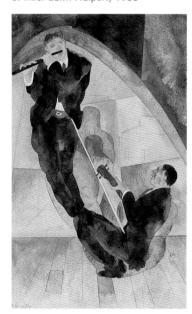

1.38 Charles Demuth, *Acrobats*, 1916. Watercolor, 10 x 7 3/4 in. (25.4 x 19.7 cm). New Britain Museum of American Art, Harriet Russell Stanley Fund

1.39 Charles Demuth, *Vaudeville Musicians*, 1917. Watercolor and pencil, 13 x 8 in. (33 x 20.3 cm). The Museum of Modern Art, New York, Abby Aldrich Rockefeller Fund

1.40 Charles Demuth, *Two Acrobats*, 1918. Watercolor and graphite on paper, 13 x 8 in. (33 x 20.3 cm). Walker Art Center, Minneapolis, Gift of Mrs. Edith Halpert, 1955

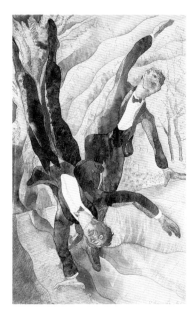

ambiguous, with no clear indication of ground or recession. Especially in this work, he used lighting to heighten and explore spatial abstraction; the indeterminate wash of watercolor posits two- and three-dimensionality simultaneously in the image. Demuth worked to tease pictorial abstraction out of the arresting but disorienting visual experience of American popular theaters. By doing so, he contributed to the developing language of American early modernism.

"Iridescence of the moment" was the expression Marsden Hartley coined to describe the seduction of vaudeville. While certain performances had their charm, the idea of fleeting spectacle epitomized for him the magic of this medium. Hartley had hit upon an excellent phrase to sum up the array of

1.41 Charles Demuth, *Acrobats*,
1919. Watercolor and pencil on paper,
13 x 7⅞ in. (33 x 20 cm). The
Museum of Modern Art, New York,
Gift of Abby Aldrich Rockefeller

1.42 Professor Faucher, Trick
Vaudeville Bicyclist, 1900. Silver
gelatin print. The Byron Collection,
Museum of the City of New York

1.43 Keith's Bicycle Track, 1901–2.
Silver gelatin print. The Byron
Collection, Museum of the City of
New York

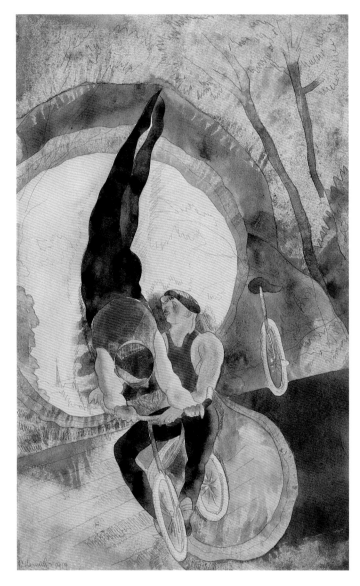

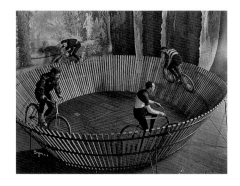

forces that found synthesis in vaudeville, and popular entertainment generally, in the late nineteenth and early twentieth centuries. Modern life in American cities was marked, to recall Miriam Hansen's expression, by an "unabashed display of visuality." Heightened forms of show emerged across the cultural landscape and were made more intense by each new technological wonder. These conditions of modernity permeated American society. They were used without restraint in popular entertainment. Astute artists found pictorial languages to tell contemporary viewers then, and remind us today, about the vocabulary of display that vaudeville and early film incorporated. Hartley judged vaudeville's greatest value to be "something for the eye first and last."[43] It is our good fortune that a number of other American artists thought so, too.

1.44 Charles Demuth, *Vaudeville Dancers*, 1918. Watercolor and pencil on paper, 8 x 11½ in. (20.3 x 29.2 cm). The Museum of Modern Art, New York, Museum purchase

1.45 Charles Demuth, *Vaudeville*, 1917. Watercolor and pencil on paper, 8 x 10½ in. (20.3 x 26.7 cm). The Museum of Modern Art, New York, Katherine Cornell Fund

Notes

1 Florence Sinow, letter recalling her experiences in the vaudeville audience, as quoted in Snyder, *Voice of the City*, 129. Snyder has written insightfully on vaudeville performance and its social impact. My understanding of its importance owes significantly to his numerous perceptive publications on the subject.

2 Georg Simmel, "The Metropolis and Mental Life," in *Classic Essays on the Culture of Cities*, ed. Richard Sennett (New York: Appleton, Century, Crofts, 1969), 48. Barth, *City People*, 207.

3 Charles Baudelaire, "The Painter of Modern Life," *The Painter of Modern Life and Other Essays*, trans. and ed. Jonathan Mayne (London: Phaidon, 1964), 1–40. See also Michele Hannoosh, "Painters of Modern Life: Baudelaire and the Impressionists," in Sharpe and Leonard Wallock, *Visions of the Modern City*, 168–88. Thomas Crow, "Modernism and Mass Culture," 22.

4 For the multinational rise of impressionism, see Lothar Brauner and Heinz Rodewald, *Malerie der deutschen Impressionisten*, exh. cat. (Berlin: Staatliche Mussen zu Berlin, 1976); Laura L. Meixner, *An International Episode: Millet, Monet, and Their North American Counterparts*, exh. cat. (Memphis, Tenn.: Dixon Gallery and Gardens, 1982); Kate Flint, ed., *Impressionists in England: The Critical Reception* (London: Routledge and Kegan Paul, 1984); William H. Gerdts, *American Impressionism* (New York: Artabras, 1984); Josef Kern, *Impressionismus im Wilhelminischen Deutschland* (Würzburg: Konighausen and Neumann, 1989); Serge Govens de Heusch, *Het Impressionisme en het fauvisme in België*, exh. cat. (Ludion, Belgium: Musée d'Ixelles, 1990); Peter Winenger, Peter Müller, and Martina Haja, *Emil Jakob Schindler und der österreichische Stimmungsexpressionismus* (Graz, Austria: Akademische Druck- und Verlagsanstalt, 1991); Georg Brühl, *Die Cassirers: Streiter für Impressionismus* (Leipzig: Edition Leipzig, 1991); Weinberg, Bolger, and Curry, *American Impressionism and Realism*; Johan Georg von Hollenzollern and Peter-Klaus Schuster, *Manet bis van Gogh: Hugo von Tschudi und der Kampf um die Moderne* (Munich: Prestel Verlag, 1996); and Vladimir Kruglov and Vladimir Lenyashin, *Russian Impressionism* (New York: Abrams, 2000).

5 Hassam quoted in Weinberg, Bolger, and Curry, *American Impressionism and Realism*, 4; Lipchitz quoted in Roeder, "What Have Modernists Looked At?" 56.

6 The 1846 New York visitor was a young seminarian, Charles Loring Brace, quoted in Edwin G. Burrows and Mike Wallace, "Seeing New York," *Gotham: A History of New York City to 1898* (New York: Oxford University Press, 1999), 692. For population statistics, see Kenneth T. Jackson, ed., *The Encyclopedia of New York City* (New Haven: Yale University Press, 1995), 921–22; and *Twelfth Census of the United States Taken in the Year 1900* (Washington, D.C.: United States Census Office, 1901), pl. 10. Simmel, "The Metropolis and Mental Life," in *Classic Essays on the Culture of Cities*, 48.

7 The first quotation here is from Hansen, "America, Paris, the Alps," 363. Taylor, "Launching of a Commercial Culture," 108.

8 Quoted in Snyder, *The Voice of the City*, 16–17. See also Butsch, "Bowery B'hoys and Matinee Ladies"; Kibler, *Rank Ladies*; and Peiss, *Cheap Amusements*.

9 Nasaw, *Going Out*, 3–4.

10 This cultural phenomenon is sensitively analyzed in Nasaw, *Going Out*. For other significant studies on the rise of leisure, see Braden, *Leisure and Entertainment in America*; Butsch, *Making of American Audiences*; Butsch, *For Fun and Profit*; Erenberg, *Steppin' Out*; Grover, *Hard at Play*; Harris, *Cultural Excursions*; Lynes, *Lively Audience*; Pisano, *Idle Hours*; and Rosenzweig, *Eight Hours for What We Will*. William R. Leach has argued that the shift from agricultural labor to tedious factory and clerical work increased the importance of life outside work and hence made leisure activities take on great meaning in people's lives. See Leach, "Strategists of Display," 101.

11 Oscar Hammerstein opened two roof gardens, the Olympia (above the Olympia theater) and the Paradise (above the Victoria Theatre). The Olympia closed in 1898, and the Victoria opened the following year. Hammerstein added a covered roof for the summer of 1901, the approximate date of the Glackens painting, which shows a roof enclosure. For more on the Victoria Roof Garden, see Johnson, *Roof Gardens*, 77–95. For more on the Glackens painting, see Kathryn Harris, Lewis Erenberg, and Brendan Gill, "William J. Glackens's *Hammerstein's Roof Garden*," in *Frames of Reference: Looking at American Art, 1900–1950, Works from the Whitney Museum of American Art*, ed. Beth Venn and Adam D. Weinberg (New York: Whitney Museum of American Art, in association with University of California Press, 1999), 126–35.

12 For the contributions of vaudeville and film, respectively, to the rise of American mass culture, see Snyder, "Vaudeville Circuit"; and May, *Screening Out the Past*.

13 For the nature and variety of vaudeville perfor-
mance, see Holland, *Strange Feats and Clever
Turns*; and McNamara, *American Popular
Entertainments*. Caroline Caffin lauded vaude-
ville novelty in *Vaudeville*, 3.

14 For turn-of-the-century visual amusements, see
Balzar, *Optical Amusements*; and McCullough,
Living Pictures. Singer, "Modernity,
Hyperstimulus, and the Rise of Popular
Sensationalism," 93.

15 Nye, *Electrifying America*, 35. For other studies
of the impact of electrification, see Andreas
Blühm and Louise Lippincott, *Light! The
Industrial Age, 1750–1900, Art and Science,
Technology and Society* (Pittsburgh: Carnegie
Museum of Art and Van Gogh Museum, in
association with Thames and Hudson, 2000);
Nasaw, "Cities of Light"; Wolfgang
Schivelbusch, *Licht, Schein, und Wahn:
Auftritte der elektrischen Beleuchtung im 20.
Jahrhundert* (Berlin: Ernest and Sohn, 1992);
and Schivelbusch, *Disenchanted Night*.

16 David E. Nye discusses Lewis's *Main Street* in
Electrifying America, 54. Dreiser, *Sister Carrie*
(1900; rpt. New York: Bantam, 1992), 2.

17 David Belasco, *The Theatre Through Its Stage
Door* (New York: Harper and Brothers, 1919),
56. The influential cultural critic James G.
Huneker went out on a limb by claiming that
Belasco had pioneered lighting effects before
his famous stage contemporaries Adolphe
Appia (in Italy), Gordon Craig (in England),
and Max Reinhardt (in Germany); quoted in
Gostä Bergman, *Lighting in the Theatre*
(Stockholm: Almquist and Wiksell Inter-
national; and Totowa, N.J.: Rowman and C.
Hiefield, 1977), 310. For Shinn's relationship
with Belasco, see Wong, *Everett Shinn*, 43.

18 Robert C. Allen offered the first persuasively
argued study of the interwoven history of
vaudeville and film. See *Vaudeville and Film*.
For the early movie viewers who fled their
seats, see Gunning, "An Aesthetic of
Astonishment." See also Marianne Doane,
"'When the direction of the force acting on the
body is changed': The Moving Image,"
*Femme Fatales: Feminism, Film Theory,
Psychoanalysis* (New York: Routledge, 1991),
188–205; and Lynn Kirby, "Male Hysteria and
Early Cinema," *Camera Obscura* 17 (May
1988): 113–31.

19 For studies on the Kinetoscope, see Gordon
Hendricks, *The Kinetoscope: America's First
Commercially Successful Motion Picture
Exhibitor* (1966; rpt., New York: Arno, 1972);
and Charles Musser, *Thomas A. Edison and
His Kinetographic Motion Pictures* (New Bruns-
wick, N.J.: Friends of Edison National Historic
Site with Rutgers University Press, 1995).

20 Regarding early film's dependence on the per-
formance conventions of vaudeville, see
Hansen, *Babel and Babylon*, 23–59; Robinson,
"The Inherited Repertoire: Origins of Movie
Picture Content," in *From Peep Show to
Palace*, 68–87; and Musser, "Thomas Edison
and the Amusement World," in *Emergence of
Cinema*, 55–89. Robert C. Allen discusses the
various attractions other than performance in
vaudeville halls, taking particular note of the
opulence of Oscar Hammerstein's Olympia
theater, and abundant amenities of Proctor's
Pleasure Palace. See *Horrible Prettiness*,
183–85, 315–16. Gunther Barth argues that
the unstructured circulation and the related
interrupted, fragmentary experience of vaude-
ville made it very similar to modern urban life.
City People, 207.

21 "Early cinema relied for its subject matter on
representational strategies of a vast repertoire
of commercial amusements that flourished
around the end of the century. The Wild West,
minstrel and magic shows, the burlesque, the
playlet, the dance number, pornographic dis-
plays, acrobats, and animal acts—all supplied
the cinema with subject matter, performance
conventions, and viewer expectations, so did
the magic lantern and the stereoptican shows
with their configuration of projected image,
darkened theatre space, and sound accompa-
niment." Hansen, *Babel and Babylon*, 29. For
studies of early motion picture theaters and
their audiences, see Robert C. Allen, "From
Exhibition to Reception: Reflections on the
Audience in Film History," in *Screen Histories*,
ed. Annette Kuhn and Jackie Stacey (Oxford:
Clarendon, 1998), 13–21; Garth Jowett, "The
First Motion Picture Audiences," in Fell, *Film
Before Griffith*, 196–206; Merritt, "Nickelodeon
Theatres"; and Stokes and Maltby, *American
Movie Audiences*. A debate about the nature
of nickelodeon attendance provides rich infor-
mation about shifting audience patterns. See
Allen, "Motion Picture Exhibition"; Ben Singer,
"Manhattan's Nickelodeons: New Data on
Audiences and Exhibitors," *Cinema Journal* 34,
no. 3 (1995): 3–35; and Sumiko Higashi,
Robert C. Allen, and Ben Singer, "Dialogue on
Class and Manhattan's Nickelodeons," *Cinema
Journal* 35, no. 3 (1996): 72–128.

22 For the persistence of the variety format in film
presentation, see Allen, "Movies in Vaudeville,"
81. The quotation is from Robinson, "The
Inherited Repertoire," 68.

23 Hansen, *Babel and Babylon*, 45. Gunning,
"Cinema of Attraction."

24 Tracing the history discussed here, Anne
Friedberg identifies the point when postmod-
ernism began as the moment when the cinema

of attraction faded to "classic cinema" or viewing that depends on spectators' rapt engagement in the narrative. When what one sees is fictitious and set in "an imaginary elsewhere and an imaginary 'elsewhen,' experience is greatly informed by 'a mobilized virtual gaze.'" Friedberg, "Cinema and the Postmodern Condition," 60. See also Friedberg, *Window Shopping*. For a related study, see John Berger, "Every Time We Say Goodbye," *Sight and Sound* 1, no. 2 (1991): 14–17.

25 Gunning, "Cinema of Attraction," 64.

26 Ibid., 65.

27 Quotation from Gunning, "Now You See It, Now You Don't," 4. "These early films explicitly acknowledge their spectator," Gunning writes elsewhere, "seeming to reach outwards and confront. Contemplative absorption is impossible here. The viewer's curiosity is aroused and fulfilled through a marked encounter, a direct stimulus, a succession of shocks." "Aesthetic of Astonishment," 38. Kathryn Helgesen Fuller has shown that early posters advertising film reflected early cinema's direct engagement of viewers. "Viewing the Viewers," 117.

28 For the first quotation see William R. Leach, "Transformations in a Culture of Consumption: Women and Department Stores, 1890–1925," *Journal of American History* 71, no. 2 (September 1984): 325. For the change in terminology, see Leach, "Strategists of Display," 111–15, 122–25. See also Leach, *Land of Desire*.

29 Taylor, "Launching of a Commercial Culture"; quotations, 110, 108. Walter Benjamin, "Paris, Capital of the Nineteenth Century," in *Reflections: Essays, Aphorisms, Autobiographical Writing*, ed. Peter Demetz (New York: Schocken, 1978), 146–62. Siegfried Kracauer, "Cult of Distraction: On Berlin's Picture Palaces," in *The Mass Ornament: Weimar Essays*, trans. and ed. Thomas Y. Levin (Cambridge: Harvard University Press, 1995), 322–28. For further analysis of the rise of consumer culture, see the above-cited publications by Leach and by Taylor, as well as Kenneth Ames, *Accumulation and Display: Mass Marketing Household Goods in America, 1880–1920*, exh. cat. (Winterthur, Del.: Henry Francis du Pont Winterthur Museum, 1986); Michele H. Bogart, *Artists, Advertising, and the Borders of Art* (Chicago: University of Chicago Press, 1995); Bronner, *Consuming Visions*; Fox and Lears, *Culture of Consumption*; and Nancy Von Rosk, "Domestic Visions and Shifting Identities: The Urban Novel and the Rise of a Consumer Culture in America," Ph.D. diss., University of New Hampshire, 1999.

30 Thorstein Veblen, *The Theory of the Leisure Class: An Economic Study in the Evolution of Institutions* (New York: Macmillan, 1899). See also Jackson Lears, "Beyond Veblen: Rethinking Consumer Culture in America," in Bronner, *Consuming Visions*, 73–97.

31 Weiss, *Popular Culture*, xvi.

32 Leja, "Modernism's Subjects," 65. Henry James, *The Painter's Eye: Notes and Essays on the Pictorial Arts*, ed. John Sweeney (London: R. Hart-David, 1956), 216.

33 Lisa Tickner, "Modernism and Modernity," in *Modern Life and Modern Subjects: British Art in the Early Twentieth Century* (New Haven: Yale University Press, 2000), 189.

34 Alfred Stieglitz/Georgia O'Keeffe Archives, Yale Collection of American Literature, Beinecke Rare Book and Manuscript Library, Yale University. For information on Stieglitz's interest in vaudeville, see Richard Whelan, *Alfred Stieglitz: A Biography* (1995; rpt., New York: Da Capo, 1997), 121–22.

35 Hartley and Demuth were models for the character Charles Marsden in O'Neill's 1928 *Strange Interlude*. For a comprehensive study of Demuth's later abstract portraits, see Robin Jaffee Frank, *Charles Demuth: Poster Portraits, 1923–1929*, exh. cat. (New Haven: Yale University Art Gallery, 1995). Hartley had written several articles on vaudeville, including "Vaudeville," *Dial* 68 (March 1920): 335–42. On the planned but unrealized Demuth-Hartley collaboration, see Frank, *Demuth*, 17.

36 For Glackens's popular-theater illustrations, see Weintraub, "Fine Art and Popular Entertainment," 69.

37 DeShazo, "The Theatre," and "The Movies," in *Everett Shinn*, 71–81, 113–19. For the Shinn-Belasco relationship, see Wong, "Relationships and Recognition: 'A man has only to move forward,'" in *Everett Shinn*, 36–40. For other studies of Shinn's involvement in and images of the popular theater, see Ferber, "Stagestruck," 62–63; and Yount, "Consuming Drama."

38 For Kuhn's costume-delivery job, see Philip Rhys Adams, *Walt Kuhn, Painter: His Life and Work* (Columbus: Ohio State University Press, 1978), 9. For the quotation, see Frank Getlein, *Walt Kuhn, 1877–1949*, exh. cat. (New York: Kennedy Galleries, 1977), unpaginated.

39 Levin, "Edward Hopper," 123, 126. Pamela N. Koob, *Edward Hopper's New York Movie*, exh. cat. (New York: Bertha and Karl Leubsdorf Art Gallery, Hunter College, 1998), 4–5.

40 The rapport between vaudeville performers and audiences is noted throughout the literature on this medium. For essays pointing up this connection in Ashcan art, see Robert W. Snyder, "City in Transition," in Zurier, Snyder,

and Mecklenburg, *Metropolitan Lives*, 54; and Fairman, "Landscape of Display," 212.

41 Zurier and Snyder, Introduction *to Metropolitan Lives*, 14. Zurier's forthcoming book *Picturing the City: Urban Vision and Representation in the Art of the Ashcan School* (Berkeley: University of California Press), will contribute a fresh, rich analysis of these artists' engagement with and responses to the shifting cultural practices that resulted from urban modernity. My understanding of the artists' accomplishments has been deepened by her writings.

42 Haskell, *Charles Demuth*, 54–55.

43 Hartley, "Vaudeville," in *Adventures in the Arts*, 172, 173.

CHAPTER 2

IT BEGINS WITH THE LIGHTS:
ELECTRIFICATION AND THE RISE
OF PUBLIC ENTERTAINMENT

DAVID NASAW

Before the electric lights were turned on, the city after dark was a place of pleasures, but forbidden ones. People who went out at night, it could be assumed, were in pursuit of the illicit and immoral. Only the rich, magically transported from home to hotel ballroom or opera house in private carriages, were immune from suspicion. Respectable folk went home after dark, leaving the streets of the city to sporting men, streetwalkers, ruffians, and waifs. What they knew about the netherworld of darkness—and its delights—came from voyeuristic literature produced for their delectation by such reporters as George G. Foster of the *New York Tribune*. "New York by Gas-Light! What a task have we undertaken!" Foster wrote in the introduction to his 1850 guidebook, invoking the first-person plural to yoke his readers to him as he traveled the city after dark. "To penetrate beneath the thick veil of night and lay bare the fearful mysteries of darkness in the metropolis—the festivities of prostitution, the orgies of pauperism, the haunts of theft and murder, the scenes of drunkenness and beastly debauch, and all the sad realities that go to make up the lower stratum—the under-ground story—of life in New York!"[1]

Was the city after sundown as fraught with danger as its chroniclers proclaimed it to be? Probably not. But the fact that it was portrayed as such—in newspaper columns, magazine sketches, guidebooks, advice manuals, and sermons—had a decided impact. Fear kept citizens indoors. Those who valued their reputations had added incentive to remain off the streets after nightfall. The ambitious clerk dared not be mistaken for a sporting man; and the young woman owed it to her family—and to her future husband—to steer clear of any implication that she might be a streetwalker. "A tenet exists in the unwritten constitution of the polite world," a *Harper's New Monthly Magazine* article proclaimed in 1878, "that prescribes an early hour after which women shall not be seen unescorted on Broadway."[2]

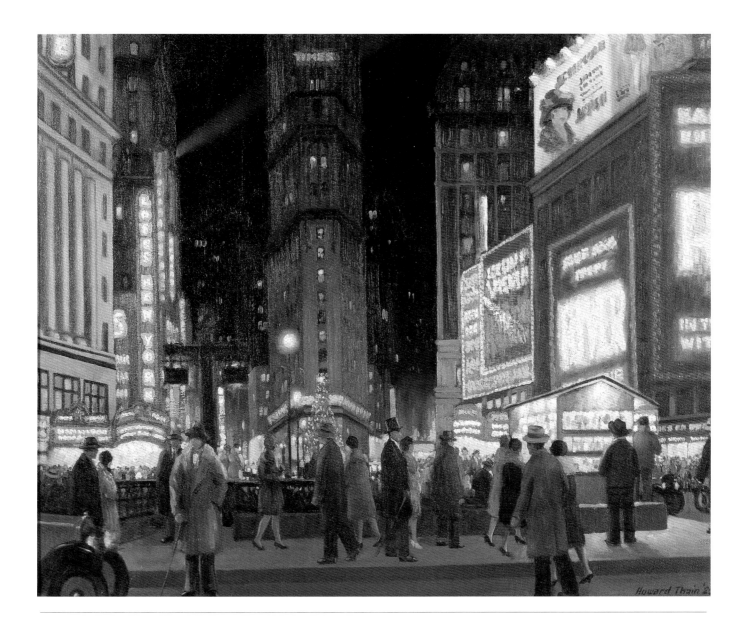

2.1 Howard A. Thain, *The Great White Way, Times Square, New York City*, c. 1925. Oil on canvas, 30 x 36 in. (76.2 x 91.4 cm). The New-York Historical Society

With the city shrouded in darkness and peril, there was no possibility for a "nightlife." Reading popular guidebooks, such as *Lights and Shadows of New York Life* by James D. McCabe, Jr. (1872), one is struck by the absence of any "after-dark amusements" section. There are instead chapters on "places" of amusement; McCabe's occupies fifteen pages of the 850 in his book. There he describes the "sixteen theatres in New York usually in full operation" and, in one brief paragraph devoted to each, minstrelsy, concerts, lectures, and the circus. Such is the sum total of New York nighttime amusements that respectable citizens are invited to sample. McCabe warns residents and visitors alike to beware of trespassing beyond these boundaries. "The curiosity of all persons concerning the darker side of city life," the author alerts his

readers in the preface, "can be fully satisfied by a perusal of the sketches presented in this volume. It is not safe for a stranger to undertake to explore these places for himself. . . . The city is full of danger."[3]

The "thick veil of night" that George G. Foster described in 1850 as enveloping New York—and, by extension, other American cities—was not lifted all at once. The first street lamps, fueled by gas, appeared in the mid-nineteenth century. They emitted a hazy, smoke-tinged glow that barely extended beyond the outline of the lampposts and was quickly extinguished by even moderate gusts of wind. In 1879 the first "electric arc" lights were installed on the perimeter of a public square in Cleveland by their inventor, Charles Brush. The illumination they gave off was, unlike the gas lamps, so brilliantly harsh (at two thousand candle power, each one was as strong as a modern floodlight) that a local newspaper reported that spectators had to wear "smoked glasses to protect their eyes from the glare." Brush found investors, established the Brush Electric Company, and installed electric arc lights on selected streets in Cleveland, then in New York, Philadelphia, San Francisco, and Boston.[4]

While Brush was lighting the public square in Cleveland, Thomas Alva Edison, in the New York City area, was perfecting his own electrical-generating system and an incandescent lightbulb that could illuminate the city streets more efficiently and effectively than Brush's intimidating arc lights. By fall 1882 Edison had raised enough money to construct a central generating station with six huge dynamos on Pearl Street in lower Manhattan that produced enough electricity to light twelve hundred sixteen-candle lamps.

Central generating stations were the most efficient means of producing electricity, but building and maintaining them took an enormous investment of capital, capital that was hard to recoup because the demand for electricity was as yet modest. Only in the late 1880s and 1890s, as the electric streetcar was perfected, did the need expand to the point at which the cost of building new power plants and enlarging old ones became manageable.

The generation of electricity—to run streetcars and light the city streets—was by the early 1890s a growth industry, with several companies, including those of Brush, Edison, and George Westinghouse, competing for municipal franchises. As the cost of electricity fell, it became possible for the city's retail establishments, especially department stores, hotels, and theaters, to use electric lamps for exterior display and interior lighting. Only people's

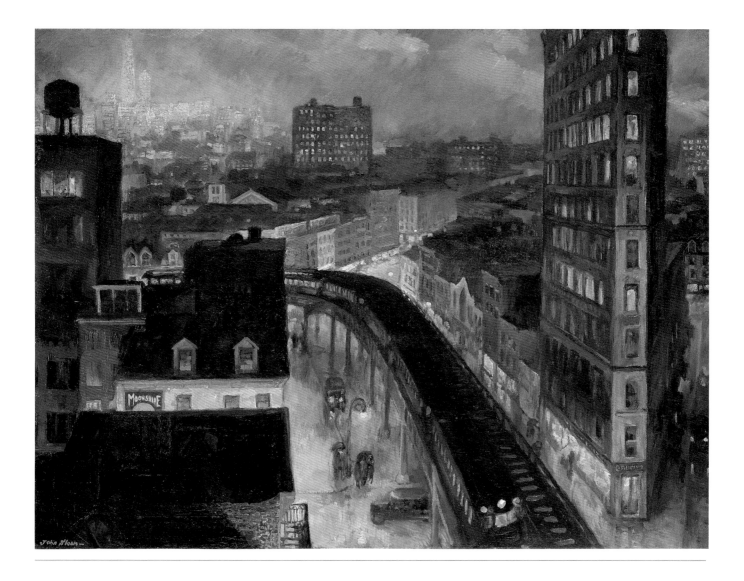

2.2 John Sloan, *The City from Greenwich Village*, 1922. Oil on canvas, 26 x 33 3/4 in. (66 x 85.7 cm). National Gallery of Art, Washington, D.C., Gift of Helen Farr Sloan

homes were left behind in the rush toward electrification. Kerosene lamps, though they were unstable, smoky, malodorous, and easily extinguished, and though they devoured the oxygen in a room, would remain the standard in the homes of all but the wealthy until the 1920s.

American cities were far ahead of their European counterparts in using electricity to light the streets. By 1903 New York had almost 17,000 electric streetlights, Philadelphia nearly 10,000, and Chicago close to 9,000—compared with 1,291 in Munich, 735 in Berlin, and 399 in Hamburg. A Chicago journalist writing in 1900 described the changes in the city's lighting as "little short of marvelous. The field where but yesterday the flickering gas flame held full sway now blazes nightly in the glow of myriads of electric lamps, aggregating in intensity the illuminating power of 15,000,000 candles."[5]

2.3 The Great White Way, New York. Broadway, looking south from Forty-second Street, 1908. Silver gelatin print. Prints and Photographs Division, Library of Congress

2.4 Street view at night, Herald Square Theatre, Broadway and Thirty-fifth Street, New York, 1907. Silver gelatin print. Prints and Photographs Division, Library of Congress

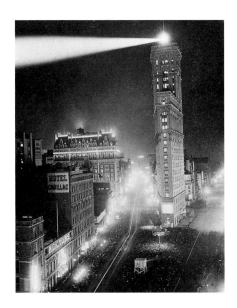

Electric arc lights encased in frosted glass to mute the glare and incandescent street lamps with their warmer, gentler glow were changing the face of the city after dark. As important for our purposes, they were changing the image of the city as represented in newspaper and magazine coverage and in fiction. The same media that had only a couple of decades earlier portrayed the nighttime streets as awash in crime and debauchery were by the 1890s describing them as centers of glitter and gaiety.

The contrast between the captivating, electrically illuminated streets and the claustrophobic, kerosene-lit rooms to which most of New York's working people returned at dusk was too great not to have an impact on daily life in the metropolis. The journalist and author Richard Harding Davis, writing about Broadway in 1892, described the solace and succor that workers found there after dark,

> when the shop fronts are lighted, and the entrances to the theaters blaze out on the sidewalk like open fireplaces. . . . It is at this hour that the clerk appears, dressed in his other suit, the one which he keeps for the evening, and the girl bachelor, who is either a saleslady or a working-girl, as she chooses to call herself . . . can and does walk alone . . . at night unmolested, if she so wishes it. . . . She has found her hall bedroom cold and lonely after the long working day behind a counter or at a loom, and the loneliness tends to homesickness . . . so she puts on her hat and steps down a side-street and loses herself in the unending processions of Broadway, where, though she knows no one, and no one wants to know her, there is light and color, and she is at least not alone.[6]

Noticeably missing from this account is any overt threat of danger. Davis gives no compelling reason why either the clerk or the bachelor girl should resist the siren call of the street. On the contrary, they have every reason to escape from their homes and the "loneliness [that] tends to homesickness" and join their neighbors out-of-doors.

Theodore Dreiser elaborated on this theme in *Sister Carrie* (1900), his brilliant novel of life in the American city of the 1890s. Carrie Meeber leaves her parents' home in a small midwestern town to live with her sister and brother-in-law in Chicago and find work there. She is dazzled by the city from the moment she glimpses it from the window of her railway car: "To the child, the

genius with imagination, or the wholly untraveled, the approach to a great city for the first time is a wonderful thing. Particularly if it be evening. . . . Ah, the promise of the night. . . . The streets, the lamp, the lighted chamber. . . . The theatres, the halls, the parties, the ways of rest and the paths of song."

Carrie's excitement is short-lived. It is extinguished on meeting her sister and traveling with her to the "hum-drum, narrow" flat that is to be her home in Chicago. "Amid all the maze, uproar and novelty, she felt cold reality taking her by the hand. No world of light and merriment. No round of amusement. Her sister carried with her much of the grimness of shift and toil." The contrast between the dull, commonplace, dark interior of her sister's home and the glitter of the city outside is too much for the eighteen-year-old to bear. "The lights, the tinkle of car bells, the late murmur of the city, bespoke its power to her. 'I will have a fine time,' she thought to herself over and over and over."[7] But first she has to escape from her sister's flat.

In *Sister Carrie*, Dreiser has inverted all the tropes of nineteenth-century sentimental literature. Home and family are no longer represented as sources of warmth, comfort, and companionship. It is not the hearth that welcomes stranger and family member alike but the twinkling lights of the city and the promise of pleasures they evoke. The city's new face after dark, so dramatically described by Dreiser through the eyes of Carrie Meeber, also was highlighted in turn-of-the-century guidebooks and tourist manuals. Instead of admonishing readers to tread carefully, as their predecessors had, the guides urged visitors and residents to get out and join in the spectacle of urban nightlife. "It is an old, old theme, and an oft-told tale," reported the *Four-Track News*, a travel magazine published by the New York Central and Hudson Railroad, "but when the lights are on, and the season is in full swing, as it is now, any evening . . . when Broadway is really itself, it is a continuous vaudeville that is worth many times the 'price of admission'—especially as no admission price is asked. Where else is there such a free performance—such a festive panorama of gay life as Broadway 'puts up' when the lights are on."[8]

Rand McNally's *Bird's-Eye Views and Guide to Chicago* (1893) identified the "Beautiful Lights at Night" as one of the attractions that out-of-towners must not miss: "It is literally true that the genius of Edison has added a thousand beauties to the night. The visitor from the country can scarcely fail to be impressed by the brilliancy of an evening in town."[9]

Electric lights not only made it possible for respectable folk to walk the city streets after sunset, but they also marked the way to the newly constructed places of amusement that redefined the nature of nightlife in the metropolis. Where there once had been only opera houses and theaters for the wealthy and concert saloons and brothels for the sporting men, there now arose a panoply of electrically lit amusement spaces for the middling people. The most prominent among these in the late 1880s and 1890s were the vaudeville halls, theaters, and palaces, each one marked inside and out by electric lighting. In his 1915 primer *The Vaudeville Theatre: Building, Operation, Management*, Edward Renton warned prospective theater owners to "provide liberally for electrical illumination of the front. A famous showman once said, 'White paint and white lights will draw people, and flies'—and this is especially true with reference to white lights and many of them. The electric sign—or signs—on the front should receive consideration in the form of a liberal appropriation." A June 1915 article in the *New York Morning Telegraph* explained to readers that the construction of new theaters was contributing to an increase in land values because "a theatre means light, and light is one of the best advertisements in the world. Other property owners bask in the light shining from the theatres and reap rich profits with very little sowing."[10]

The vaudeville entrepreneurs used electric lighting to draw attention to their theaters and mark them as safe, secure venues. The lights served as beacons as well as ornaments in an attempt to convince women that they were welcome and would be made comfortable inside.

2.5 Electric Vaudeville Palace, Lancaster, Pennsylvania, n.d. Silver gelatin print. Archives of Q. David Bowers, Wolfeboro, New Hampshire

2.6 Electric and Palace theaters, Charleroi, Pennsylvania, c. 1908. Postcard. Collection of Maggie Valentine, San Antonio, Texas. Side by side in Charleroi's theater district were the Electric, a nickelodeon, and the Palace, a vaudeville house.

The lights that festooned the first generation of moving-picture theaters in the early 1900s performed the same functions. They greeted visitors, publicized the content of the amusements within, and declared that the entrepreneurs had nothing to hide. The proprietors used electric lights to serve notice that their shows were as up-to-date, as "new," as the century itself. To underscore the point, many of the early storefront theaters and nickelodeons incorporated *electric* into their very names (figs. 2.5, 2.6).

The first self-contained theaters to show moving pictures were housed in converted storefronts. The screen (usually a white sheet) was in back, the projector in front, the space between filled with folding chairs. To compensate for the rather grim setting inside, theater owners strung electric lights outside. By 1905 the storefront moving-picture business had proved so profitable that owners were willing the spend the extra money required to build new theaters from the ground up; electric lighting was an essential design element in every one of them. As an article in the September 1909 issue of the *Nickelodeon*, the new industry's trade journal, pointed out, moving-picture theater owners, unlike proprietors of the "so-called legitimate theater," could not afford to rely on billboards and newspaper notices to attract an audience. They had to "depend almost entirely upon the attractiveness of the exterior theater to bring the first visit from the patron." There were, the article continued, "three

well-recognized means of rendering the exterior of the theater attractive. . . . 1. Outlining in incandescent lamps. 2. Electric signs. 3. Flaming arc lamps." Although all three kinds of electrical lighting were essential, "flaming arc lamps" were most important in attracting new customers. They "flood the theater front and surrounding premises with warm, cheerful light, and furthermore, cause the entire locality to stand out in vivid and striking contrast at a distance of several blocks, on account of the light, and its excellent diffusion."[11]

If the street lamps had turned night into day, the electrification of the urban amusement places transformed it into a carnival of lights. There was no escape from the aura of excitement projected onto the street and into the night sky. The theater exteriors were bathed in light: flashing, tracing, flickering, swirling, jumping, flooding electric lights. The signature architectural elements of the new picture theaters were their marquees, which jutted out promiscuously, colonizing the sidewalks beneath them. Attached to the marquees were gigantic vertical signs that reached several stories above the building, projecting the theaters' names so that distant elevated-train passengers could see them as they passed by.

Each new theater, each new palace took pride—and gloated publicly—over the number of electric lights embedded in its exterior. The Saxe Brothers advertised their Princess Theater, which opened in Milwaukee in December 1909, by calling attention to its forty-foot facade with an ornamental arch over the entrance and 1,500 incandescent lightbulbs to attract the eye. In 1913 in Denver alone, the seven moving-picture and vaudeville houses on Curtis Street between Sixteenth and Eighteenth streets employed a total of 10,387 electrical lamps to light up the street. The Paris had more than four thousand lamps in a variety of colors; the Isis, which had *only* twenty-two hundred, had already announced plans to add another two thousand. When the Vitagraph Company converted the Criterion on Broadway in Manhattan from a musical playhouse into a moving-picture palace in 1914, it spent $10,000 alone on an electrically lit marquee.[12]

If the lights served as ornament, advertising, and beacon for the new theaters, they took on an added function in the amusement parks that were being constructed, then enlarged, on the outskirts of all major (and most minor) American cities early in the new century. The millions of lights that lit up these new urban playgrounds did more than banish the darkness—and the fear associated with it. They became an integral part of the show itself. "At

2.7 Luna Park, Kaleidoscope Tower at night, 1904. Silver gelatin print. The Gotscho-Schleisner Collection, Museum of the City of New York

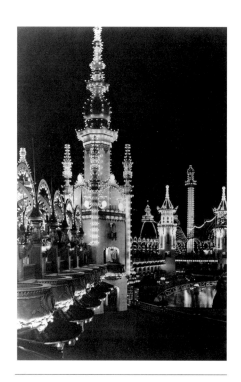

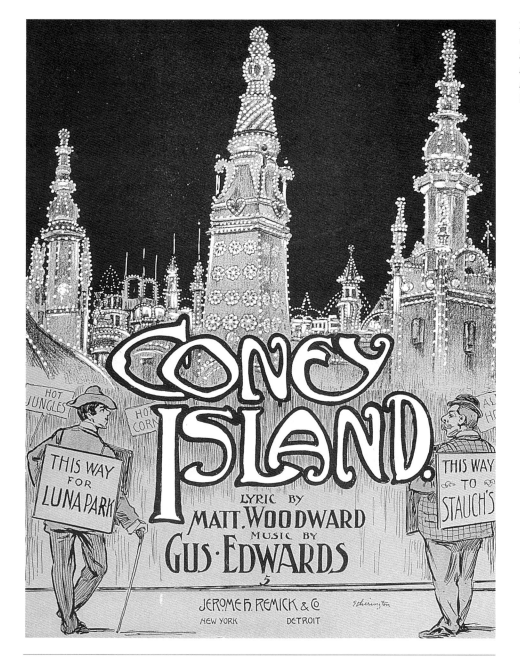

2.8 "Coney Island," 1907. Sheet music cover. Sam DeVincent Illustrated American Sheet Music Collection, Archives Center, National Museum of American History, Smithsonian Institution, Washington, D.C.

night the Park presents a picture of bewildering amazement, wonder and beauty, when 50,000 electric lights transform the Park from darkness into the brightest day," proclaimed a brochure advertising Luna Park in Scranton, Pennsylvania. "The lighting of the Park is lavish, and far from description; to know its wonders it must be seen."[13]

 Luna Park on Coney Island was studded with a quarter-million lightbulbs that lit up the towers, arches, and minarets in a carnivalesque flashing, glittering, twinkling skyline that was visible for miles (figs. 2.7, 2.8). At dusk, wrote the journalist Alfred Bigelow Paine after his first visit there, "Tall towers that

2.9 Illustrated song slide from song dated 1909, Marnan collection, Minneapolis

had grown dim suddenly broke forth in electric outlines and gay rosettes of color, as the living spark of light traveled hither and thither until the place was transformed into an enchanted garden, of such a sort as Aladdin never dreamed." Luna Park's ascendancy in the world of electric amusements lasted only one season. In 1904 Dreamland opened its gates across Surf Avenue. To compete with Luna's "electric tower," Dreamland's owners built a 375-foot-tall tower modeled on the Giralda in Seville. "To eclipse Luna's nighttime display, Dreamland installed a million electric lights, 100,000 for the tower alone."[14]

It is difficult, perhaps impossible, for those of us who have grown up with flashing, blinking, glittering electric lights punctuating our everyday lives to understand the excitement with which city folk greeted them a century ago. Commercial public amusements form the backdrop against which we live our lives. Bombarded by sights and sounds produced for profit and distributed by multimedia conglomerates, we lack the means to imagine a world without

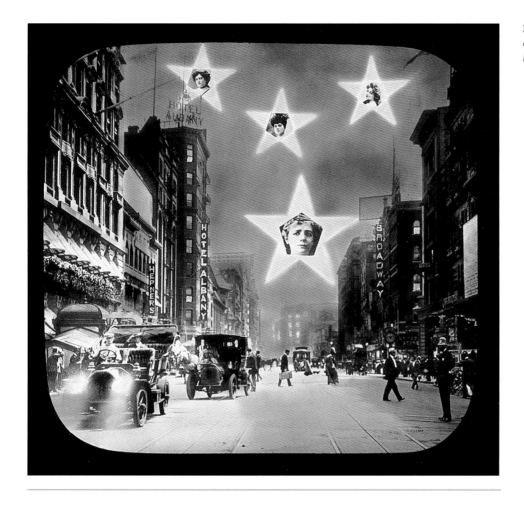

2.10 Illustrated song slide from song dated c. 1910, Marnan collection, Minneapolis

them. And yet there once was a world without them, followed, in an instant, by a world in which they were inescapable. The transition from one space to another was suffused with magic. And that magic was represented viscerally by the electric lights.

Although none of us can escape our perch in the present, we must try nonetheless to write our histories forward—in the same direction that we live our lives. The past, as the historian David Lowenthal has famously put it, "is a foreign country." In this essay I have tried to revisit that past and recapture the sense of excitement with which urban Americans greeted the emerging world of popular amusements at the dawn of the last century. There were many elements to the great leap forward that transfigured everyday life in the United States. The electric lighting of the city and its amusement places was not a first cause, but it was an essential ingredient.

For a parting glimpse at how the advent of electric lighting affected city people a hundred years ago, it seems apt to return to Dreiser and Sister

Carrie. She has spent her first day walking the streets of Chicago, looking for work, and being turned away everywhere. On her way back to her sister's flat late in the afternoon, she passes a "large wholesale shoe house." Taken with "one of those forlorn impulses which often grow out of a fixed sense of defeat," she inquires of "a middle-aged gentleman sitting at a small desk" behind a plate-glass window if there is work available within. There is, but not in the office at the front of the building. She is directed around to a side entrance and up a freight elevator to the fourth floor of the factory, where she is told that she might have a job if she returns "at eight o'clock Monday morning." The job pays $4.50 a week, $1.50 less than she expected. Still, she accepts it and takes the elevator down to the street:

> People were already pouring out of the buildings, their labor ended for the day. She noticed that they were pleased. . . . She hurried on, tired perhaps, but no longer weary of foot. . . . Ah, long the winter in Chicago—the lights, the crowd, the amusement. This was a great, pleasing metropolis after all. . . . She would live in Chicago, her mind kept saying to itself. She would have a better time than she ever had before—she would be happy.[15]

Notes

1 George G. Foster, *New York by Gas-Light and Other Urban Sketches* (1850; rpt., ed. and with an introduction, Stuart M. Blumin, Berkeley: University of California Press, 1990), 69.

2 "Life on Broadway," *Harper's New Monthly Magazine* (1878), rpt. in Frank Oppel, ed., *Gaslight New York Revisited* (New York: Castle, 1989), 41.

3 James D. McCabe, Jr., *Lights and Shadows of New York Life* (Philadelphia: National Publishing, 1872), 15–16, 470–86.

4 Jon C. Teaford, *The Unheralded Triumph: City Government in America, 1870–1900* (Baltimore: Johns Hopkins University Press, 1984), 229–30.

5 Ibid., 230; cited in Harold Platt, *The Electric City: Energy and the Growth of the Chicago Area, 1880–1930* (Chicago: University of Chicago Press, 1991), 91.

6 Richard Harding Davis, "Broadway," in *The Great Streets of the World* (New York: Scribner's, 1892), 26.

7 Dreiser, *Sister Carrie* (1900; rpt. New York: Penguin, 1981), 10, 11, 30.

8 *Four-Track News* 6, no. 2 (February 1904): 121.

9 *Bird's-Eye Views and Guide to Chicago* (Chicago: Rand, McNally, 1893), 108–9.

10 Edward Renton, *The Vaudeville Theatre: Building, Operation, Management* (New York: Gotham, 1915), 51; Nellie Revell, "News and Gossip of the Vaudeville World," *New York Morning Telegraph*, June 6, 1915, quoted in Snyder, *Voice of the City*, 85.

11 R. F. Pierce, "Exterior Lighting of Picture Theaters," *Nickelodeon* 2, no. 3 (September 1909): 85.

12 Larry Widen, "Milwaukee's Princess Theater," *Marquee* 17, no. 2 (second quarter, 1985): 20; "Illumination of Denver's Picture Theaters: Effects on Civic Activity," *Motography* 9, no. 2 (January 18, 1913): 41–43; *Variety* 32 (November 21, 1913): 8.

13 "Promotional Brochure 1907 Season," clipping file: Amusement Parks: U.S.: Scranton (Pa.): Luna Park, New York Public Library at Lincoln Center.

14 Albert Bigelow Paine, "The New Coney Island," *Century Magazine* 68 (August 1904): 535; John F. Kasson, *Amusing the Million: Coney Island at the Turn of the Century* (New York: Hill and Wang, 1978), 85.

15 Dreiser, *Sister Carrie*, 28, 29.

CHAPTER 3

"A DECIDED SENSATION":

CINEMA, VAUDEVILLE, AND BURLESQUE

ROBERT C. ALLEN

 An early scene in *Yankee Doodle Dandy*, the 1942 film biography of George M. Cohan, is set in the Cohan family dressing room of the turn-of-the-century Brooklyn theater where the thirteen-year-old George is starring in the comedy *Peck's Bad Boy*. The theater manager bursts in to tell the Cohans that "Mr. Albee" is on his way to see them. Tumult ensues as George's parents prepare to meet him. Neither they nor the American movie audience of the early 1940s needed reminding that Mr. Albee was E. F. Albee; that Albee managed B. F. Keith's chain of vaudeville theaters; that the Keith theaters were the highest of the "high class" vaudeville theaters; that through his management of the Keith circuit and its affiliated booking office Albee controlled the fates of hundreds of performers; or that high-class vaudeville was the most important and most popular form of theatrical entertainment in the United States at the turn of the century.

The 1940s audience probably had already forgotten—and most movie audiences since then have never known—that the cinema itself was a turn-of-the-century visual novelty that Albee and other managers brought into the American show business "big time" when they turned it into a vaudeville act in the spring and summer of 1896. As the *New York Dramatic Mirror* said of the debut of the Lumière Cinématographe at Keith's New Union Square Theatre in July 1896, the movies in vaudeville were "a decided sensation."[1] For most of the next decade the vaudeville audience *was* the urban audience for the movies in the United States, and most "movie" audiences in cities across the country experienced this technological novelty as the act that opened or closed the vaudeville bill.

For more than fifty years, histories of the American cinema worked hard to downplay the connection between vaudeville and film. The history of cin-

ema as an art form in the United States, it was long argued, *really* begins with the ascendance of narrative films after 1905. We cannot *really* say that an audience for the movies existed, went the argument, until entire programs of movies began to be shown in storefront nickelodeon theaters to proletarian audiences, around 1907. Besides, we were told, after the initial novelty of projected motion pictures faded, movies inexplicably became so unpopular with vaudeville audiences that managers used them as "chasers": acts designed to drive patrons from the theater at the end of the program. One of the first film histories, Terry Ramsaye's *A Million and One Nights* (1926), charged that vaudeville had "cheapened and enslaved" the movies, and the normally astute Gilbert Seldes wrote in 1929 that the cinema in vaudeville was like an infant who "had acquired a large vocabulary and was saying nothing whatever of interest." As recently as 1975 students of film history were told that the use of movies in vaudeville was "certainly . . . the lowest point in motion picture history."[2]

In short, in order to be the worthy subject of its own history, the cinema had to be seen as institutionally, socially, and aesthetically autonomous from the other forms of popular entertainment whose stages and screens it shared and to which its early fortunes were inextricably linked. Vaudeville was cast as the illegitimate nineteenth-century stepfather to the American cinema, from whose shadow the cinema had to emerge quickly so that it could claim its own, mature identity. In this version of film history, the Oedipal cinema quite literally finds its voice, slays its tired old stepfather, and takes his middle-class audience-partner as its own.

Cinema historiography of the 1980s and 1990s has, to some degree, rehabilitated the films of the period before the rise of the narrative form (c. 1905–10). Where prior generations of film historians looked at "primitive" films and saw only the crude exploitation of the medium's capacity to give the illusion of motion, contemporary film historians—thanks in part to the discovery and preservation of early films in archives and museums since the 1970s—have acknowledged the variety of filmic forms and corresponding audience appeals represented by the films that vaudeville audiences saw during the first decade when motion pictures were projected. One such historian, Tom Gunning, has characterized these early films as a "cinema of attraction," in part to emphasize their heterogeneous subject matter, styles, and functions within the various entertainment bills of fare that included movies at the turn of the century.[3]

3.1 Illustrated song slide for song dated 1908. Marnan collection, Minneapolis

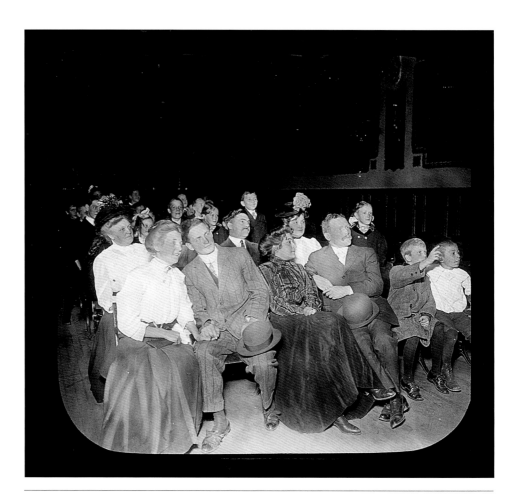

Besides reading and revising the early cinema's history through the films (and fragments of films) that have survived in some form, contemporary film historians have begun mapping what we might call the social experience of film viewing as it varied across time as well as at a given historical moment— among groups within a particular audience for the movies (by class, race, gender, and so on), from venue to venue, region to region, big city to small town.

We are just beginning to appreciate the vast range of physical environments with which Americans nationwide came to associate their first "moviegoing" experiences: the rococo auditoriums of enormous vaudeville theaters in big cities; erstwhile cigar stores converted into Main Street Bijoux in smaller cities and market towns; under canvas (and sometimes under the stars) in the summer at amusement parks and in the fall at agricultural fairs; and thousands of opera houses, YMCAs, church basements, Odd Fellows halls, vacant lots, converted stores, tents, and other immediately available spaces in small towns, villages, mining settlements, and lumber camps, where itinerant

showmen set up their clattering projectors for a few days or a week from 1896 until at least the 1930s. The "attraction" represented by, let us say, the American Mutoscope and Biograph Company's *Panorama of the Times Building* (1905) or the Edison Manufacturing Company's *Coney Island at Night* (1905) depended, among other things, on whether you were a middle-class woman taking a break from shopping at Proctor's palatial vaudeville theater on Manhattan's Fifty-eighth Street (motto: "After breakfast go to Proctor's; after Proctor's go to bed") or a spooning couple sitting in a canoe on a moonlit lake outside Asheville, North Carolina (where, beginning in the summer of 1902, films were projected onto a screen erected on a conveniently situated island).[4]

Film historians are today also acknowledging just how imbricated various forms of popular entertainment were at the turn of the century. They are pointing out just how much some early films relied for their appeal upon the audience's presumed knowledge of the conventions of other entertainment media and, in some cases, their acquaintance with specific images, actors, narratives, and performances drawn from non-filmic forms. Edison's most popular film during his company's first season as a provider of cinematic vaudeville acts was a fifteen-second shot of actors John Rice and May Irwin kissing—or, as the *New York World* put it, "42 Feet of Kiss in 600 Pictures." Vaudeville audiences had to fill in the significance of this first on-screen kiss: it reproduced the end of the final scene of that year's hit New York musical farce *The Widow Jones*. Even vaudeville audiences in San Francisco knew that the kiss was not just a kiss but the kiss from the play, and their pleasure in it clearly derived from being able to make this connection. Edwin S. Porter's phenomenally successful early western, *The Great Train Robbery* (1903), not only borrowed from the spectacle of turn-of-the-century Wild West shows and drew upon the audience's knowledge of the conventions of the dime novel and serialized newspaper fiction but also referred to recently staged western dramas, which some of the film's New York audiences might well have seen. The film historian Charles Musser argues that the audience's ability to read sequential scenes in the film as representing simultaneous action depended upon its familiarity with the train-robbery narrative from iterations in other media.[5]

Vaudeville, theatrical, and circus acts were among the first subjects of American films, captured not theatrically in situ but, in the interest of illumination, posed in front of the makeshift mise-en-scène of Thomas Edison's Black Maria studio in West Orange, New Jersey, and the Biograph Company's

Manhattan-rooftop perch. Indeed, even before films were projected in vaudeville theaters, vaudeville performers and snippets of their acts were recorded on film as subjects for Edison's peep-show device, the Kinetoscope, which was installed in penny arcades, hotel lobbies, and saloons in 1894 and 1895. Early film historians (writing in the 1930s and later) cited these brief performance vignettes as evidence of early filmmakers' lack of imagination and/or saw them as the stunted expressions of the early cinema's technological infancy: Edison's initial heavy, electrically tethered movie camera restricted the range of its subject matter to human and animal movement that could be staged a few feet in front of an immobile eye.

But the choice of vaudeville and theatrical acts as subjects of Edison's earliest films also reflects his desire to have this new technology associated with the most popular forms of theatrical entertainment at the time in the hope that, through this association, some of their aura might enchant *his* technology. By the same token, vaudeville performers and managers were eager to have their acts immortalized by the great inventor's latest marvel. Edison, himself a vaudeville fan, was eager to meet Eugene Sandow when the celebrated strongman (accompanied by the managers of the theater where he was performing) visited West Orange in March 1894 to flex his muscles before the Kinetograph (the first motion picture camera). In addition to his $250 posing fee, Sandow insisted on being introduced to Edison. An Edison assistant captured several photographs of the two men together. In one, Edison's hand measures Sandow's biceps, the face of the Wizard of Menlo Park frozen in a "curiously comical expression."[6] From the beginning, then, motion picture producers looked to other forms of entertainment for cross-promotional opportunities.

3.2 Eugene Sandow, 1894. Film Stills Archive, The Museum of Modern Art, New York

Today my students "read" the fifty-foot film of Sandow shot that day in 1894 as a comically awkward bit of physical-culture posing by a pre–steroid era muscle guy wearing a diaper (fig. 3.2). But to Edison, Sandow, and many of the people who dropped their pennies into the Kinetoscope slot to see this film in 1894, I remind students, the "subject" of this film was much more complex. It showed one of that era's great masculine celebrities lending his celebrity to the work of another of the era's great public figures. The film promoted Sandow as well as the venue within which he had achieved his celebrity: vaudeville. The vaudeville auditorium and Edison's Kinetoscope were the only places where Sandow's art could be fully appreciated. It was little wonder, then, that some Kinetoscope parlors called themselves Automatic Vaudeville.

The ability of early movie audiences to ironize cinema's relationship to the theatrical forms and venues on which it depended—as well as their own role as spectators of the movies in vaudeville—becomes a subject of early cinema itself. In Edwin S. Porter's *Uncle Josh at the Motion Picture Show* (1902) a character clearly coded to read "uncultured rube" by urban vaudeville audiences watches his first motion picture in a theater. As we (the viewers of both the film and the film-within-a-film that Uncle Josh views) watch him, Uncle Josh becomes increasingly agitated as the aesthetic distance between him and the represented world in the film collapses, and he rushes toward the screen to intervene in the action. On one level, Porter's film is a comic testimony to the power of cinematic verisimilitude. But its joke also turns on Uncle Josh's naïveté as a member of the audience.

Early vaudeville audiences for motion pictures would have understood the movies as the most recent in a long line of novelty acts upon which vaudeville had come to rely in the 1890s. Charles Musser cites an 1896 *San Francisco Chronicle* review of the Orpheum vaudeville theater that placed the movies in the same category as a popular black opera singer, a dog-and-monkey circus act, and trained cats.[7] Such acts fed the urban vaudeville audience's appetite for displays of difference, oddity, and innovation of all kinds. The motion picture apparatus was itself such an innovation, and the fact that it gave photographically realistic reproductions of objects in motion was, in and of itself, sufficient to qualify it as a novelty act—regardless of the subjects of those representations.

But as the most perceptually convincing system for the reproduction of human vision ever devised, film also had the capacity to represent other forms of novelty as *its* subjects. Thus the Edison Company, Biograph, and other early film producers quickly seized upon opportunities to display modern technological innovations, particularly ones that compressed time and space: trains, automobiles, subways, ferries, and the like. These filmmakers also devised novel ways of representing the experience of these innovations. Cameras were set up beside railroad tracks so that audiences could be placed only a few feet from the path of an oncoming locomotive. Cameras were mounted on flatcars and pushed through train tunnels. Biograph's 1897 version of the phantom-locomotive film thrilled vaudeville audiences across the country. "The way in which the unseen energy swallows up space and flings itself into the distances is as mysterious and impressive almost as an allegory," a reporter for the *New York Mail and Express* exclaimed. "One holds his breath

instinctively as he is swept along in the rush of the phantom cars. His attention is held almost with the vise of a fate."[8]

The history of vaudeville is bound up with the display of visual novelties—technological, human, animal, and performative. Indeed, one direct antecedent of vaudeville was the nineteenth-century popular-entertainment form dedicated to the exhibiting of the odd and unfamiliar: the dime museum. In 1883 E. F. Albee's boss, Benjamin Franklin Keith, began his career in "vaudeville" when he opened one such museum in a converted hat store on Boston's Washington Street. His first attraction was a tiny, prematurely born infant dubbed Little Alice, "the smallest baby ever born to live." Like those opened by hundreds of other showmen in cheap-entertainment precincts nationwide during the 1870s and early 1880s, Keith's confusingly named New York Dime Museum consisted of two rooms: an exhibition hall for the display of inanimate curiosities (stuffed examples of exotic animal species, pickled physiological anomalies, mechanical gizmos, historical artifacts, and so forth), and a lecture hall, where living human and animal oddities could be displayed and where variety acts were performed. It was on the eight-by-ten-foot stage of his dime museum's "Theatre Room" that Keith presented his first "vaudeville" bill in the spring of 1883: Professor Thomas Pryor ("The Man with the Talking Hands"), Professor Angelo's performing birds, and an unnamed Irish tenor. The variety acts helped draw repeat business to the museum from customers for whom the appeal of stuffed animals and other such exhibits had dissipated. To encourage passersby on busy Washington Street to drop in, Keith instituted a "continuous performance" policy in the summer of 1885: the variety bill was to be repeated without pause from the museum's opening at 10 A.M. until its close at 10 P.M.[9]

Keith saw this policy as a means of overcoming the uncertain drawing power of stuffed and living oddities and of tapping into the growing middle-class market for "respectable" family entertainment. But to gain access to a more bourgeois audience, he had to sever the ties between variety and the dime museum and relocate performance to a venue that this audience would find respectable. In 1886 he acquired the nine hundred–seat Bijou Theater, just down the street from his museum. There he inaugurated his style of vaudeville: large programs of morally unobjectionable acts diverse enough so that all audience members were likely to find something they liked, performed in theatrical settings that were shrines to middle-class notions of taste, luxury,

and cleanliness. This approach was to make Keith the most powerful show business mogul in America by the time projected movies were introduced to paying audiences in 1896.

The first time movies were shown in a vaudeville theater—at Koster and Bial's Music Hall in Manhattan on April 23, 1896—they were projected on a drop curtain lowered across the proscenium onto which an elaborate picture frame had been painted (figs. 3.3–3.5). For several years thereafter, posters that promoted various traveling motion picture showmen frequently represented movie images as surrounded by a baroque gilt frame and depicted the presentation of movies as framed within the ornate space of the vaudeville theater. Film history's obsession with identifying the first movie audiences as proletarian and the first movie theaters as storefront nickelodeons has obscured the very different physical, architectural, and social frames that surrounded the first ten years of movie exhibition in vaudeville—frames that the film industry itself would attempt to reconstruct in the picture palaces of the 1910s and 1920s.

In the early 1890s vaudeville magnates such as Keith, Martin Beck, and Frederick F. Proctor used the atmosphere created by their theaters as part of their strategy to solidify vaudeville's position among middle-class audiences by separating it from the working-class dime museum and concert-saloon milieus of its recent past. E. F. Albee was placed in charge of the design and construction of Keith's growing chain of East Coast theaters in the early 1890s; his determination to place Keith's unobjectionable brand of variety entertainment within bourgeois-fantasy environments contributed enormously to the chain's success.

B. F. Keith's New Theatre opened in Boston in 1894 (fig. 3.6). It was designed by Albee to have the scale and amenities of America's most prestigious legitimate theaters, and to have the architectural feel of a transplanted European palace or public building—if baroque palazzi had utilized the latest American building and decorating techniques, that is. Its Washington Street facade incorporated marble pillars, pilasters, gargoyles, stained glass, and electrical illumination. Its lobby and hallways were floored in white marble and lined with leather sofas and oil paintings. Albee refashioned the men's room as a "smoking and reading room" for gentlemen, and the ladies' as "suites of rooms . . . furnished with every toilet requisite." Bostonians eagerly showed up for tours of the theater, as if it were a museum or civic monument. The

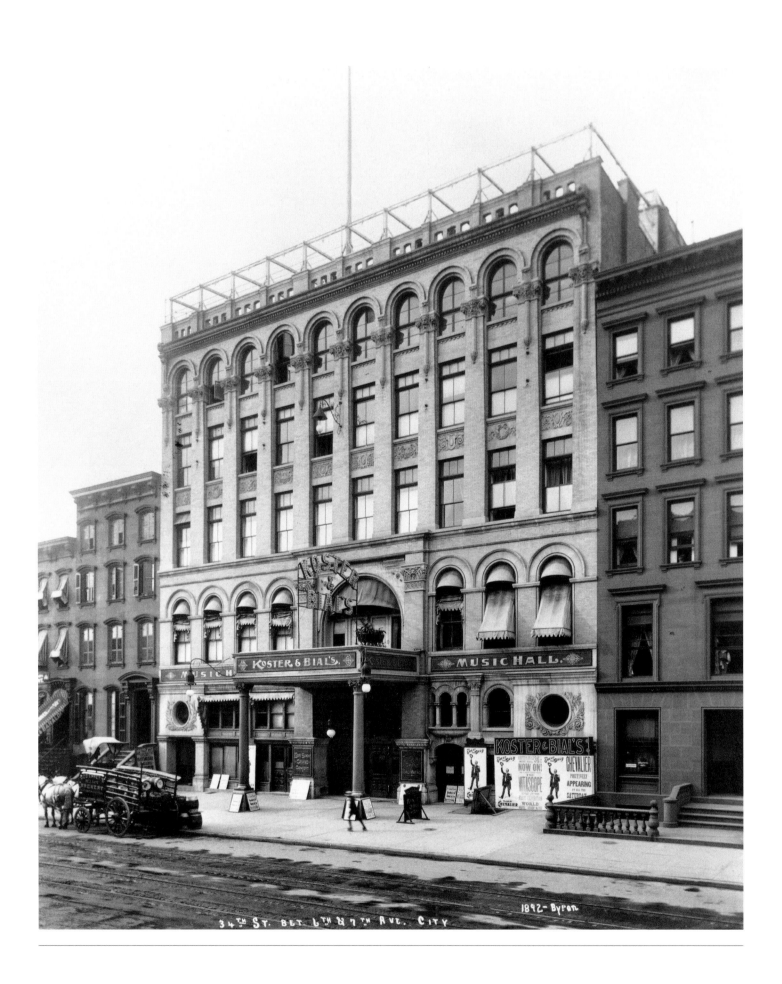

34TH ST. BET. 6TH & 7TH AVE. CITY

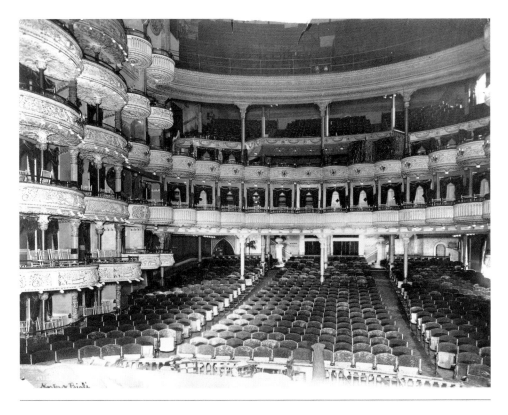

3.3 (opposite) Koster and Bial's Music Hall, New York, 1896. Silver gelatin print. The Byron Collection, Museum of the City of New York. Notice the Edison Vitascope poster at the right of the entrance. It advertises the first public projection of film in the United States.

3.4 (left) Interior, Koster and Bial's Music Hall, New York, c. 1896. Silver gelatin print. The Byron Collection, Museum of the City of New York

3.5 Edison's Greatest Marvel, the Vitascope, 1896. Lithograph (poster). Prints and Photographs Division, Library of Congress

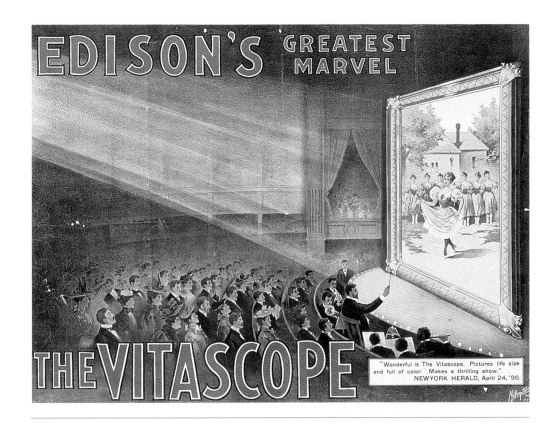

3.6 B. F. Keith's [New] Theatre, Boston, 1894. Postcard. Collection of Maggie Valentine, San Antonio, Texas

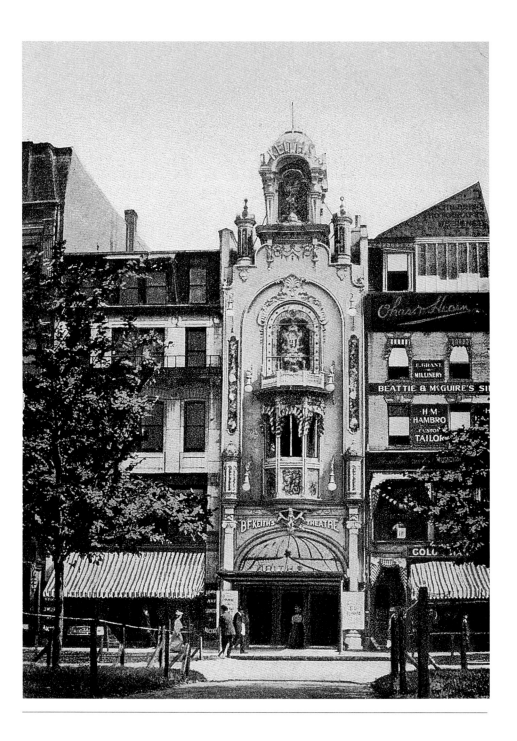

final attraction on the tour was the state-of-the-art boiler. A red velvet carpet led to the gleaming machine attended by stokers in spotless white uniforms, beside which Albee had placed "oiling cans . . . standing on gilt onyx-topped tables, just as if they were handsome toilet bottles."[10]

Frederick F. Proctor, against whom Keith competed in the early 1890s and with whom he was to form a partnership in the early 1900s, attempted to out-

Albee Keith in New York with his Proctor's Pleasure Palace, which opened the autumn before the movies' debut. Surrounding three indoor performance venues plus a roof garden, its romanesque facade extended two hundred feet along Fifty-eighth Street between Third and Lexington avenues. In the basement were a library, a barbershop, a Turkish bath, a flower stand, and a café. But Proctor's held the distinction of being New York's most opulent vaudeville theater for only two months. In November 1895 the flamboyant Oscar Hammerstein opened his Olympia theater. Occupying the entire block of Broadway between Fifty-fourth and Fifty-fifth streets, it could accommodate three thousand patrons in its three interior theaters and another thousand on its roof garden. Below street level were cafés, billiard rooms, a bowling alley, and Turkish baths. It was, as one chronicler of the city's cultural life put it, "a structure of superlatives."[11]

Within these superlative structures, Keith and his fellow vaudeville magnates attempted the reintegration of the American popular theatrical audience, which had been fragmented in the 1840s and 1850s by class awareness and antagonism. Specific forms of entertainment that had combined to make an evening at the theater for a socially and economically heterogeneous audience in the 1830s—ballet, opera, spectacle, variety acts, drama—were, during the next two decades, separated and associated with particular classes in larger cities. Working-class audiences in the 1830s and 1840s claimed ownership of the theatrical experience to a degree unimaginable today. Performers who incurred the wrath of the "pittites" (those who crowded around the rim of the orchestra pit) risked being driven from the stage by choruses of boos and fusillades of rotten fruits and vegetables. And managers who attempted to control the audience risked riot.[12]

Keith's imagined democratic audience for vaudeville in the 1890s was hardly the noisily contentious and potentially violent one of an earlier generation, however. He advertised his theaters as appealing "to all classes of people equally"; and indeed, with tickets costing as little as fifteen cents for a daytime balcony seat and no more than a dollar for a evening box seat, Keith's vaudeville was accessible to a much wider segment of the urban populace than was legitimate theater.

The economic democracy of vaudeville belied a not so subtle class orientation. Vaudeville assumed a general acceptance of bourgeois norms of taste and behavior, both among audience members and onstage (fig. 3.7). One

3.7 Card prohibiting vaudeville performers from using profanity, B. F. Keith's New Union Square Theatre, n.d. Warshaw Collection of Business Americana, Archives Center, National Museum of American History, Smithsonian Institution, Washington, D.C.

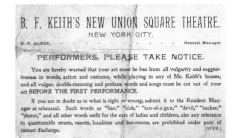

Mary wore a great big hat
as the other ladies do
And when she went to a picture show
she shut off all the view.

3.8 Magic lantern announcement slide, n.d. Marnan collection, Minneapolis

3.9 Ted Mark's St. Patrick Concert, American Theatre, New York, March 15, 1903. Silver gelatin print. The Byron Collection, Museum of the City of New York

chronicler claimed that the dressing rooms of every Keith house contained this warning notice to performers:

> If you have not the ability to entertain Mr. Keith's audiences with risk of offending them, do the best you can. Lack of talent will be less open to censure than would be an insult to a patron. . . . If you are guilty of uttering anything sacrilegious or even suggestive you will be immediately closed and will never again be allowed in a theater where Mr. Keith is in authority.[13]

Uniformed ushers monitored audience behavior. Newcomers were handed flyers reminding them that in Keith theaters ladies removed their hats and gentlemen did not smoke, talk, or stamp their feet. Offering or withholding polite laughter and applause were the only sanctioned ways of expressing approval or disapproval. Keith's attempt to force his heterogeneous audiences into the mold of middle-class respectability once they became vaudeville audience members was never entirely successful, however. The working-class men and boys who packed the cheapest seats high up in the gallery often had very different tastes from the middle-class families in the orchestra and box seats; they did not limit themselves to withholding applause when an act did not please them.[14]

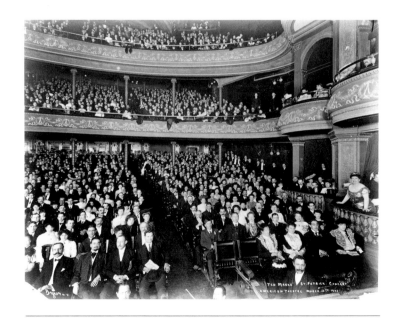

Keith's vigilant policing of onstage attractions and audience manners made vaudeville the first form of American theatrical entertainment to be attended in significant numbers by unescorted middle-class women. By the mid-1890s many vaudeville houses were located in or near busy retail districts. Department store shopping expeditions could include a quick stop at a vaudeville show. Mothers also brought their children. Indeed, by the time movies debuted in 1896, children may well have constituted one-quarter of the total audience; early comic films screened in vaudeville theaters, such as *Jack and the Beanstalk* (1902) and the spectacular fantasies of Georges Méliès (*A Trip to the Moon* [1902], for example), appealed particularly to them.[15]

For Keith, the broad-based composition of the vaudeville audience was mirrored in the catholicity of his programming. To the audience, vaudeville was distinguished from other entertainments by its unique presentational, environmental, and institutional form. Its content, however, was simply the aggregate of all the types of entertainment from which it borrowed. Although certain kinds of acts became standards, almost any attraction that could fit on a stage, be presented in seven to twenty minutes, and tour a circuit of theaters by rail was a potential act—provided, of course, that it conformed to Keith's notions of propriety and taste. Actors lured from the legitimate stage fashioned one-act "playlets" to serve as vehicles for their vaudeville acts. Concert singers and opera stars performed arias. Oscar Hammerstein once presented as a vaudeville act someone who had been trapped for days in a well. And the former chorus girl Evelyn Nesbit cashed in on her notoriety as the woman at the center of the 1906 Harry Thaw–Stanford White murder case by appearing in vaudeville in 1913.

Long before movies were first shown at Koster and Bial's Music Hall, vaudeville had absorbed a number of visual entertainments that previously had operated independent of any particular venue: shadowgraphy, magic-lantern shows, magical illusions, and that confusingly named (for our purposes) novelty, "living pictures." These were not motion pictures but rather immobile human tableaux. Presented in the United States as early as the 1830s, living pictures fed the nineteenth-century appetite for mimesis by presenting people arranged to imitate famous paintings or statues, surrounded by appropriate scenery and props, and staged within a giant picture frame. Enterprising showmen of the 1840s discovered that attendance increased markedly when the artworks chosen to be brought to life revealed a good deal

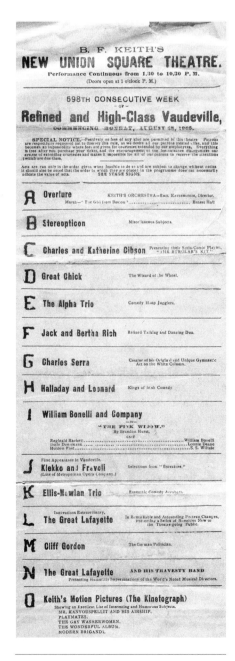

3.10 Program, B. F. Keith's New Union Square Theatre, August 28, 1905. Warshaw Collection of Business Americana, Archives Center, National Museum of American History, Smithsonian Institution, Washington, D.C. Notice the inclusion of motion pictures on this vaudeville program.

3.11 Everett Shinn, *Keith's Union Square*, c. 1906. Oil on canvas, 20³/₈ x 24³/₈ in. (51.7 x 62 cm). Brooklyn Museum of Art, Dick S. Ramsay Fund

of the human form. A craze for living pictures in vaudeville immediately preceded the introduction of movies; they were a regular part of the program at Koster and Bial's in 1894 and 1895. But these tableaux vivants were carefully sanitized: a year before Edison's Vitascope was presented there, Koster and Bial's featured nine tableaux from Gounod's *Faust*, accompanied by excerpts from the opera score.

Vaudeville kept some forms of visual entertainment alive that otherwise might well have disappeared. The price paid by the practitioners of these entertainments, however, was the loss of their formal and economic autonomy. Puppetry is a good example. Itinerant puppet troupes toured widely in the years after the Civil War, renting out local theaters to stage their elaborate multi-act performances, which drew upon English pantomime and spectacle theater. As vaudeville emerged in the 1880s, puppetry found a new and more economically stable venue. Yet in order to make their shows standard vaudeville acts, puppeteers had to condense them drastically so that they ran no more than twenty minutes. Walter Deaves, a master puppeteer who toured the Keith circuit in the mid-1890s, realized more fully than most of his contemporaries that puppetry was no longer viable outside vaudeville. He abandoned the old form, based on pantomime and spectacle, and organized his act as a miniature vaudeville bill, complete with tiny proscenium, puppet pit orchestra, and puppet audience. By about 1910 audiences expected to see puppet vaudeville whenever they saw puppetry in vaudeville.[16]

Living pictures and puppetry played the same roles on the bill that motion pictures were eventually to assume: all were, in vaudeville parlance, "dumb" acts. Like animal acts, acrobats, and magical illusionists, their appeal was largely, if not entirely, visual. In the late 1890s, most vaudeville theaters abandoned Keith's continuous-performance format and began running two shows of nine or more acts each day. Patrons could still arrive and leave whenever it suited them, but the vaudeville bill took on a discrete form. Individual acts were chosen and organized according to their function within the program rather than the particular "contents" of the acts themselves. Dumb acts frequently opened and closed the show: they did not have to be heard to be appreciated, so the noise of late-arriving or early-departing patrons did not greatly diminish their effect. Puppetry adapted to its role as a dumb act by largely dropping the dialogue and songs that had been important parts of various puppet shows in the 1870s and 1880s.[17]

The media historian Henry Jenkins has attempted to identify the elements of an "aesthetic" that distinguished the vaudeville performance tradition from that of other late nineteenth- and early twentieth-century forms of theater. First, writes Jenkins, vaudeville acts strove for an immediate and discernible response—laughter or applause. Almost as soon as they went onstage, performers had to connect with the audience and keep its attention and favor until the act ended. Response (or lack of it) provided instant feedback, and performers reflexively adjusted their acts from show to show and town to town. The vaudeville performer's relationship with the audience was direct; there was no pretense of an invisible "fourth wall" separating the world onstage from that beyond the footlights. Vaudeville favored display and spectacle over narrative. Finally, although a given comedy or musical act might be built around the impersonation of stock characters or even follow a narrative line, audiences understood that these elements were unrelated to those in any other act on the bill.[18]

We should also note that vaudeville lacked a unifying narrational voice to provide audiences with cues about the meaning of any particular moment or the relation between one act and another. Unlike the English music hall, American vaudeville had no "chairman" or master of ceremonies whose onstage repartee with performers and banter with the audience tied the show together. In melodrama, opera, and romantic ballet, spectacle was ultimately framed within narrative and dramatic logic and made meaningful in relation to a moral and social world view that was revealed in the fate of characters at the end of the piece. By contrast, in vaudeville audiences were left to determine the meaning of each act on their own. But whatever that meaning might be, there was no overall meaning to which the individual acts contributed.

Vaudeville reveled in immediate gratification, in sensation, and in the variety of its attractions. Its aesthetic was in fact democratic. The length and frequency of applause and laughter formed the collective voice of the audience, and theater managers carefully noted how each group (orchestra, boxes, and gallery, men, women, and children) "voted" for each act. Acts failed only because they failed to please. And when they did, they were replaced by other acts that could fit in the same functional slot on the program.

Jenkins notes that "modernists of all nationalities" found in vaudeville and its European variety-theater counterparts an aesthetic and phenomenological break from what they saw as the tired conventions of nineteenth-century

3.12 Theatre Unique, New York, 1908. Silver gelatin print. The Byron Collection, Museum of the City of New York

3.13 Illustrated song slide, featuring Theatre Unique, for song dated 1908. Marnan collection, Minneapolis

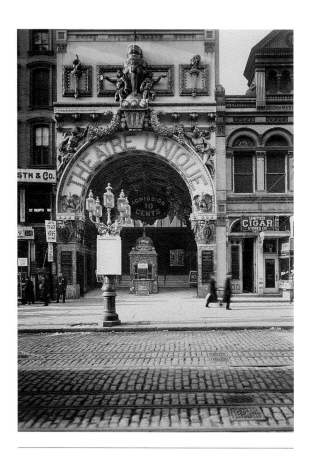

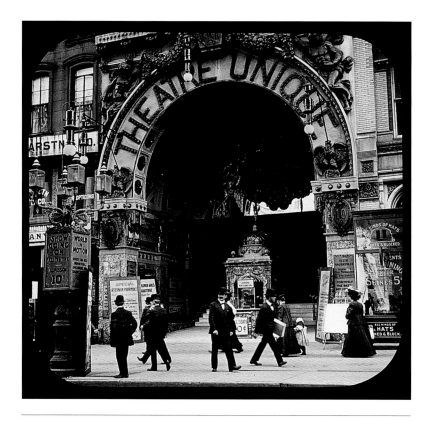

theatrical realism. The leading Italian Futurist Filippo T. Marinetti found the form particularly rejuvenating: Variety, he wrote, "is lucky in having no tradition, no masters, no dogma and it is fed by swift actuality. . . . [It] is absolutely practical, because it proposes to distract and amuse the public with comic effects, erotic stimulation, or imaginative astonishment. . . . The authors, actors, and technicians of the Variety Theatre have only one reason for existing and triumphing: incessantly to invent new elements of astonishment."[19] Substitute the words "early cinema" for "Variety Theatre," and you have an apt description of its aesthetic. In other words, the subject matter of individual films, their representational styles and modes of address, and their inclusion as an attraction in vaudeville all reflected a sensibility mirroring that of the other acts on the program as well as that of the vaudeville bill as a whole. The movies not only "appeared" in vaudeville; they also were experienced via the same aesthetic.

The range of acceptable display and how it was represented in vaudeville was, of course, circumscribed, particularly where the display of the female body was concerned. One of the ways vaudeville established itself in the 1880s and 1890s as a refined and respectable entertainment for audiences of middle-class men, women, and children was by differentiating itself sharply from the other form of variety theater with which it is today frequently confused: burlesque.

Burlesque burst upon the American show business scene in 1868 with the successful but controversial American tour of Lydia Thompson and her troupe of "British Blondes." Thompson used Greek myths, fairy tales, and fables as dramatic excuses for cross-dressed comedy (women played both male and female roles) that involved outrageous puns, topical allusions, and nonsensical stage business, frequently interspersed with comic songs and dances. The British Blondes played for seven months in New York, four of them in Niblo's Garden, one of the city's most fashionable theaters. The following season, their tour took them as far as San Francisco. Several competing troupes were quickly formed and followed in Thompson's wake.

Today it is difficult to understand what made Lydia Thompson's brand of burlesque so appealing to some (she took in more than any theatrical attraction in New York in 1868–69) and so disturbing to others. The novelty of burlesque lay in its overturning of Victorian notions of appropriate female behavior, dress, gesture, and language. Thompson, who typically played the leading male roles in her shows, presented an impertinent caricature of

masculinity. She and her sister performers made fun of social conventions and upset rationality through their nonsensical puns. They dared to address the audience directly. Their costumes immodestly flaunted their femininity: tight-fitting bodices and thigh-length pantaloons worn over opaque silk tights. By the end of their New York run, the troupe had been denounced by culturally conservative ministers and suffragists alike. Burlesque was called the "leg business" and its performers the "nude women" of the American stage. But it was Thompson's audacity, her awareness of creating a spectacle of herself that upset critics as much as, if not more than, the brevity of the burlesque costume. As the actress and suffragist Olive Logan put it in 1869: "The nude woman [of burlesque] represents nothing but herself. She runs upon the stage giggling; trots down to the footlights, winks at the audience, rattles off from her tongue some stupid attempts at wit . . . and is always peculiarly and emphatically herself,—the woman, that is, whose name is on the bills in large letters, and who considers herself an object of admiration to the spectators."[20] Or as Thompson herself put it in her 1869 burlesque *Sinbad*, "We are aware of our own awarishness."[21]

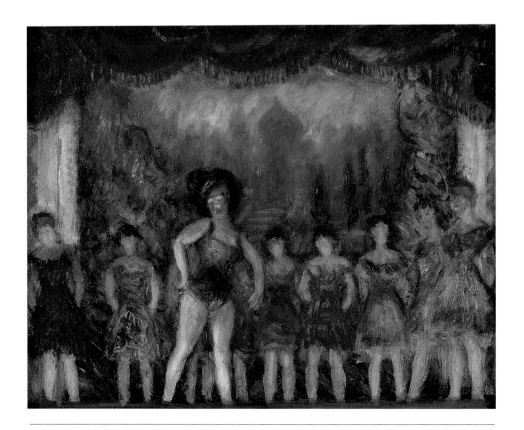

3.14 William J. Glackens, *Study for Music Hall Turn*, c. 1918. Oil on canvas, 13 x 16 in. (33 x 40.6 cm). Museum of Art, Fort Lauderdale, Florida, Bequest of Ira Glackens

Although Thompson played for audiences of middle-class men and women at one of New York's most prestigious theaters in 1869, within a few years burlesque had been driven off the bourgeois stage and reorganized as a working class–oriented entertainment centered on the display of the female form and performed for all-male (or nearly so) audiences in burlesque-only theaters in urban tenderloin districts.

Unlike vaudeville acts, which traveled independent of one another, burlesque companies toured as ensembles—garish posters heralding their arrival at venues such as Chicago's Star and Garter Theater and Brooklyn's New Empire. By 1912 about seventy companies were touring among some one hundred burlesque theaters, most of which were in the East and Midwest. (The same year, there were about four hundred vaudeville theaters operating in large and medium-sized cities nationwide and attracting a million patrons weekly.) Burlesque theater managers did not share Albee and Keith's penchant for cleanliness and opulence; they rightly assumed that marble floors and onyx oilcan stands were not needed to help attract *their* patrons.[22]

By the early 1870s burlesque troupes had adapted the three-part format of the minstrel show: an ensemble "first part" of comic banter and singing; an "olio" of individual specialty numbers; and a concluding comic sketch. By the 1890s, however, women had lost their voices as the subjects of potentially transgressive humor and had become merely sexualized objects on display. Male comedians now provided the humor in burlesque.

Burlesque's reliance upon female sexuality as its main draw greatly increased after the belly dance—or "cooch," as it came it be called in burlesque—was performed on the Midway of the Chicago World's Columbian Exposition in 1893. Within months, practically every burlesque troupe in America had added a Fatima, a Little Egypt, or a Zora doing her version of the *danse du ventre*. The year movies were introduced in vaudeville, 1896, also marked the first recorded performance of the striptease. The *National Police Gazette*, that venerable chronicler of the American demimonde, reported that belly-dancers at a St. Louis fair competed with one another to be the most revealing. The apparent winner was a dancer named Omeena, who "takes off almost all of her clothing, and is sufficiently suggestive to satisfy the most blasé old roué."[23]

It should not be surprising that patterns of feminine sexual display originated or promoted by burlesque should find their way into forms of purely

visual representation. In the 1870s burlesque performers were among the most common subjects of carte de visite photographs, sold by the millions in tobacco shops across the country. They also appeared as subjects in some of the five million sets of stereographic photographs made in the United States in the latter decades of the nineteenth century. One especially popular set of these "picture stories," "How Biddy Served the Potatoes Undressed," was produced in 1898 and issued by no fewer than eight companies. In it a woman seated with her husband at their dining table tells Biddy, the new maid, to bring them their potatoes "undressed." In the next image, Biddy reappears with a platter of potatoes but wearing one less article of clothing. In the final image, Biddy, now down to her petticoat, declares, "Even if it costs me my job, I'll not serve 'em any more undressed than I already am!"[24]

At the same time that vaudeville audiences were watching films of trains rushing through tunnels and re-creations of Boer War battles, an important subindustry was developing within the young but increasingly "respectable" motion picture business—one predicated upon a kind of female display only hinted at in such Edison efforts as *Annabella's Serpentine Dance* (1894) and *The Franchonetti Sisters* (1903). This subindustry relied heavily on the kind of sexualized spectacle then common in burlesque and in quasi-pornographic photography.

Among Edison's rivals between 1896 and 1908 (the year the two joined forces) was the American Mutoscope and Biograph Company, one of whose founders, W. K. L. Dickson, had been assigned by Edison to head the team that developed the Kinetograph in 1891. After leaving Edison in 1895, he helped develop a flip-card peep-show device, the Mutoscope, to compete with Edison's Kinetoscope, along with a camera-projector apparatus, the Biograph, which was used to show movies in Keith-circuit and other vaudeville theaters. But at the same time Dickson's Biograph Company was making *Comedy Cake Walk*, *On the Flying Rings*, *Expert Punching Bag*, and *Skating on Lake, Central Park* for middle-class-family audiences, it also was producing peep-show "films" for saloons and penny arcades such as *Pajama Girl*, *A Hustling Soubrette*, and *Poor Girls: It Was a Hot Night and the Mosquitoes Were Thick*. (For more about Dickson, see Walter Murch's essay in this book.)

These brief, salacious flip-card items were an important part of the Biograph Company's output for more than a decade. By 1908, the year D. W. Griffith began working as an actor at Biograph's Manhattan studio, the "spicy"

cinematic vignettes were being made at night while the family-fare films were shot during the day. That Griffith acted in some of these after-hours movies, and might even have made his directorial debut with *A Scene in a Dressing Room* (1908) or *The Merry Widow at a Supper Party* (1908), represents a delicious irony, given the resolutely Victorian standards embodied in his subsequent mainstream productions for Biograph.[25]

About a decade after movies were first shown in vaudeville theaters, the audience for vaudeville and for the movies grew enormously as new, low-price venues for both forms sprang up in large cities. An article in the March 17, 1906, issue of *Variety* (then only a year old) entitled "Nickel Vaudeville" noted that numerous vacant stores along major Manhattan thoroughfares had been transformed into makeshift movie theaters. Ironically, one of the first of these New York "nickelodeons," located across from Tammany Hall on East Fourteenth Street, had until recently been a dime museum. Trading in anatomical curiosities for a screen, piano, and 122 chairs, the theater offered three one-reel films (approximately thirty minutes' worth) *and* a vaudeville act (a song sung to magic lantern slides) for just five cents. Within six months *Variety's* Chicago correspondent counted more than a hundred five-cent movie theaters in that city, and by April 1907 the new trade paper *Moving Picture World* claimed that some twenty-five hundred to three thousand nickelodeons had opened nationwide.[26]

Traditional cinema historiography has seen the nickelodeon explosion as marking the movies' institutional liberation from the stultifying grip of vaudeville and the alignment of American cinema with its more authentic working-class urban audience. The actual situation, however, was a bit more complicated. The proliferation of storefront movie theaters in 1906–7 was but one aspect of a more general expansion in popularly priced urban entertainment between 1905 and 1908. Keith's and the other major vaudeville circuits built and renovated theaters across the country. The burlesque "wheels" (circuits) achieved their greatest reach around 1906. The five-cent movie theater boom followed by about a year a ten-cent *vaudeville* boom. Entrepreneurs leased old legitimate theaters and offered three or four programs of vaudeville per day with ticket prices ranging from ten to thirty cents. Others mounted low-cost vaudeville shows in rented storefronts. By the end of 1905 *Variety* recognized two classes of vaudeville: the "high class" or "big time" vaudeville of Keith and Proctor, and a lower tier of "ten-cent," "nickel," or "family" vaudeville

venues. As we have seen, vaudeville acts were a feature of many storefront nickelodeons from the beginning. Demand for new movies quickly outstripped supply, and just as Keith had done at his dime museum in 1883, nickelodeon managers looked to cheap vaudeville acts to provide another source of appeal.[27]

Although the "nickelodeon period" looms large in standard accounts of early American cinema, it lasted only a few years. Cutthroat competition developed in many cities with the rapid conversion of numerous vacant stores in the same neighborhoods into nickelodeons. With a frequent and dependable supply of new pictures a problem, nickelodeon managers sought other ways to differentiate themselves. In 1908 William Fox (of later movie-production fame) leased the old Dewey Theatre near Union Square and converted it into a showcase for both movies *and* vaudeville. For as little as ten cents, patrons could sit in comfortable seats in the large auditorium (patrolled by twelve uniformed ushers) and watch a two-hour program of movies and vaudeville acts. On Thanksgiving Day 1908, Fox sold twelve thousand tickets—the biggest single-day box-office take for a "movie theater" up to that time. Marcus Loew (whose later purchases and consolidations formed the basis of Metro-Goldwyn-Mayer) also struggled to make money from nickelodeons until he began leasing theaters and presenting programs of vaudeville and film. By summer 1909 Loew's People's Vaudeville Company operated twelve such "small time" vaudeville theaters—as they were called to differentiate them from "high class" venues such as Keith's—throughout the New York City area. By combining movies with vaudeville in large theaters, Fox, Loew, and other such innovators effectively brought the nickelodeon era to an end. Their vaudeville bills, cheap prices, and comfortable surroundings attracted patrons away from high-class vaudeville theaters who would not have ventured into storefront nickelodeons.[28]

Just as big-time vaudeville is marginalized in accounts of the first decade of commercial motion picture exhibition, so does small-time vaudeville go largely unnoticed in chronicles of the movies' second decade. But it was vaudeville—both big-time and small-time—and not the nickelodeon that provided the model for urban motion picture exhibition in the 1910s and 1920s. The first "deluxe theatre built expressly for showing movies in New York" opened in February 1913 at the corner of 116th Street and Seventh Avenue in Harlem. The twelve hundred–seat Regent Theater, designed by the famed

3.15 "At the 10 Cent Movie Show," 1913. Sheet music cover. Sam DeVincent Illustrated American Sheet Music Collection, Archives Center, National Museum of American History, Smithsonian Institution, Washington, D.C.

theatrical architect Thomas Lamb, was built in the same neighborhood as Keith's Alhambra Theater and used its vaudevillelike environment and elements (including printed programs, uniformed ushers, and an eight-piece orchestra) along with the novelty appeal of the longer and more narratively elaborate feature film to draw the area's "stolid first-generation *Burgherkind*" away from Keith's.

But by far the most famous of the first-generation picture palaces was the Strand Theater. Originally announcing the Strand in 1912 as a new Broadway vaudeville theater, owners Mitchell and Moe Mark lured Samuel F. ("Roxy") Rothafel away from his job as manager of the Regent and gave him "carte blanche to devise the most spectacular entertainment New York had ever seen in a movie house." What Roxy designed was a vaudeville atmosphere for the presentation of the new feature film. Press reports of the Strand's opening in April 1914 directly echo those that had heralded the opening of Keith's New Theatre in Boston exactly twenty years earlier. Uniformed ushers led patrons from the Strand's "sumptuous" foyer into its four thousand–seat auditorium, which had been "done as sort of a neo-Corinthian temple topped by a vast cove-lit dome." Furthermore, the program that preceded the "headlining" feature film that evening (the nine-reel western epic *The Spoilers*) would not have been out of place as part of a high-class vaudeville bill: the orchestra's rousing rendition of the National Anthem substituted for a dumb act, and Brahms's Hungarian Rhapsody No. 2 settled the audience down. A newsreel and a travelogue were followed by a singer, a Keystone Kops short, and the Strand Quartette playing a selection from Verdi's *Rigoletto*.

Thus the exhibition venue frequently cited as marking the movies' final break with vaudeville, the picture palace, actually took its programmatic form, scale, and pricing structure from small-time vaudeville (with its hybrid program of live acts and motion pictures offered for less than a seat at Keith's New Union Square) and its environmental aesthetic from high-class vaudeville. Framing the feature-film attraction of a given week with various "acts" (both live and cinematic) designed to appeal to a diverse audience (men and women, adults and children, fans of opera and of slapstick) and offering this heterogeneous fare at low prices in an atmosphere where one was "surrounded by the forests of classic columns, armies of uniformed flunkies, galleries of oil paintings, and arcades of mirrors" all comprised a transparent attempt to lure big-time and small-time vaudeville audiences alike. For a dime or a quarter,

the picture palace offered a version of what vaudeville audiences enjoyed at Keith's, along with a novelty that the big-time vaudeville bill could not accommodate: the ninety-minute feature film.[29]

Vaudeville performers were definitely supporting acts in the picture palaces of the 1910s and early 1920s, although they helped fill the huge auditoriums of what came to be called "presentation houses" with habitual customers when the initial allure of the feature film faded. Conventional wisdom has it that the introduction of sound in the late 1920s finally killed off vaudeville—both the big-time and the use of vaudeville acts in movie theaters. Certainly, the removal of pit orchestras from nearly all movie theaters following the advent of talkies, combined with the significant costs managers had to absorb in equipping their auditoriums for sound, made the inclusion of live acts all but unsupportable. But by the time audiences saw and heard Al Jolson do his vaudeville shtick in *The Jazz Singer* in fall 1927, big-time vaudeville had been in decline for more than a decade (fig. 3.16). First small-time vaudeville and then movie theaters lured audiences away from more expensive big-time houses after 1910. Although attendance at the movies surged after World War I, vaudeville endured one slump after another in the early 1920s, idling more than twelve thousand vaudeville acts.

Beginning in 1915, such show business entrepreneurs as Earl Carroll, Florenz Ziegfeld, and George White discovered that by taking a vaudeville bill, tying the acts together with a slender narrative or thematic thread, and including at least one big production number, they could turn the bill into a revue, open it on Broadway, and charge two dollars admission. Revues attracted audiences and talent away from vaudeville in the 1920s.

By the end of 1926—the year *before The Jazz Singer*—only twelve big-time vaudeville theaters were still open. In 1928 the Radio Corporation of America (RCA) absorbed what was left of the once-dominating Keith-Albee organization to provide the exhibition-component core of its new film production and distribution company, Radio-Keith-Orpheum (RKO).[30]

Yet even as vaudeville's power as a show business institution waned, its influence was still very much felt in other forms of entertainment. In a 1930 vaudeville valediction, George M. Cohan himself pointed to more than one hundred performers then starring on Broadway or in the movies whose training had come on the vaudeville stage. Although traditional film histories downplay the connection, Henry Jenkins has argued that many of the musical and

3.16 Opening night of *The Jazz Singer*, Warners' Theatre, Times Square, New York, October 6, 1927. Film Stills Archive, The Museum of Modern Art, New York

comedy stars of early sound cinema not only learned their craft in vaudeville but also brought to the talkies "a particular style of performance characteristic of the vaudeville tradition."[31] The vaudeville aesthetic of visual and comic economy, immediate sensory impact, and direct engagement with the audience can be seen in the films of Jolson, Eddie Cantor, and the Marx Brothers.

The aesthetic, cultural, and social impulses represented in the heterogeneous "cinema of attraction" of the vaudeville era were not expunged when cinema became obsessed with narrative after 1905. Instead, they were rechanneled and reformulated. Every television news program can in a way be traced back to the Lumières' *Coronation of the Czar of Russia* (1896, shown at Keith's New Union Square Theatre that July). Every stomach-turning and dizzying effect provoked by an IMAX film bears a trace of the sensation produced by the phantom-locomotive films of cinema's first season in vaudeville. Every *Star Wars* episode owes a debt to Méliès's *A Trip to the Moon*. Every program on the Travel Channel attempts the same feat of spatial relocation first attempted in the hundreds of travel "views" that vaudeville audiences enjoyed. And every minute of every "reality" TV program yet made recalls the early cinema's unique ability to frame and capture the visual sensation of the quotidian and give it back to us on the screen as an object of contemplation.

3.17 Howard A. Thain, *Opening Night, Ziegfeld Follies*, c. 1926. Oil on canvas, 16⅛ x 20⅛ in. (41 x 51.1 cm). Museum of the City of New York, Bequest of Robert R. Preato

Notes

1 *New York Dramatic Mirror*, July 4, 1896.
2 Ramsaye, *A Million and One Nights*, 264; Gilbert Seldes, *An Hour with the Movies and Talkies* (Philadelphia: Lippincott, 1929), 20; Garth Jowett, *Film: The Democratic Art* (Boston: Little, Brown, 1975), 29. On the use of films as "chasers" in vaudeville, see Robert Grau, *The Theatre of Science* (New York: Broadway, 1914); Benjamin Hampton, *A History of the Movies* (New York: Covici, Friede, 1931); Joseph H. North, *The Early Development of the Motion Picture* (New York: Arno, 1973); Ramsaye, *A Million and One Nights*; Arthur Knight, *The Liveliest Art* (New York: Mentor, 1957); and Gerald Mast, *A Short History of the Movies* (New York: Bobbs-Merrill, 1971). I demonstrate the problems with this "theory" of early film history in Robert C. Allen, "Contra the Chaser Theory," *Wide Angle* 3, no. 1 (1979): 4–11. See also my debate on this subject with the film historian Charles Musser: Robert C. Allen, "Looking at 'Another Look at the Chaser Theory,'" *Studies in Visual Communication* 10, no. 4 (1984): 45–50, and Musser, "Another Look at the Chaser Theory," ibid., 22–44.
3 See Gunning, "Cinema of Attraction."
4 See, among many other recent works on early film exhibition and audiences, Waller, *Main Street Amusements*; Peiss, *Cheap Amusements*; Rosenzweig, *Eight Hours for What We Will*; Fuller, *At the Picture Show*; Butsch, *Making of American Audiences*; Gomery, *Shared Pleasures*; Musser in collaboration with Nelson, *High-Class Moving Pictures*; Stokes and Maltby, *American Movie Audiences*; and Allen, *Vaudeville and Film*. I discuss the importance of the social experience of moviegoing as part of film historiography in Robert C. Allen, "From Exhibition to Reception: Reflections on the Audience in Film History," *Screen* 31, no. 4 (winter 1990): 347–56.
5 On film audiences' familiarity with *The Widow Jones*, see Musser, *Before the Nickelodeon*, 65, 80. Porter's film took its title from and based its plot on Scott Marble's 1896 stage melodrama *The Great Train Robbery*, a production of which had been staged in New York in February 1902. See Musser, *Before the Nickelodeon*, 253–59.
6 See Musser's account of this meeting in *Before the Nickelodeon*, 39–41.
7 Ibid., 80–81.
8 "Where the Past Speaks," *New York Mail and Express*, September 25, 1897, quoted in Kemp Niver, ed., *Biograph Bulletins: 1896–1908* (Los Angeles: Locare Research Group, 1971), 28. See also Allen, "Contra the Chaser Theory."
9 *Boston Herald*, January 14, February 11 and 25, April 1, and May 20, 1883. See Robert C. Allen, "B. F. Keith and the Origins of American Vaudeville," *Theatre Survey* 21, no. 2 (November 1980): 105–15. I also discuss the rise of vaudeville in Allen, "The Institutionalization of Burlesque," in *Horrible Prettiness*.
10 See the brochures "B. F. Keith's New Theater" and "The Model Playhouse of the Country," Harvard Theater Collection, Harvard University, Cambridge.
11 Maxwell F. Marcuse, *This Was New York* (New York: Carlton, 1965), 199.
12 On the most notorious and deadly theatrical riot in American theater history, see Peter Buckley, "To the Opera House: Culture and Society in New York City, 1820–1860," Ph.D. diss., State University of New York at Stony Brook, 1984. On the larger social context of antebellum riots, see David Grimsted, "Rioting in Its Jacksonian Setting," *American Historical Review* 77 (1972): 361–97.
13 Quoted in Gilbert, *American Vaudeville*, 202.
14 M. Alison Kibler discusses vaudeville's attempts to negotiate class differences within its audience in *Rank Ladies*.
15 The exact demographic makeup of the vaudeville audience is difficult to ascertain. Keith theater managers' weekly reports and the newspaper clippings they saved, however, indicate that women and children were especially valued patrons. These report and clipping books are included in the Keith/Albee Collection, University of Iowa Library, Iowa City.
16 See Paul McPharlin, *The Puppet Theatre in America* (Boston: Plays, Inc., 1969).
17 For an analysis of the logic of the vaudeville program written by a booking agent, see George A. Gottlieb, "Psychology of the American Vaudeville Show from the Manager's Point of View," *Current Opinion*, April 1916, 257–58.
18 Jenkins, *What Made Pistachio Nuts?* See also Kibler, *Rank Ladies*, 83.
19 Filippo Tommaso Marinetti, "The Variety Theatre," in Michael Kirby, *Futurist Performance* (New York: Dutton, 1971), 179–86, quoted in Jenkins, *What Made Pistachio Nuts?* 62.
20 Olive Logan, *Apropos of Women and Theatres* (New York: Carleton, 1869), 134–35. On burlesque, see also Allen, *Horrible Prettiness*.
21 Quoted in Richard White, "The Age of Burlesque," *Galaxy*, August 1869, 260.
22 *Billboard*, February 10, 1906, 8–9; Irving Zeidman, *The American Burlesque Show* (New York: Hawthorn, 1967), 62–67.

23 *National Police Gazette*, October 31, 1896, 2.

24 See William C. Darrah, *Cartes de Visite in Nineteenth-Century Photography* (Gettysburg, Pa.: Darrah, 1981); and William C. Darrah, *The World of Stereographs* (Gettysburg, Pa.: Darrah, 1977).

25 Cooper Graham et al., *D. W. Griffith and the Biograph Company* (Metuchen, N.J.: Scarecrow, 1988), 313.

26 "Nickel Vaudeville," *Variety*, March 17, 1906, 4; "Will Close Five-Cent Theatres," *Variety*, October 6, 1906, 5; "The Nickelodeon," *Moving Picture World*, May 4, 1907, 140.

27 "Ten-Cent Theatres in the West," *Dramatic Mirror*, June 3, 1905, 16; "Cheap Vaudeville Invades Harlem," *Dramatic Mirror*, June 3, 1905, 16; "The Evolution of Cheap Vaudeville," *Variety*, December 14, 1907, 10; "Five-Cent Vaudeville," *Dramatic Mirror*, August 19, 1905, 16; *Variety*, December 30, 1905, 6.

28 For William Fox, see Glendon Allvine, *The Greatest Fox of Them All* (New York: Lyle Stuart, 1969), 35–45; "Dewey Theatre," *Variety*, December 19, 1908, 13; and "$1200 in One Day," *Variety*, December 12, 1908, 12. For the origins of Metro-Goldwyn-Mayer, see Bosley Crowther, *The Lion's Share: The Story of an Entertainment Empire* (New York: Dutton, 1957), 23–39. For small-time vaudeville, see "10-15-25 the Thing," *Variety*, August 28, 1909, 8.

29 Quoted material from Ben Hall, *The Best Remaining Seats: The Story of the Golden Age of the Movie Palace* (New York: Potter, 1961), 30–31.

30 On the decline of vaudeville, see Abel Green and Joe Laurie, Jr., *Show Biz: From Vaude to Video* (New York: Henry Holt, 1951).

31 George M. Cohan, "Vaudeville as an American Institution," *Variety*, January 8, 1930, 10, quoted in Jenkins, *What Made Pistachio Nuts?* 59–60.

CHAPTER 4

SETTING THE STAGE
FOR MOTION PICTURES

C. LANCE BROCKMAN

 By the end of the nineteenth century, American theatrical managers were engaged in a frenzied race to find and stage, for equally avid audiences, large-scale productions that emphasized scenic spectacle. Competing productions lured audiences by promising sensational and highly visual stage illusions. Their extravagant advertisements made such claims as "Ingenious and Mechanical Effects," "Two Train Cars of Elaborate Scenery," and "Scenery, Costumes, Properties and Ballets on a Scale of Magnificence Never before Attempted in America."

Audiences had grown weary of the familiar plots of most melodramas, and even the star power of such actors as Joseph Jefferson, Mme. Helena Modjeska, and James O'Neill no longer resonated. As a reporter for the *Minneapolis Tribune* put it in 1898, "There are some who cry the quality of the drama is inferior to what we had a dozen years ago. They proclaim from the housetops that the stage is given over to farce comedies, burlesques, extravaganzas to the detriment and loss of the better quality plays. . . . How much more the public demands in the way of amusements today than it required ten years ago, only the hard pressed manager knows."[1]

Added to the menu of entertainment options available in the 1890s was a new form of diversion—the motion picture—created to satisfy the insatiable appetite of American audiences. The earliest cinematic efforts were short in length and coarse in quality; many borrowed heavily from the subject matter and visual aesthetics of late-nineteenth-century theater, including a reliance on painted backgrounds. In his *History of the American Theatre, 1700–1950*, Glenn Hughes articulated the reaction of live-theater impresarios to the intrusion of the movies: "In 1900 scarcely a showman took the motion picture seriously, for it was still a cheap novelty, a rather contemptible side-show. Ten years later suspicions were growing that this upstart of the entertainment

world bore watching; another five years and many a managerial brow broke out in a cold sweat."[2] Heralded in the 1890s press as "the most marvelous piece of photography this century has seen," film and camera technology continued to develop, and by 1920 movies were on the way to becoming the dominant force shaping popular culture in the first half of the twentieth century.[3]

Efforts to replicate nature for the sake of entertainment date back to the scenic illusions created for the Renaissance stage. Although it is not necessary to reach back that far in history in order fully to understand the transition from a stage picture to motion pictures, it is useful to examine several important artistic and technological advances that occurred during the nineteenth century. Each represents an attempt to capture the illusion of nature, and all helped pave the way for movies.

By the end of the nineteenth century, American audiences were still captivated by spectacle dramas that wrapped a story around visual effects "never attempted before on stage." The most famous—and last—of these extravaganzas was based on General Lew Wallace's 1880 novel, *Ben-Hur: A Tale of the Christ*. The book had attracted a readership unequaled, it was said, by any volume except the Bible. For theater audiences in 1899 and, later, movie audiences (in 1907, 1925, and 1959), the main allure was obvious—an opportunity to witness the widely publicized, climactic chariot race between Judah Ben-Hur and Messala. As illustrated in a 1900 issue of *Scientific American*, this complex and stunning set piece was the result of merging realistic scenic art of the nineteenth century with a sophisticated stagecraft that had only lately been made possible by the development of electrified stage machinery (fig. 4.1). In his book *Playing Out the Empire*, the theater historian David Mayer explains why the chariot race was pivotal: "There was no new technology [for the design of the chariot race]: moving scenic backcloths or dioramas set as "endless belts" had been used in theaters since 1820s. Treadmills that enabled horses to gallop in place and that moved forwards or backwards at the touch of off-stage controls had been in theatrical use for a decade. It was the combination of these techniques, and the overall design, that gave the scene its apparent uniqueness and originality."[4] Theater managers who rushed to add *Ben-Hur* to their repertoires were forced to close their houses for two to three days in order to install the necessary elaborate machinery. But this interruption of revenue nearly always paid off because most productions of the play were tremendous financial successes. Eventually,

4.1 The chariot race from the New York stage production of *Ben-Hur*, illustrated in the August 25, 1900, issue of *Scientific American*. This cutaway image depicts the complicated machinery used to achieve the stage effects.

4.2 The auditorium and stage of Thomas Edison's theater at the International Exhibition of Electricity, Munich, 1882, as illustrated in the November 10, 1883, issue of *Scientific American Supplement*. The illustration not only shows wing-and-drop scenery but also depicts the first theater equipped with a complete incandescent-lighting system.

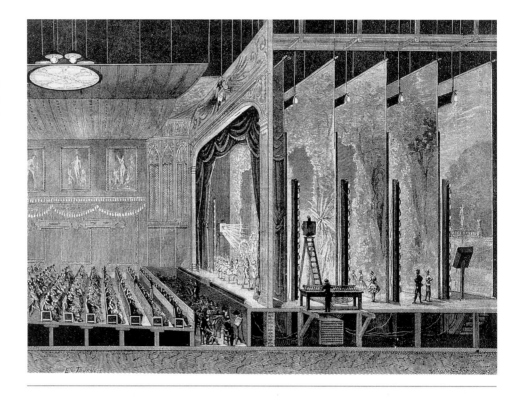

however, *Ben-Hur* was recognized as a signpost that marked the end of an era: theater was no longer the sole form of entertainment that would satisfy audiences' hunger for novelty and spectacle.

The proliferation of technical advances during the nineteenth century was a major factor in the evolution of artistically ambitious productions. The worldwide distribution of these advances was accelerated by new modes of transportation and communication and by the universal popularity of world fairs. As the globe seemed to shrink with alarming speed, Americans and Europeans were on the edge of their seats in anticipation of the next dazzling achievement.

The first documentation of visual spectacle and illusionary effects for the stage appears in the writings of two Italian Renaissance artisans, Nicola Sabbattini and Sebastiano Serlio. They provided basic instructions on how to incorporate sophisticated systems of mechanical perspective that would transmit a sense of realism in plays and intermezzos. Sabbattini additionally supplied specific instructions and illustrations for producing various visual effects, such as rolling waves, apparitions, and full-stage conflagrations. These writings reveal how demanding Renaissance audiences were for visual spectacle. More significantly, they established the basis for the aesthetic of the stage picture and for scenery that would be designed through the nineteenth century.[5]

The stage picture, contained within a proscenium arch, was created with scenery consisting of two parts: shutters and wings, or backdrops and cut drops. The shutters or backdrops provided the central composition, the representational subject matter of the scene. Surrounding these shutters or backdrops were either wings or cut drops—painted, as need be, to resemble trees, colonnades, or architectural walls; they completed the visual composition while masking the offstage areas from the audience's view. Shutter-and-wing, the earliest form of scenery, consisted of large painted panels stretched over wooden frames, not unlike an artist's canvas. Because these panels were flexible, they could be installed in any large hall. Changing scenic locations simply meant sliding these pieces laterally on and off stage. Primarily used in the nineteenth century and only in specially designed theaters, backdrops and cut drops were similar to the shutter-and-wing arrangement, except that the large canvases were stretched by gravity between upper and lower wooden battens. Shifting the stage picture involved raising the canvases into open loft areas above the stage. When these two forms of scenery were used interchangeably, the combination was called wing-and-drop scenery. In figure 4.2, three cut drops painted to resemble trees complement the scene and frame the garden backdrop at the rear of the stage.

To establish specific locations needed for most plays, every theater required a set of "stock" backdrops painted to resemble generic locations: a traditional street, conservatory, garden, palace interior, rocky pass, landscape, prison or dungeon, and deep woods. In the latter half of the nineteenth century, the most elaborate piece of scenery in the theater was the drop curtain that hung at the front of the stage. It displayed an idyllic or romantic scene, surrounded by an ornate frame and swagged draperies, in imitation of the fine art exhibited in European academies.

Beginning in the Renaissance, theater audiences were accustomed to seeing richly painted and intricately detailed scenery that gave them a sense of place. They also were used to stage lighting that was merely painted into the visual composition and seemed, therefore, frozen in a moment of time. In 1781 the British stage designer and innovator Philippe Jacques de Loutherbourg challenged the traditional depiction of lighting in scenery by creating his revolutionary Eidophusikon, or Representation of Nature.[6] This attraction dazzled London audiences and won accolades from such artists as Thomas Gainsborough and Sir Joshua Reynolds. Also referred to as "Various

Imitations of Natural Phenomena, represented by Moving Pictures," the Eidophusikon was a miniature theater with a proscenium opening six feet wide by eight feet high. According to the theater historian Ralph G. Allen, although this peep show was not a legitimate theater piece with actors and a script, "its influence on subsequent stage design and technology was perhaps greater than that of any single play or pantomime that appeared in the latter half of the eighteenth century."[7]

To the standard wing-and-drop scenery Loutherbourg added colored-silk screens and opaque shutters. By varying their angle, he was able to control the color and intensity of the lighting and thus create a fluid stage picture that transformed the scene by imitating natural atmospheric changes of light. To enhance this effect, Loutherbourg used backdrops that were painted with a combination of opaque paint and thin dye. When this scenery, known as translucent, was lit from the front, the painted composition was revealed. But when the light source was behind the backdrop, many defined areas were reduced to shadowy shapes. In the thinly painted areas, light poured through the dyed fabric the way it does through stained-glass windows or magic-lantern slides. Although he achieved his groundbreaking effects only on a miniature stage, Loutherbourg anticipated the need for controlled and chang-ing theatrical lighting that mimicked nature. The introduction of gaslight in 1817 and, near the end of the century, the adoption of electric lighting were the next significant developments in this area.

Louis Jacques Mandé Daguerre, inventor of the daguerreotype, explored the possibility of creating moving light early in his career, when he worked as a stage designer. Daguerre and his partner Charles Marie Bouton expanded on Loutherbourg's ideas with a new entertainment called the Diorama, which debuted in Paris in 1822. This elaborate project necessitated the con-struction of a building that was engineered to provide the illusion of natural light. Spectators sat on risers that were attached to a rotating platform. When the scenic screens and silks were manipulated, one scene would slowly be revealed and transformed, through lighting, from daybreak to sunset to night. During the dark interval, the audience was slowly turned to view a different pictorial subject, where more realistic effects of moving and "nat-ural" light would be demonstrated.[8]

At the same time Loutherbourg was experimenting with moving light to establish a sense of time, another illusionary novelty—the panorama—was

capturing the popular imagination. Devised in the 1780s by the Scottish portraitist Robert Barker, the panorama (or cyclorama, as it eventually was renamed) was an immense 360-degree painting displayed in a large, circular exhibition building. The novelty of the panorama was that it seemed to transport the spectator to another place or time—a famous city, say, or a defining moment in history, with battles and religious events being the most popular. According to an 1886 article, "How a Great Battle Panorama Is Made," "The aim of the battle panorama is to reproduce not only the field of the conflict, as it was at the time, but also the most striking events of the battle as they would have appeared to a spectator from the same standpoint."[9]

First seen in this country as early as 1795, panoramas remained popular through the mid-nineteenth century. Then in the 1880s, nostalgic interest in the Civil War prompted a revival of these large documentary paintings. The skills of numerous artists were required in order to achieve maximum accuracy. Landscape painters would complete the overall composition, while specialty artists would depict individual figures, paying meticulous attention to the details of their military uniforms. These artists often relied upon daguerreotypes to help them craft likenesses of the more famous officers and their horses.[10]

To make this form of amusement commercially viable, cyclorama buildings were constructed to strict standards, and the painted backdrops were standardized, too, at fifty feet high by four hundred feet in circumference. Panoramas were usually installed in two sections: the large painted backdrops of linen or canvas representing the background and middle ground; and a detailed three-dimensional foreground "arranged to aid the perspective of the painting" (fig. 4.3). Typically in a battle panorama, an intricate terrain was sculpted from tons of earth, logs, and live and dead trees; scaled clay figures were added to represent the soldiers and horses. All these dimensional objects in the foreground created natural shadows that carefully blended with the painted shadows of the backdrops "to make it nearly impossible for a spectator to determine at any point which is real and which is painted."[11]

A significant precursor to motion pictures was the moving panorama. First introduced in English Christmas pantomimes, these devices were long, continuous expanses of painted and translucent fabric wound on spools that scrolled laterally behind a miniature proscenium arch or frame. Although their subject matter varied, most moving panoramas were travelogues, both

4.3 This illustration from Albert A. Hopkins's book *Magic: Stage Illusions and Scientific Diversions* (1898) shows the spatial relation between the platform for spectators, painted dropcloth, and three-dimensional foreground in a cyclorama. The cyclorama here, produced during the 1880s, depicted the Battle of Gettysburg.

4.4 John Banvard's Mississippi panorama, illustrated in the December 16, 1848, issue of *Scientific American*.

educational and entertaining, that took the spectator on a visual journey. For the first time, audiences experienced the thrill of seeing the environment move, sideways, instead of remaining static as it did on the traditional stage.

In America the panorama craze was primarily a mid-nineteenth-century phenomenon. Many were painted to reveal the splendor and variety of scenery along the Mississippi River, the geographical line separating the civilized eastern United States from the untamed West. To generate audience interest, panorama painters boasted proudly about the size and scope of their creations, touting travelogues, for example, as "The Biggest Picture in the World" or the "Three Mile Painting." John Banvard created perhaps the most famous of these panoramas, and certainly one of the best promoted, in 1846 (fig. 4.4). His representation of the Mississippi, from the mouth of the Missouri River down to New Orleans, engaged audiences in Boston, New York, and then throughout Europe; the tour culminated with a command showing for Queen Victoria. To narrate the painting, the artist or a narrator—"travel guide" described the changing scenes while embellishing the presentation with first-hand tales of the hardships endured in executing the many *plein-air* sketches required for a full-scale panorama. The narrator heightened the drama by spinning wild tales of encounters with Indians and local rustics.

In 1852 the English painter and entrepreneur Albert Smith explored the full potential of panoramic presentation with his program "Ascent of Mont Blanc." The performance space in Egyptian Hall in London's Piccadilly was converted into a replica of a Swiss chalet, replete with a pond stocked with fish and surrounded by Alpine plants (fig. 4.5). Smith used a traditional

panorama for the lateral "journey" to the base of the mountain; after intermission, a second panorama, which scrolled vertically, was installed to simulate the climb to the summit. The popularity of Smith's novel adaptation set off a "veritable flood of Mont Blanciana—Mont Blanc fans, roses, board games, sheet music, and even nougat."[12]

The translucent moving panorama transcended the static backgrounds of both the stage and the circular panorama by apparently altering both time and place in full view of the audience. Soon, other forms of theatrical entertainment were adapting this new technique for simulating changes of time and location. The painted sky on backdrops and shutters, like the source of light in paintings, was fixed and unchanging. But substituting a large panorama for this painted illusion made it possible to vary the background and thus reflect atmospheric change appropriate to a particular play. For the audience, the stage picture could miraculously change from the pastels of sunrise to the bright light of midday to the brooding dimness of an approaching storm; simply scrolling the sky panorama from backstage produced these effects. Unlike the traditional landscape backdrops or even the moving panorama, in which the entire painted composition—background, middle ground, and foreground—was created as one, the sky panoramas moved independently of the rest of the stage picture. The resulting evocation of natural light guided the expectations of theater audiences.[13]

4.5 "Mr. [Albert] Smith's 'Ascent of Mont Blanc,' at the Egyptian Hall, Piccadilly," as shown in the December 25, 1852, issue of the *Illustrated London News*.

Among the most ambitious and costly theatrical projects of the late nineteenth century was the Spectatorium, which the noted theatrical manager Steele MacKaye proposed for the 1893 World's Columbian Exposition in Chicago. Although the Spectatorium was never built, MacKaye's vision for "a new form of art" embodied in its design broke with accepted theatrical aesthetics and prefigured many of the changes in popular entertainment that were to occur in the new century. MacKaye recognized the potential of electricity for providing a safer and more natural and controllable means of illumination. Furthermore, he understood how this newest form of energy could be harnessed to move immense platforms and machinery, previously the backbreaking work of numerous stagehands.

The impetus to develop more efficient stage machinery arose from earlier attempts to improve stagecraft and to free the theater from two-dimensional painted scenery. MacKaye is credited with creating sliding or movable stages and under-the-seat hat storage. His most noteworthy invention, however, was the famous elevator stage for the Madison Square Theater, an ingenious contrivance that reduced the intervals between scene changes in plays.

For the Chicago exposition, MacKaye envisioned a grandiose "spectatorio"—a word he coined—that would combine a form of stagecraft heralded as "a startling advancement in realism" with a musical oratorio composed for "three full-scale choral groups accompanied by an orchestra of 120 pieces."[14] In keeping with the fair's main theme, the production was entitled *The Great Discovery or The World Finder*, a six-act extravaganza commemorating the life of Christopher Columbus. The vast building designed to hold MacKaye's production was to be divided into two distinct spaces: the audience area, which resembled a Greek-style amphitheater, with seating for nine thousand; and the even larger Scenitorium, which would accommodate all the extensive stage equipment. To promote the project with investors and clarify the complex and innovative stage mechanics, MacKaye devised scale models that were complete in every detail, down to the fully functional electrified effects. He later described some specifics of this unparalleled venture:

> There were to be twenty-five telescopic stages, all of which were to be furnished with *scenery of an entirely new species* developed by myself. The frame [arched proscenium] of the stage pictures was 150 feet [wide] by 70 feet [high], and the full range of the vision of the public,

at the horizon of the picture, would have been over 400 feet. It would have required over six miles of railroad track for these stages to move upon, and their aggregate weight would have been over 1,200 tons. In making a change of scene, the [electrical] machinery of the building would have easily controlled over 600 tons, and would have made each change within forty seconds.[15]

Although these stage mechanics were indeed impressive, it was the proposed electrified lighting and realistic effects that revealed the potential for creating a more sculptural and naturalistic theatrical space. To take full advantage of the new lighting, MacKaye abandoned the painted two-dimensional wing-and-drop scenery for fully detailed three-dimensional architectural forms, including large-scale replicas of Columbus's ships, the *Niña*, *Pinta*, and *Santa Maria*. To illuminate the stage naturalistically, an intense sun with "the capacity of fifty arc lights" was to track a semicircle behind the proscenium; this would simulate accurate angles of light representing changes during various times of day and also create realistic shadows on the three-dimensional scenic units. In addition, large projectors in the Spectatorium were engineered for naturalistic sky treatments, electrified to relay "accurate depictions" of constellations and atmospheric effects from both the Northern and Southern Hemispheres, falling stars, and meteors. A sophisticated system of electric fans and humidifiers would create atmospheric effects, including fog, while elaborate wave machines would agitate the water and thus conjure up turbulent seas.[16]

MacKaye's "new form of art" demonstrated an attempt to achieve a level of realistic presentation that boldly ignored established boundaries and resources of performance on the live stage. The grandiose scale of the proposed Spectatorium makes it seem more suitable for an art form that was yet to come—the early epic films of D. W. Griffith and Cecil B. DeMille. Eventually, MacKaye's son Percy adapted his father's vision in mounting some of the first outdoors epic civic dramas and historic pageants that enthralled American audiences after the turn of the century.

By the end of the nineteenth century, moving panoramas and cycloramas represented state-of-the-art technology and were integral features of popular-culture entertainment. For the 1900 Exposition Universelle in Paris, these devices, in the form of attractions or rides that simultaneously manipulated time and space, created for fairgoers the sensation of traveling on trains, ships,

or balloons. An illustration in a September 1900 issue of *Scientific American* shows the Maréorama, a sophisticated "ride" that fused technology and artistry (fig. 4.6). For the "trip," as many as seven hundred fairgoers at a time "boarded" a spectator platform shaped and decorated like a ship. The illusion of travel was accomplished by two moving panoramas, twenty-five hundred feet long by forty feet high, that scrolled on either side of the platform. An elaborate mechanism of hydraulic piston engines driven by electric motors simulated the motion of a ship.[17]

Another major attraction at the exposition, the Balloon Cineorama (also known as the Cineorama Air-Balloon Panorama), integrated the new technology of projection and moving pictures that would replace the painted cyclorama and moving panorama (fig. 4.7). To create the illusion of motion, ten synchronized cameras were used to record a fifteen hundred–foot ascent over Paris in a hot-air balloon. The spectators, standing on a circular platform that resembled the balloon's basket, were then treated to the "sensation of travel without entailing any of the dangers." The effect, called a "cinemato-graphic" panorama, was generated by ten synchronized projectors powered by electric arc lights. The spectators first experienced the ascent, and then when the direction in which the successive frames were projected was reversed, they

4.6 Employing dual panoramas and a platform for spectators that was rolled from side to side by hydraulic pistons, the Maréorama at the 1900 Exposition Universelle in Paris gave fairgoers a turn-of-the-century version of virtual reality. This illustration appeared in the September 29, 1900, issue of *Scientific American*.

felt as though they were in a balloon that was descending and landing.[18]

Perhaps more than anyone, the Swiss designer and theoretician Adolphe Appia rejected the romanticized stage images and painted scenery of nineteenth-century theater. In 1898 he called for a new type of theatrical performance, one that emphasized the emotions of the playwright and actor; by incorporating both sculptural scenery and the new "living" incandescent light, he sought to illuminate the subconscious intent of the playwright. In his seminal treatise *Music and the Art of the Theatre*, he expounded on the importance of lighting as the unifying element of a new art form:

> As a result of this newly established relationship, the dramatist's text will be able to dictate the nature of the actor's role more precisely, and this, in turn, will permit the actor to demand that the setting serve him more effectively. This will inevitably increase already existing conflict between the three-dimensional *practical* scenery and the painted scenery, since the latter by its very nature is, and will always be, in conflict with the actor. Ultimately, this conflict between stage painting and the more dynamic forces of the theatre will reduce the importance of painted scenery. Thus lighting, finding itself for the most part freed from the drudgery of merely illuminating the painted canvases, recovers its rightful role of independence and enters actively into the service of the actor.[19]

The refinement of the incandescent lightbulb produced two conflicting results. First, as stage lighting became stronger and more saturated with color, the inability of painted scenery to summon up a believable "world of the play" became glaringly apparent. For much of the nineteenth century, actors and scenery were unified under the soft glow of stage light into a perfect mise-en-scène. Now, however, the new electric spotlight made the natural shadows cast by the actor and the shadows painted by the scenic artists all too obvious. Painted stage scenery, as an imitation of nature, was doomed. Second, the brighter light made it possible to produce larger and more detailed images on the picture sheet or screen. In reaction to the improved lighting, artists who painted scenery for vaudeville and burlesque adopted the new illustrative style featured in popular magazines and promoted by emerging schools of art. The romantic imagery of the theater was replaced by bold colors and a graphic

4.7 The Balloon Cineorama at the 1900 Exposition Universelle in Paris substituted cameras and projectors for the static painted panoramas of the nineteenth century. This illustration appeared in the September 1, 1900, issue of *Scientific American Supplement*.

4.8 This illustration from Albert A. Hopkins's book *Magic: Stage Illusions and Scientific Diversions* (1898) depicts the first public projection of Thomas Edison's Vitascope in a vaudeville theater.

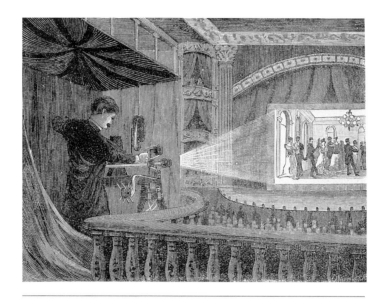

look that was forthrightly modern. (For more about the initial impact of electrical lighting on theaters, see David Nasaw's essay in this book.)

In the 1920s many new theaters were built to meet the dual demands of vaudeville and motion pictures; at the same time, many older legitimate theaters were converted into movie houses (fig. 4.8). By the time the stock market crashed in 1929, road-show business had died, stock companies had disappeared, and vaudeville was rapidly on the wane.[20]

Thanks to enormous technological advances, the movies overcame many of the obstacles that had long stymied the theatrical world. Historically, theater audiences were accustomed only to lateral movement within the confines of the proscenium arch. Even in the earliest movies, however, the "fourth wall" of the theater was removed, so that speeding trains, say, or galloping horses would seem to emerge through the screen. Clearly, when two pieces of film were spliced together, there was no need for lengthy scene shifts. And as camera technology became more sophisticated, the close-up provided an element of visual intimacy with the actor that was impossible to achieve on even the smallest stage. When the first flickering images appeared on the picture sheet in vaudeville houses, the vast potential of this latest technological advance was beyond people's imagination. Yet the immediate success of the new medium and its overwhelming acceptance by audiences clearly indicated that the American public was ready for a form of spectacle and novelty that had been nurtured in the theater but could be satisfied only by the motion picture.

Notes

1 "Lamenting the Loss of the Grand Opera House," *Minneapolis Tribune*, June 12, 1898. I found this clipping in the L. N. Scott Scrapbooks of the Grand Opera House and the Metropolitan Theatre (Minneapolis) Collection P. A. no. 30, Performing Arts Archives, University of Minnesota Libraries–Twin Cities. Although the scrapbooks are not paginated and generally lack citations, they provide an excellent chronological documentation of local theater for the years 1892–1928.

2 Glenn Hughes, *A History of the American Theatre, 1700–1950* (London: Samuel French, 1951), 321.

3 "Bill of the Play," L. N. Scott Scrapbooks, June 26, 1897. The quotation is from an article about the Veriscope film of the James J. Corbett–Robert Fitzsimmons heavyweight championship bout held in Carson City, Nevada, March 17, 1897. Although originally screened at the Metropolitan Theatre in June, the "two and a third miles of film" created an overnight sensation, and the film returned for a longer engagement the following January.

4 David Mayer, *Playing Out the Empire: Ben-Hur and Other Toga Plays and Films, 1883–1908* (Oxford: Clarendon, 1994), 193.

5 Allardyce Nicoll, John H. McDowell, and George R. Kernodle, trans., *The Renaissance Stage: Documents of Serlio, Sabbattini, and Furtenbach* (Coral Gables, Fla.: University of Miami Press, 1958), 111.

6 Richard D. Atlick, *The Shows of London* (Cambridge: Harvard University Press, 1978), 121.

7 Ralph G. Allen, "The Eidophusikon," *Theatre Design and Technology* 7 (December 1966): 12.

8 Helmut and Alison Gernsheim, *L. J. M. Daguerre, 1785–1851* (Cleveland: World Publishing, 1956), 8.

9 Theodore R. Davis, "How a Great Battle Panorama Is Made," *St. Nicholas* 14, no. 2 (December 1886): 99.

10 The popularity of panoramas during the first half of the nineteenth century is noted in Ralph Hyde, *Panoramania! The Art and Entertainment of the "All Embracing" View*, exh. cat. (London: Trefoil Publications for the Barbican Art Gallery, 1988), 58. The careful depiction of individual figures is noted in Davis, "Battle Panorama," 100.

11 Both quotations are from Davis, "Battle Panorama," 110.

12 "The Ascent of Mont Blanc," *Illustrated London News* 21 (December 25, 1852): 565. "Montblanciana" is described in Hyde, *Panoramania!* 133.

13 Thomas Moses, *My Diary* (unpublished ms., 1932), 29, John R. Rothgeb Papers, Theatre Arts Collection, Harry Ransom Research Center, University of Texas-Austin.

14 David F. Burg, *Chicago's White City of 1893* (Lexington: University of Kentucky Press, 1976), 228.

15 Quoted in Percy MacKaye, *Epoch: The Life of Steele MacKaye*, 2 vols. (New York: Boni and Liveright, 1927), 2: 346–47.

16 Ibid.

17 "The Maréorama," *Scientific American* 83 (September 29, 1900): 150. See also Emmanuelle Toulet, "Cinema Paris, 1900," *Persistence of Vision* 9 (1991): 10–36.

18 Leonard de Vries, ed., *Victorian Inventions* (New York: American Heritage, 1971), 126. This book is a collection of articles published between 1865 and 1900 in *Scientific American*, the French periodical *La Nature*, and the Dutch journal *De Natuu* in which the scientific developments of that period in the United States, France, and the Netherlands were discussed.

19 Adolphe Appia, *Music and the Art of the Theatre*, trans. Robert R. Corrigan and Mary Douglas Dirks (Coral Gables, Fla.: University of Miami Press, 1962), 25–26.

20 Hughes, *History of the American Theatre*, 381.

CHAPTER 5

IN ORDER:
FRAGMENTATION IN FILM AND
VAUDEVILLE

LEO CHARNEY

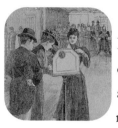Like cubism, jazz, and other forms of early twentieth-century culture, film and vaudeville were arts of fragmentation. As such, they arose from an international culture of urban modernity, succinctly described by the sociologist Georg Simmel in 1903 as "the rapid crowding of changing images, the sharp discontinuity in the grasp of a single glance, and the unexpectedness of onrushing impressions." Yet even as these media drew energy from this environment, they also strove, through their very status as constructed works, to bring order to that chaos—or at least to transfigure it into a more ordered and orderly experience. "This is not every-day life," Brett Page observed in his 1915 manual *Writing for Vaudeville*, "but . . . life as it would be if it were compactly ordered—life purposeful, and leading surely to an evident somewhere." The creators of these entertainment forms wanted to trade on the energetic disjunctiveness of modern life while corralling that potential disarray into more systematic means of expression.[1]

The popular arts of modernity, in other words, aspired to use the tools of modernity to achieve the very kind of predictable, organized effects that modernity's chaotic atmosphere seemed to weaken. Filmmakers and vaudeville artists hoped to arouse such strong physical responses as shock, fright, and laughter, but they also wanted to manage their materials so that those responses would ideally be reliable, predictable, and under the artist's control. Order, in both senses of the word, became the guiding structural principle of those working in both vaudeville and cinema: they wanted to keep things in order by putting them in order. Artists in the two media believed that they could achieve predictable responses from their audiences if they could find the optimal order in which to assemble their effects. Formal order would keep order among spectators, allowing them to respond as planned by the people who put the work together (even if those spectators did not realize it themselves).

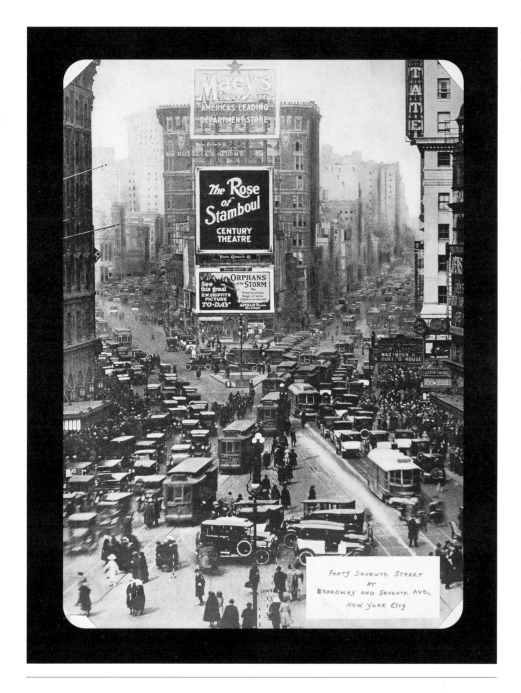

5.1 Times Square, New York, 1922. Silver gelatin print. Billy Rose Theatre Collection, The New York Public Library for the Performing Arts, Astor, Lenox, and Tilden Foundations

At the simplest level, the disjunctive forms of vaudeville and cinema reflected the tumultuous new society from which they emerged. As the critic Albert McLean, Jr., expressed this view, vaudeville "was born of social and economic pressures upon the masses and was nurtured by persistent anxieties. . . . Vaudeville sought to allay those common tensions among city-dwellers brought about by their crowded lives, by their worries over employment and scarcity, by the growing depersonalization of their occupations, and by the

5.2 Tony Pastor's Theatre, Fourteenth Street near Third Avenue, c. 1890. Silver gelatin print. The Byron Collection, Museum of the City of New York. Pastor, the "father of vaudeville," opened this theater near Union Square in 1881. It became one of New York's most popular vaudeville houses.

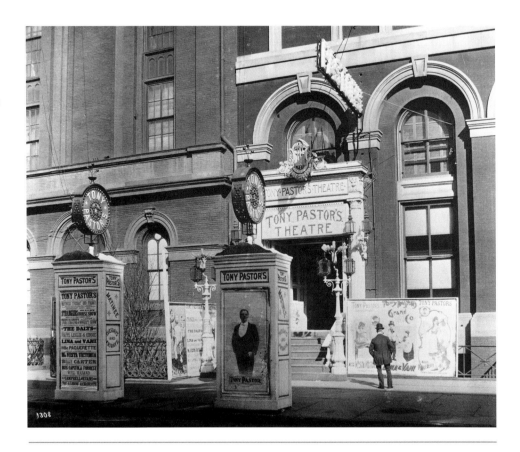

erosion of their simple moral values." The cultural historian Stephen Kern has written, along similar lines, that "cinema reproduced the mechanization, jerkiness, and rush of modern times." Although these links between the wider culture and its new entertainment media are surely significant, cinema and vaudeville can also never be said simply to have reflected their surrounding society, for they were first and foremost commodities, products for purchase. As such, their uses of fragmentation must be seen as highly conscious and primarily strategic, exercised in the service of selling a product that was engineered to be as attractive to consumers as possible. If vaudeville was, in McLean's words, "one means by which Americans came to terms with a crisis in culture," it was also, as a popular entertainment, a means of diverting people from that same sense of anxious crisis. This potential contradiction became, in practice, the engine of success for both vaudeville and cinema, as they could reflect the texture of the life around them while also offering a respite from it. This was their secret appeal, even if their surface attraction arose from humor or exciting imagery or the allure of chaos. They aspired to

find a means to reenact the kinetic sensations of urban life—the fun, exhila-rating, stimulating part of that life—while attracting audiences by assuaging its negative underside, its uncertainty and instability. They adopted familiar indicators of peoples' lives—above all, the style and flash of contemporary life—without the corresponding threats of economic dislocation, social alien-ation, or rapid cultural change. This canny maneuver allowed both media to sell themselves as stimulating yet familiar, drawing on the feeling of daily life while also offering a diversion from it. This strategic dual purpose marked the emerging outline, in vaudeville and cinema, of mass-culture entertainment as a unique twentieth-century form.[2]

In American culture of the early twentieth century, especially between 1910 and 1915, the evolving media of vaudeville and cinema figured in a wider cultural concern with order as a means of creating maximum regularity and predictability of results. The most influential person in this drive for rational efficiency was the industrial expert Frederick Winslow Taylor, whose studies established the principles by which new modes of industry and entertainment took shape in this period. Taylor began working on his models of factory efficiency in the 1880s, and their influence had been felt well before he pub-lished *The Principles of Scientific Management* in 1911. For Taylor, each part of the factory process had to be as streamlined and rational as possible, with

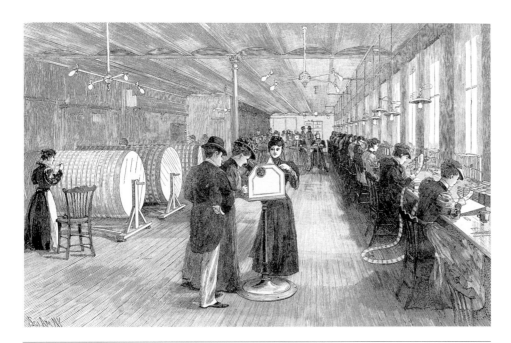

5.3 This illustration from Albert A. Hopkins's book *Magic: Stage Illusions and Scientific Diversions* (1898) depicts a moment during film produc-tion, with a Mutoscope viewing machine in the foreground.

such goals as "rigid rules for each motion of every man, and the perfection and standardization of all implements and working conditions." His views directly affected how both cinema and vaudeville organized themselves as businesses. Perhaps more important, vaudeville and cinema became modernity's emblematic entertainment media by turning the popular interest in order into forms that audiences could tangibly experience. As businesses, art forms, entertainments, and representations of a new mass culture, vaudeville and cinema could have it both ways, foregrounding the seductive allure of chaos while backing it up with formal control and organization.[3]

The first two decades of cinema's development in America, from its origins in the mid-1890s through the formalization of its conventions by around 1917, were marked by this evolving negotiation between fragmentation and order. Such pioneer American filmmakers as Edwin S. Porter and D. W. Griffith strove to find ways to tell coherent stories in a new medium that was intrinsically fragmentary. A motion picture is literally nothing more than an assemblage of pieces of film, discontinuous in both time (a movie story rarely plays out in continuous, "real" time) and space (a movie story rarely plays out in one shot with a moving camera in a continuous, "real" space). A unique language of film storytelling emerged in this period from the effort to impose an order, in both senses of the word, on these pieces of film, to transform them into something that cinema's new viewers could learn to interpret as a sequenced story. As the film historian Charles Musser has written about the problems of watching American movies before 1907, "If a story was unfamiliar and complicated, how was the spectator to know if the succeeding shot was backwards or forwards in time? The temporal/spatial and narrative relationships between different characters and lines of action were often vague, or worse—confusing."[4] The task of early filmmakers was clear-cut: to impose structure by creating a language that could put time, space, and story in a logical and comprehensible order for an audience.

The earliest motion pictures were mainly one-shot documents of single actions, sometimes real—such as Thomas Edison's 1903 short of an elephant being electrocuted, numerous shorts of trains in motion or crashing into each other, or shots of microscopic animals—or staged, as in skits, stories, or gags, often taken from vaudeville itself. The film historian Tom Gunning has called these early films "attractions" (a term borrowed from the Soviet filmmaker Sergei Eisenstein), contrasting them to the later development of a storytelling

cinema: "Rather than being [involved] with narrative action or empathy with character psychology," the viewer of attractions "does not get lost in a fictional world and its drama."[5] The film attraction resembled the vaudeville act more than it did the detailed stories that we associate with later cinema—and, in fact, these early films were often shown as part of vaudeville programs, mixed together with live routines.

Between 1907 and 1917 Porter and Griffith led the way toward a cinema that would allow viewers to understand the story's sequence in time and to piece together its order in space. The close-up was the most striking development in American films after 1908, allowing filmmakers to direct the viewer's attention to what they had defined in advance as the important parts of the story. This innovation, associated primarily with Griffith, enabled films to move beyond the melodramatic, gestural acting, derived from theater, that had characterized many earlier films. Close-ups provided a way to show emotion on an actor's face or focus on one detail of a story, and they gradually invoked a larger vocabulary of closer shots, longer shots, and medium-length shots. "The closer view," as the film historian Eileen Bowser has put it, "is an essential part of the new style that was to become the classical Hollywood cinema. It is only as it becomes part of a complex of varied camera positions that break up the spaces of a scene, or our viewpoint of a scene, that it joins this new narrative system." Close-ups, in other words, could be useful and meaningful only as a function of their order, their placement in relation to shots of other distances. The close-up's implicit command—"Pay special attention to this!"—works only as a contrast with shots that are farther from the action. Shots of varying distances made films more fragmentary, leading to complaints in trade journals and the popular press that movies were hard to follow. But with this increased fragmentation came increased control; the filmmaker could order the viewer's experience by coherently aligning the story's pieces, and the outcry over what one critic called "a total lack of uniformity" in a film's disparate elements only heightened the impulse to impose such order.[6]

As filmmakers struggled to make their films understandable to early movie audiences, they needed to master not just the film's space but also its time, the literal order in which the story played out on screen. This need led to the development of parallel editing, or crosscutting, through which a film could jump between two or more stories going on in different places at

roughly the same time. Here again, filmmakers traded increased fragmentation for increased control. "Through parallel editing," as Gunning puts it, "we sense the hand of the storyteller as he moves us from place to place, weaving a new continuity of narrative logic." Like close-ups, crosscutting helped to point the viewer's attention where the filmmaker wanted when he wanted. Cutting among actions in different places, and determining when to show each one of them, the director implicitly told the viewer, "This is what is important in this story." As Gunning notes, Griffith's primary innovation in developing parallel editing was interruption, aggressively breaking into actions before they were complete to show something going on somewhere else, so that the "pattern of the editing overrides the natural unfolding of the action." In this manner, the filmmaker actively directed the order in which stories played out in relation to each other; and crosscutting thus furthered the narrative control begun by close-ups. The "new continuity of narrative logic," to use Gunning's phrase, was not the continuity of events in real life but rather an artificial "continuity" of narrative devices. This system was eventually formalized into the devices of "continuity editing" that allowed films to expand to feature length in the classical Hollywood studio era.[7]

The vaudeville act, from which many of these filmic conventions evolved, presented an even more overt negotiation between order and diversity. "The underlying logic of the variety show," writes the media historian Henry Jenkins, "rested on the assumption that heterogeneous entertainment was essential to attract and satisfy a mass audience." Consequently, the vaudeville bill contained as broad a mix of elements as possible. As Jenkins describes it:

> The vaudeville program was constructed from modular units of diverse material, no more than twenty minutes in length each. These individual acts were juxtaposed together with an eye toward the creation of the highest possible degree of novelty and variety rather than toward the logical relationship between the various components of the program. Each act was conceived as a discrete unit that could be slotted into a customized program and play opposite many different acts in its career. The program as a whole offered no consistent message; individual acts might offer conflicting or competing messages. In the end, what vaudeville communicated was the pleasure of infinite diversity in infinite combinations.[8]

This potentially chaotic structure created two interlocking concerns for the effects of order: the order of jokes in an individual act and the order of routines in the theater's overall program. At both levels, the success of the act was often seen to rely on how well its bits were arranged. The "art of booking and managing a vaudeville house," in Jenkins's words, "was that of the selection, juxtaposition and coordination of preconceived units, not that of direction or creation." In this period when all developing industries stressed rationality and efficiency, the vaudeville manager became like Taylor's factory manager, putting parts together with maximum efficiency in the service of maximum regularity.[9]

The primary significance of imposing order to govern an audience's response came in the vaudeville act itself. Structural formulas made up much of Page's manual, *Writing for Vaudeville*. For example:

Let us say the tenth joke in the first routine reads better as the first joke. All right, place it in your new arrangement right after the introduction. Perhaps the fourteenth point or gag fits in well after the tenth gag—fine, make that fourteenth gag the second gag. . . . Your first arrangement can invariably be improved—maybe even your seventh arrangement can be made better; very good, by shuffling the cards you may make as many arrangements as you wish and eventually arrive at the ideal routine. . . . There are a few suggestions—a very few—that can be given here to aid the beginner. Like ocean waves, monologic laughs should come in threes and nines—proved, like most rules, by exceptions.[10]

These principles went hand in hand with Taylorist assumptions about the predictability and generality of human behavior. The underside of Taylor's precepts was that they could be achieved only by treating workers as cogs in a machine. He wrote admiringly, for instance, of a bricklaying efficiency expert who "developed the exact position which each of the feet of the bricklayer should occupy with relation to the wall, the mortar box, and the pile of bricks" and reported that "it was found necessary to measure the output of each girl as often as once every hour and send a teacher to each individual who was falling behind to find what was wrong, straighten her out, and encourage her and help her to catch up."[11] The impulse to instill order in a structural or manufacturing process quickly revealed itself to rely on the urge to impose order on human behavior itself—a link reinforced in this period by the

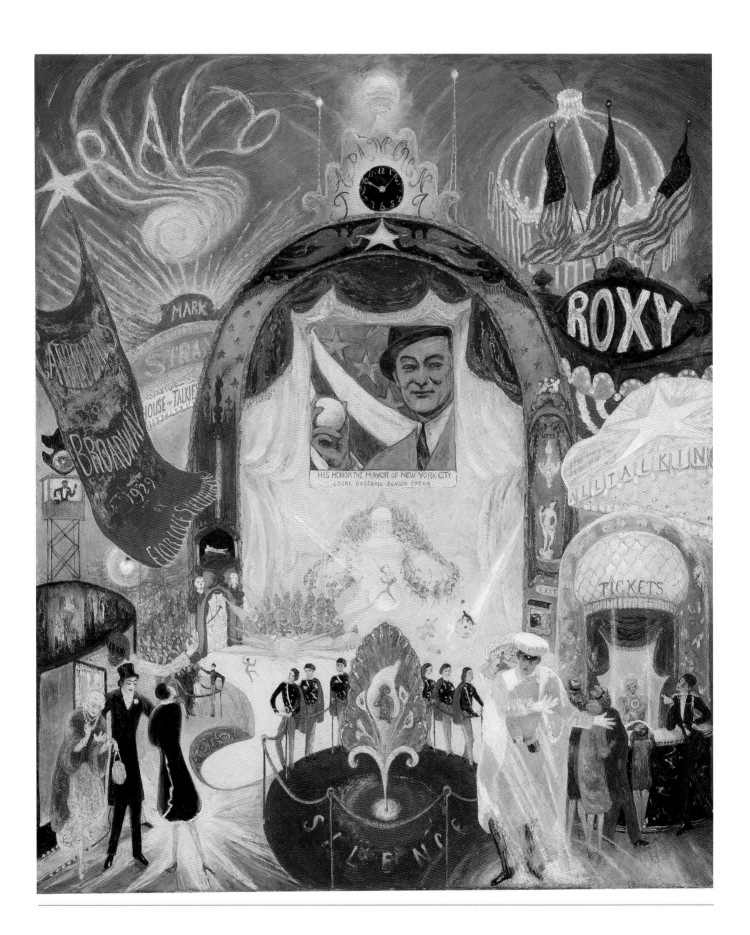

popular science of reflexology, which studied people's automatic responses to certain stimuli and how those responses could be calculated and regulated. (The most lingering example of a reflexology experiment remains that in which the leading Russian physiologist and research psychologist Ivan Pavlov used a bell to control the feeding expectations of dogs.)

In the context of vaudeville, the reflexological impulse was most explicitly expressed in a 1913 *McClure's Magazine* article by the theatrical producers George M. Cohan and George Jean Nathan. "The emotional lives of all men," they argued, "follow a fixed norm, precisely as do their physical lives. . . . If we are normal, we all cry at the same things, laugh at the same things, and are thrilled by the same things. . . . If produced at the right moment and with sufficient skill, they never fail to strike the audience in the midriff." Against this background, "the experienced playwright, in the quiet of his study, can figure out in advance precisely what constituents in his play will produce particular effects."[12]

The clashing frames of cinema and abrupt disjunctions of vaudeville, then, did not just re-evoke the sensations of modern life; more important, their creators aspired to use those jarring combinations to elicit physical responses from an audience. The vaudeville laugh was an abrupt, violent response to a stimulus—and that stimulus resulted, as in the cinematic effect, from the force of an unexpected juxtaposition. The joke's set-up prepared one expectation, the punch line delivered an unanticipated follow-up, and laughter arose from the shock of that combination. "By surprise," as Page put it in *Writing for Vaudeville*, "is meant leading the audience to believe the usual thing is going to happen, and 'springing' the unusual. . . . For instance; a meeting of two people, one of whom is anxious to avoid the other—a husband, for instance, creeping upstairs at three A.M. meeting his wife—or both anxious to avoid each other. . . . The laughter comes because of what is said at that particular moment in that particular situation."[13]

But what happens when these efforts to impose order fail to keep order? Page's manual reflects the influence of the period's scientific and pseudo-scientific efficiency and stimulus-response studies, yet even he must consistently admit exceptions and uncertainties. "But what is really the ideal arrangement of a monologue?" he asks. "Frankly, you cannot *know* until it has been tried out on an audience many, many times—and has been proved a success by actual test." Why bother, then, to lay out all this planning, when the certainty of the

5.4 Florine Stettheimer, *The Cathedrals of Broadway*, 1929. Oil on canvas, 60⅛ x 50⅛ in. (152.7 x 127.3 cm). The Metropolitan Museum of Art, New York, Gift of Ettie Stettheimer, 1953. Stettheimer celebrates the glitz and glamour of New York's picture palaces in their heyday.

5.5 Reginald Marsh, *A Paramount Picture*, 1934. Tempera on board mounted on Masonite, 36 x 28 in. (91.4 x 71.1 cm). Courtesy D. Wigmore Fine Art, Inc.

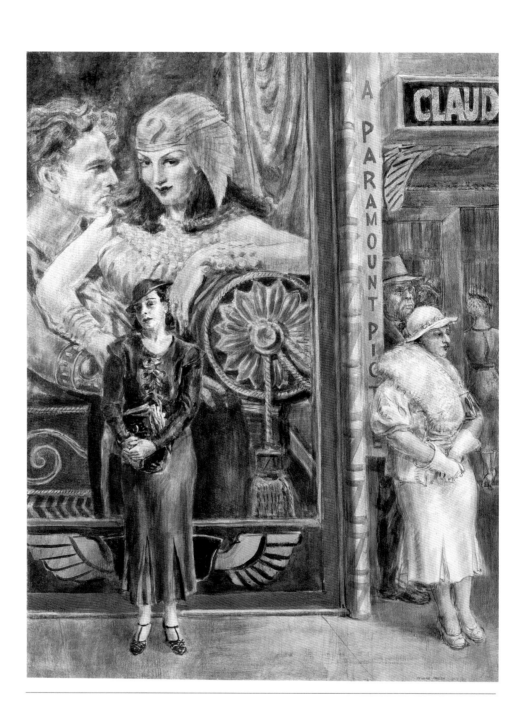

effects is compromised at every turn by the same unpredictability that the planning was designed to combat? Despite the rhetoric of precision characterizing these writings on vaudeville by Page, Cohan, and Nathan, the authors can offer only the *hope* of a predictable effect, an aspiration toward the soothing balm of a certain response. And this tentative possibility occurs always in the face of its potential to be undermined.

The language of the vaudeville writers, then, comes to seem less the technical voice of the efficiency expert than the hopeful voice of the advertiser, selling not so much vaudeville as the promise of stability itself. "A comedian in vaudeville . . . is like a salesman who has only fifteen minutes in which to make a sale," said the entertainer Eddie Cantor.[14] No less than advertisers hawking tonics, elixirs, or self-help remedies, vaudeville writers and performers offered order as a palliative for the rude shocks and unhappy unpredictability of daily life. Like any panacea, it could only fall short. But in vaudeville, the falling short was built into the system from the start. The appeal of vaudeville and cinema as new media and novel commodities arose from selling order while undermining it—or, to put it the other way around, selling the surface allure of disorder while offering a deeper, consoling structure.

For the early twentieth-century sociological critic Siegfried Kracauer, this reassertion of order over disorder represented early cinema's fall from grace. In urban movie theaters, he wrote, "the audience encounters itself; its own reality is revealed in the fragmented sequence of splendid sense impressions. Were this reality to remain hidden from the viewers, they could neither attack nor change it; its disclosure in distraction is therefore of *moral* significance." Yet in practice, this eye-opening revelation never arrives, because a movie's potentially anarchic fragmentation is in the end subordinated to conventional coherence, epitomized for Kracauer in the gaudily superficial decorations of movie theaters: "Distraction—which is meaningful only as improvisation, as a reflection of the uncontrolled anarchy of our world—is festooned with drapery and forced back into a unity that no longer exists. Rather than acknowledging the actual state of disintegration that such shows ought to represent, the movie theaters glue the pieces back together after the fact and present them as organic creations."[15]

In both vaudeville and cinema, the fragmentary quality of modern life became a *style*, a surface, a lure designed to draw customers to the product— as Kracauer emphasized by focusing on the glamour of movie theaters. But if

fragmentation is no longer fragmentary, can we continue calling it fragmentation, or does it become something else, something new? Perhaps Kracauer's reaction was less a hunger for more revolutionary entertainments than a nostalgia for simpler distinctions between order and disorder, distinctions that the environment, architecture, and entertainments of urban modernity insisted on complicating. In this period, fragmentation became, more than a means to an end, the show itself and the commodity itself.

Vaudeville and cinema offered coherence with a veneer of incoherence, laying a flashy, sexy surface disunity on top of the artwork's carefully planned structure. They both thus presented fragmentation as a show, a performance of discontinuity; their surface disunity resembled consumers' social experience, even as a deeper unity reassured consumers of an abiding order. Fragmentation became both what the media were displaying and what they were selling, and in this way vaudeville and cinema led the way for the many disorderly distractions of the century to come.

Notes

1 Georg Simmel, "The Metropolis and Mental Life," *The Sociology of Georg Simmel*, ed. and trans. Kurt H. Wolff (1903; rpt., New York: Free Press, 1950): 410; Brett Page, *Writing for Vaudeville* (Springfield, Mass.: Home Correspondence School, 1915), 190.

2 McLean, *American Vaudeville as Ritual*, 14–15, 3; Kern, *Culture of Time and Space*, 117. This peculiarly modern type of entertainment was embodied most explicitly by amusement parks. Usually located on the outskirts of cities, they offered a respite to city dwellers even while mirroring urban life's hurtling energies. On amusement parks and urban modernity, see Rabinovitz, *For the Love of Pleasure*, esp. chap. 5; Peiss, *Cheap Amusements*, esp. chap. 5; and John F. Kasson, *Amusing the Million: Coney Island at the Turn of the Century* (New York: Hill and Wang, 1978).

3 Frederick Winslow Taylor, *The Principles of Scientific Management* (New York: Harper, 1911), 71. On Taylor's influence and influences, see Martha Banta, *Taylored Lives: Narrative Productions in the Age of Taylor, Veblen, and Ford* (Chicago: University of Chicago Press, 1993); and Samuel Haber, *Efficiency and Uplift: Scientific Management in the Progressive Era, 1890–1920* (Chicago: University of Chicago Press, 1964). On Taylor's influence on the evolution of film studios and film production, see David Bordwell, Janet Staiger, and Kristin Thompson, *The Classical Hollywood Cinema: Film Style and Mode of Production to 1960* (New York: Columbia University Press, 1985), esp. 134.

4 Charles Musser, "The Nickelodeon Era Begins: Establishing the Framework for Hollywood's Mode of Representation," in Elsaesser, *Early Cinema*, 260.

5 On the phenomenon of train-crash movies, see Lynne Kirby, *Parallel Tracks: The Railroad and Silent Cinema* (Durham: Duke University Press, 1997), 57–63. Gunning, "An Aesthetic of Astonishment," 36. On attractions, also see Tom Gunning, "The Cinema of Attraction: Early Film, Its Spectator, and the Avant-Garde," in Elsaesser, *Early Cinema*, 56–62.

6 Bowser, *Transformation of Cinema*, 101. Chap. 6 of Bowser's work provides a detailed overview of the development of closer shots in American films of the period. The "lack of uniformity" complaint is aired in "The Factor of Uniformity," *Moving Picture World*, July 24, 1909, 116.

7 Although the terms *parallel editing* and *crosscutting* are often used interchangeably, Kristin Thompson has argued that *crosscutting* "moves between simultaneous events in widely separated locales," while parallel editing "differs in that the two events intercut are not simultaneous." *The Classical Hollywood Cinema*, 210. Tom Gunning, "Weaving a Narrative: Style and Economic Background in Griffith's Biograph Films," in Elsaesser, *Early Cinema*, 340–41. The most detailed overview of the techniques of continuity editing can be found in David Bordwell and Kristin Thompson, *Film Art: An Introduction*, 5th ed. (New York: McGraw Hill, 1997), 284–300.

8 Jenkins, *What Made Pistachio Nuts?* 63.

9 Ibid., 64.

10 Page, *Writing for Vaudeville*, 86–87.

11 Taylor, *Principles of Scientific Management*, 77, 94.

12 George M. Cohan and George J. Nathan, "The Mechanics of Emotion," *McClure's Magazine*, November 1913, 70–71.

13 Page, *Writing for Vaudeville*, 72.

14 Quoted in Mary B. Mullet, "We All Like the Medicine 'Doctor' Eddie Cantor Gives," *American Magazine*, July 1924, 34.

15 Siegfried Kracauer, "Cult of Distraction: On Berlin's Picture Palaces," in *The Mass Ornament: Weimar Essays*, trans. and ed. Thomas Y. Levin (Cambridge: Harvard University Press, 1995): 322–28. The essay originally appeared in *Frankfurter Zeitung*, March 4, 1926.

CHAPTER 6

CHARLES DEMUTH'S VAUDEVILLE WATERCOLORS AND THE RHYTHM AND SPECTACLE OF MODERN LIFE

LAURAL WEINTRAUB

Theater—as a source of amusement, artistic inspiration, and community—was central to the social and creative life of Charles Demuth (1883–1935) during the 1910s, when he produced his vaudeville watercolors. After returning from his second trip to Europe, in spring 1914, he divided his time between quiet Lancaster, Pennsylvania, and boisterous New York City. In Lancaster he stayed with his mother and attended vaudeville shows at the local Colonial Theatre. In New York he met with friends and associates and enjoyed various amusements. Like many in his New York circle, Demuth spent summers in the fishing town of Provincetown, Massachusetts, at the tip of Cape Cod, where an artists' colony had formed. He met the playwright Eugene O'Neill there during the summer of 1916, when the Provincetown Players—a group of writers and artists committed to staging new and experimental plays—first performed, and he became a peripheral member of that avant-garde group. Theater was to be an important point of reference in his work all through the 1920s, particularly in the paintings of contemporary Americans that he called "poster portraits," several of which pay tribute to stage personalities or allude symbolically to the world of theater.

One way to appreciate the novelty and originality of Demuth's vaudeville series of the mid- and late 1910s is to view it as a kind of prelude to the critical celebration of American popular culture that took place during the 1920s. Because Demuth himself made a small contribution to that celebration, a retrospective view is instructive. Like the influential critic Gilbert Seldes, who encouraged recognition and appreciation of what he called the nation's "lively arts," Demuth acknowledged the excellence of American musical theater in the early 1920s. He even wrote a playlet, "'You Must Come Over,' A Painting: A Play," which ostensibly was about American painting; however, one of its

two characters, "B.," preferred to discuss American musical shows and revues rather than the visual arts.[1]

When Demuth alluded to the vitality of American musical theater, he probably had at least partly in mind *Shuffle Along*, the all-black musical that was one of Broadway's most successful shows during the 1921–22 season. Its libretto was by Flournoy Miller, and it featured original songs by Eubie Blake and Noble Sissle, among them "I'm Just Wild About Harry." It also launched the careers of Josephine Baker and Paul Robeson, who were members of the chorus. For Seldes, *Shuffle Along* showcased the "barbarous rhythm" of dancers "with a sense of syncopation innate in them." He pointedly contrasted the rhythmic style of this musical with that of Florenz Ziegfeld's perennially popular *Follies*, a sensational revue that featured dazzling chorus girls in extravagant, synchronized dance numbers. The "serene smoothness of manoeuvre" that the choreographer Ned Wayburn created for Ziegfeld "[shrank] from the boards before the haphazard leaping of unstudied numbers" in *Shuffle Along*, Seldes maintained. In his view, "the colored cabaret in the theatre" was only "a diversion, a necessary and healthful variation from [the] norm." Seldes's opinion notwithstanding, *Shuffle Along* proved to have a profound influence on the evolution of musical comedy. As the dance historians Marshall and Jean Stearns contend, the form took on "a new and rhythmic life" after *Shuffle Along*, and chorus girls learned to dance to jazz.[2]

Paradoxically, both the mechanical rhythms of modern industry and the improvisational rhythms of jazz were manifested in the culture of modernity. The cultural historian John F. Kasson identifies a parallel between the rhythms associated with modern machine production and the synchronized dance numbers that delighted fans of 1930s Hollywood musicals. If those two developments are, in Kasson's phrase, "icons and rhythmic embodiments of modernity," then certainly jazz is another.[3]

Drawn by temperament to the stimulating world of popular amusement, Demuth captured in his vaudeville watercolors the diverse rhythmic patterns of modern life, the predictable rhythms of machinery, and the inventive rhythms of jazz. He represented a variety of performers, including musicians, comedians, dancers, and acrobats. In such works as *In Vaudeville: Columbia* (1919, fig. 6.1), he depicts a topical subject: the trio here performs a patriotic tribute to the United States following World War I. In others, such as

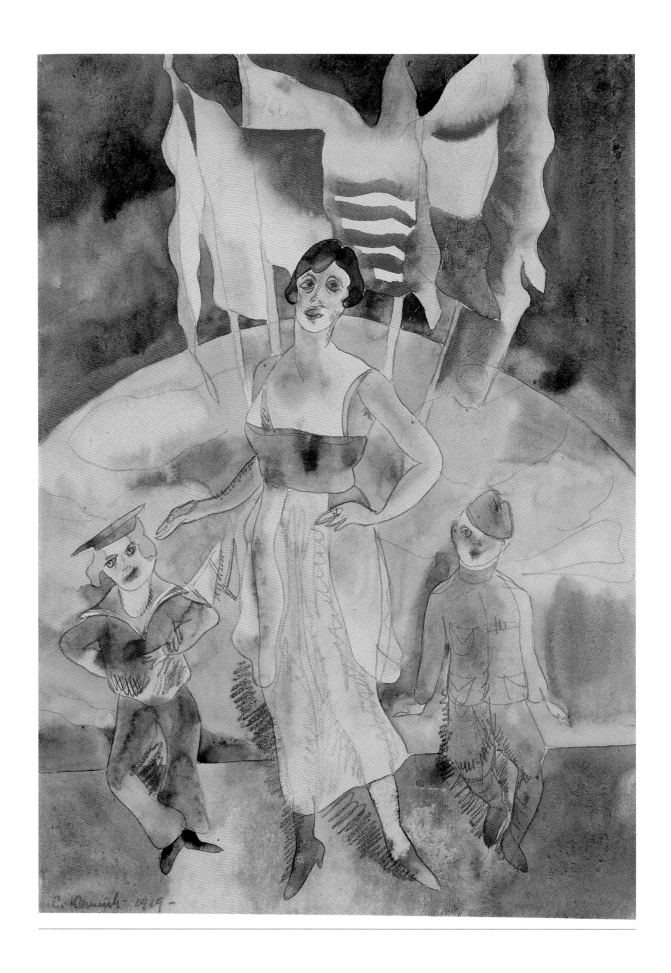

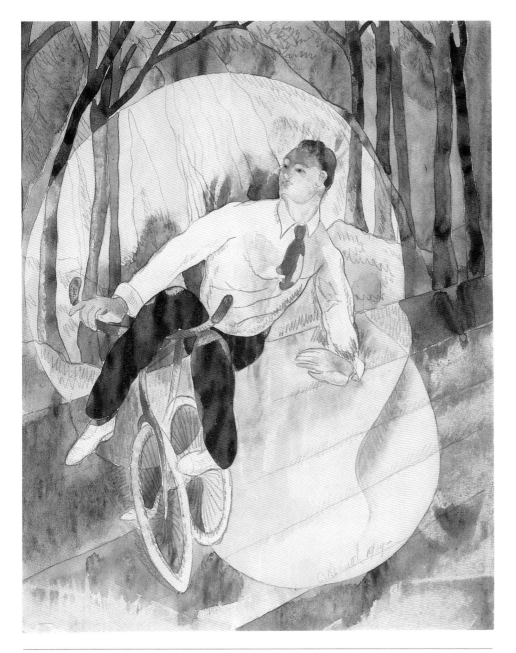

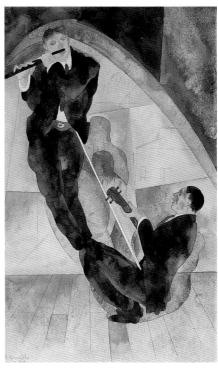

6.1 (opposite) Charles Demuth, *In Vaudeville: Columbia*, 1919. Watercolor and graphite, 11^{15}/$_{16}$ x 8 in. (30.3 x 20.3 cm). Columbus Museum of Art, Ohio, Gift of Ferdinand Howald

6.2 (above) Charles Demuth, *Vaudeville Musicians*, 1917. Watercolor and pencil, 13 x 8 in. (33 x 20.3 cm). The Museum of Modern Art, New York, Abby Aldrich Rockefeller Fund

6.3 Charles Demuth, *In Vaudeville: Bicycle Rider*, 1919. Watercolor and pencil on paper, 11 x 8 5/$_8$ in. (27.9 x 21.9 cm). The Corcoran Gallery of Art, Washington, D.C., Bequest of Mr. and Mrs. Francis Biddle

Vaudeville Musicians (1917, fig. 6.2), the specific performance serves as the launching point for his formal invention. The qualities of rhythm and movement are evident, above all, in his images of dancers and acrobats. These figures reflect a distinctly modern amalgam of rhythmic motion, with an alternating emphasis on machinelike precision and the expressive possibilities of jazz (fig. 6.3).

Some of the European modernists who came to New York in the early and mid-1910s, such as the French painters Albert Gleizes and Francis

Picabia, also recognized the expressive power of African-American music and dance and captured these art forms in their work. They regarded ragtime and early jazz as authentic manifestations of American culture. But until the so-called Jazz Age of the 1920s, most white audiences had only limited exposure to the idiom. Demuth was one of just a handful of artists active in New York in the 1910s who recognized the vitality of this form of music, which, though still largely an underground feature of the northern urban scene, had begun influencing popular culture and mores. Although he produced only a few watercolors depicting black entertainers, these works make up an essential adjunct to his vaudeville series because they reflect what was not readily seen yet often deeply felt in vaudeville: the rhythm of black music and dance.

Because Demuth tended to circumvent the norms of conventional society, he was open to experiencing and appreciating elements of contemporary entertainment that others might have either scorned or ignored. Marcel Duchamp, who was introduced to New York nightlife by Demuth in 1915, appreciated this aspect of his fellow artist: "It was fun to be with Demuth," he recalled in 1956, "because he didn't care where he was or belonged in the social scale." Demuth met Stuart Davis, another adventurer in the world of entertainment, in Provincetown in the summer of 1914. Davis had been depicting vaudeville and burlesque subjects since about 1910, when he began attending the painter Robert Henri's informal art school. More recently, he had been making images of the "Negro saloons" where he listened to music. The youthful Davis also frequented what he called "low dives" in Newark, New Jersey, to hear ragtime and jazz, and he often took friends along. Demuth apparently was inspired by Davis's example; soon after he began concentrating on vaudeville and related entertainment subjects, he produced several watercolors portraying black performers.[4]

With like-minded friends such as Davis and Duchamp, Demuth entered and explored the social world of black entertainers, a milieu that had intrigued certain curious members of white society since at least the turn of the century. He visited, and depicted in particular, the Marshall Hotel and Barron Wilkins's Café. Marshall's was a residential hostelry on New York's West Fifty-third Street; many prominent black theater people, including Will Marion Cook, J. Rosamund Johnson, Ada Overton Walker, George Walker, and Bert Williams, lived either there or in the vicinity. According to the Harlem cultural historian Jervis Anderson, Marshall's was where they all gathered "to eat, drink,

talk, and try out ideas for their work." Barron Wilkins's Café (originally called the Little Savoy) opened on West Thirty-fifth Street and later moved to Harlem. In 1948, looking back on his show business experience, Noble Sissle claimed that Wilkins's was, up until about 1908, "the most important spot where black musicians got acquainted with the wealthy New York clientele, who became the first patrons of their music." The place was popular, he said, because the proprietor kept an "open floor," allowing "anyone who had anything to offer worth while" to get up and do a number. The art critic Henry McBride expressed disgust at Demuth's choice of subject matter. Barron Wilkins's Café, which the New York police apparently shut down sometime before November 1917, must have been "revolting," he wrote. "Races of various colors intermingled, danced and drank there." Nevertheless, he held that Demuth was "entirely right" to have studied the place "in the interests of higher morality." (McBride himself made a commitment to such "interests" by acquiring Demuth's watercolor *The Jazz Singer* [1916, fig. 6.4] for his personal collection.)[5]

Negro Jazz Band (1916, fig. 6.5) is closely related to both *The Jazz Singer* and another watercolor (present location unknown) that was published in 1927 with the title *Marshall's*. All three works include a trio of musicians and prominently feature a female dancer. The one in *Negro Jazz Band* appears stationary, her feet planted firmly on the floor. The angle of her neck suggests she may be rotating her head, a typical movement in jazz dance; her raised shoulder may indicate a circling movement that is also common in jazz dance. The dancer—open, energetic, and angular—is the composition's focal point. Although there is nothing explicitly unrefined about Demuth's representation of this woman, the awkward-seeming position of her body and the suggestion of irregular movement hint at an absence of traditional grace. The subject might have been referred to as an "eccentric" dancer at the time when Demuth made the watercolor. The art critic Charles H. Caffin and his wife, Caroline, devoted a chapter of their book *Dancing and Dancers of Today* (1912) to this type of entertainer. The most notable forms of eccentric dancing, wrote the Caffins, "are derived from the negro of the old slave days, the buck and wing, cakewalks and rag-times." They contended that "there is no attempt at beauty and grace" in these dances. Instead, they noted, there is agility, loose-jointed movement, awkward angularity, and genuine humor.[6]

Although African Americans had limited opportunities to perform in mainstream vaudeville, dances derived from their culture were much in

6.4 Charles Demuth, *The Jazz Singer*, 1916. Watercolor, 12 3/4 x 7 3/4 in. (32.4 x 19.7 cm). Private collection

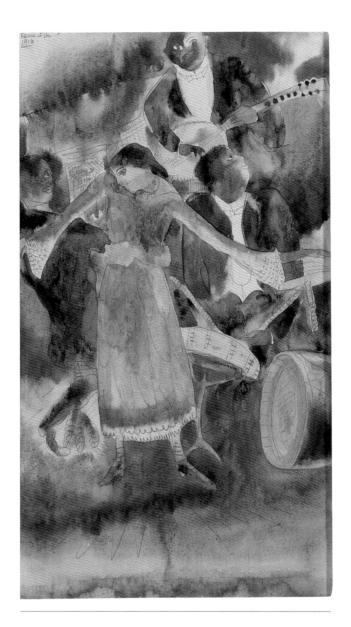

demand on the vaudeville stage. At the same time, elements of African-American music and movement were increasingly evident in contemporary social dancing. In his 1954 history of blacks in show business, Tom Fletcher noted that "dances that had hitherto been performed mainly in honky-tonks, dancehalls on the levee and in tenderloin districts began to be seen regularly in New York." Among the most popular new dances in 1914 was the Turkey Trot, which so scandalized the Vatican that it issued an official disapproval. It also prompted the reigning ballroom-dancing stars Vernon and Irene Castle to proffer their "suggestions for correct dancing," an explicit response to the vogue for the Turkey Trot and other, similar dances: wriggling the shoulders, shaking the hips, twisting the body, flouncing the elbows, pumping the arms,

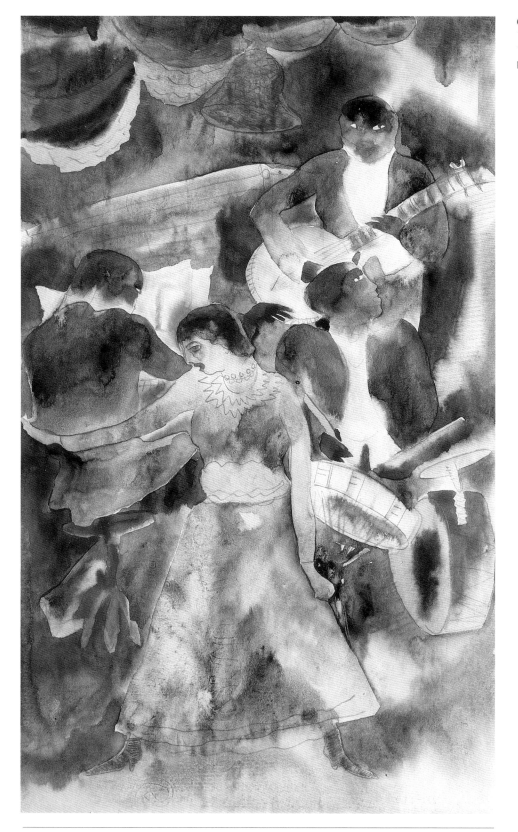

6.5 Charles Demuth, *Negro Jazz Band*, 1916. Watercolor on paper, 12⁷/₈ x 7⁷/₈ in. (32.7 x 20 cm). Dr. and Mrs. Irwin Goldstein

and hopping, they asserted, were unacceptable. The type of dancing to which Demuth alludes in *Negro Jazz Band* would have been considered, at best, gauche and ungainly by many of the artist's contemporaries. Nonetheless, eccentric dancing, with its rotary hip movements, hops, shuffles, and even animal mimicry could, when distanced from its authentic African-American roots, survive and even flourish in vaudeville. The exaggerated gestures of the male figure in Demuth's *In Vaudeville: Dancer with Chorus* (1918, fig. 6.6), for example, suggest the influence of this eccentric style.[7]

Demuth's acrobatic subjects, like his dance subjects, are animated reflections of the physical energy and rhythmic vitality of early twentieth-century popular entertainment. Moreover, his acrobats, like his eccentric dancers, represent what was generally considered lowbrow in vaudeville because of their traditional association with the circus. Never featured performers, they were instead either the first or the final act (the "chaser") on the bill, providing performances that did not tax attention while patrons were entering or exiting the theater. In his 1917 essay "The Twilight of the Acrobat," the artist Marsden Hartley expressed his suspicion and regret that the "so-called politeness" of vaudeville entailed the exclusion of acrobats. Hartley himself was a great fan of these undervalued performers and their "simple and unpretentious art." But given the wide-ranging audiences of American vaudeville, lowbrow factions were forced to compete with highbrow ones. As Seldes wrote, "The worst thing a vaudeville actor can say of an audience is 'They like the acrobats.'"[8]

For many observers sensitive to pictorial design, acrobatic performance represented a form of visual artistry. Hartley, making particular reference to the acrobats, famously referred to vaudeville as "a collection of good drawings." Caroline Caffin also noted the pictorial appeal of acrobatic performance in her 1914 book on vaudeville. Seldes, too, observed that acrobatics was interesting not only for the stunt performed in a given act but also "aesthetically for the picture formed while doing the trick." Certain acrobats—such as the Rath Brothers, who were known for their striking poses—apparently emphasized the compositional qualities of their acts. Demuth was clearly sensitive to the pictorial aspects of acrobatic performances; however, he tended to depict acrobats in motion rather than "posing acts" or stationary performers.[9]

Both *Two Acrobats* (1918, fig. 6.7) and *Acrobats* (1919, fig. 6.8) represent dynamic figures doing stunts that require physical strength, precise execution, and rhythmic coordination. In each case, a diagonal line separates stage and

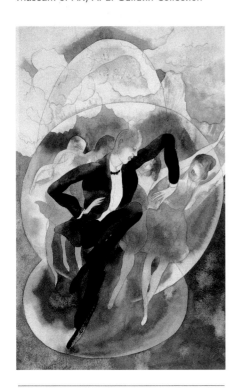

6.6 Charles Demuth, *In Vaudeville: Dancer with Chorus*, 1918. Watercolor on paper, 12³⁄₄ x 8 in. (32.4 x 20.3 cm). Philadelphia Museum of Art, A. E. Gallatin Collection

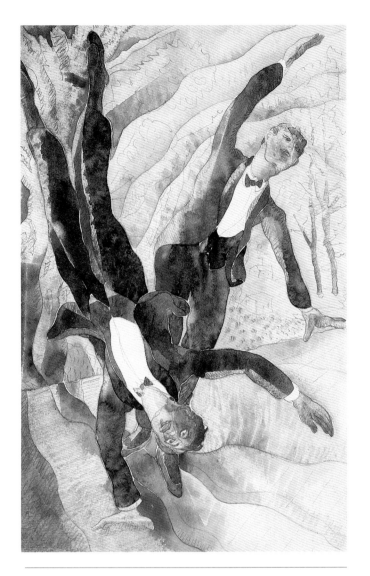

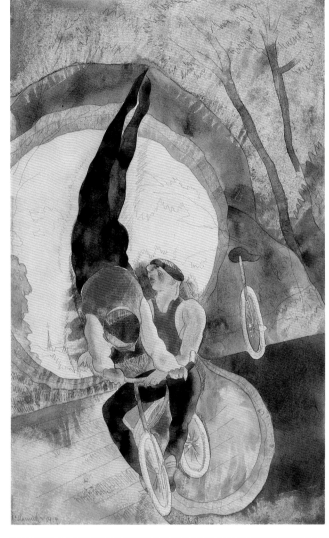

6.7 (above left) Charles Demuth, *Two Acrobats*, 1918. Watercolor and graphite on paper, 13 x 8 in. (33 x 20.3 cm). Walker Art Center, Minneapolis, Gift of Mrs. Edith Halpert, 1955

6.8 (above) Charles Demuth, *Acrobats*, 1919. Watercolor and pencil on paper, 13 x 7 7/8 in. (33 x 20 cm). The Museum of Modern Art, New York, Gift of Abby Aldrich Rockefeller

6.9 Arabian acrobats on roof of Hammerstein's Victoria Theatre, c. 1901–2. Silver gelatin print. The Byron Collection, Museum of the City of New York

backdrop, a compositional device that accentuates the dynamic character of the subject. The undulating contours of the figures suggest strength—in the muscular arms of the two acrobats performing the bicycle stunt—and sensual rhythm—in the repetition of the figures in evening attire in the pattern of light on the stage floor and set. Movement is emphasized in other ways in each composition. In *Two Acrobats*, the spotlight expands in a pattern of concentric circles, with the outline describing the arc traced by the body of the inverted figure. In *Acrobats*, the upright figure tumbles toward the right, and the inverted figure tumbles toward the left on a ground plane that appears to incline, exaggerating the momentum of their movement.

In Demuth's vaudeville watercolors and related works, dynamic figures, especially dancers and acrobats, reflect the rhythms that were beginning to animate popular theater in the latter half of the 1910s. The precise and mechanical rhythms of machinery as well as the syncopated and inventive ones of jazz are reflected in his images. In the 1920s these irrepressible rhythms—the contrasting cadences of modernity—became widely expressed in popular theater and deeply felt in American life. Because he was more receptive than many of his fellow artists to the stimulating, yet still marginal, climate of jazz, Demuth was able to capture in his work the prelude to this cultural development. He began the vaudeville series in 1915, the year that the critic and biographer Van Wyck Brooks published his seminal book *America's Coming of Age*, which advocated a new aesthetic tolerance, one that would accommodate lowbrow elements. In his watercolors of the 1910s, Charles Demuth often caught what was raw yet vital in vaudeville; he focused on the gritty realities that fans of vaudeville and musical theater were later to experience in a more integrated and polished form.

Notes

1 Charles Demuth, "'You Must Come Over,' A
 Painting: A Play," n.d. Ms. transcribed (and
 possibly emended) by Richard Weyand, in
 Richard Weyand Scrap Book, 1: 82–83 (loca-
 tion unknown); text included in Emily
 Farnham, "Charles Demuth: His Life,
 Psychology, and Works," Ph.D. diss., Ohio
 State University, 1959, 3: 929–31; and in
 Haskell, *Charles Demuth*, 41– 42.
2 Gilbert Seldes, "The Darktown Strutters on
 Broadway," *Vanity Fair* 19 (November 1922):
 67. Marshall Stearns and Jean Stearns, *Jazz
 Dance: The Story of American Vernacular Dance*
 (1968; rpt., New York: Schirmer, 1979), 139.
3 John F. Kasson, "Dances of the Machine in
 Early Twentieth-Century America," in
 Ludington, *Modern Mosaic*, 153.
4 Marcel Duchamp, interview by Emily Farnham,
 January 21, 1956, in Farnham, "Charles
 Demuth," 3: 974. See also Marcel Duchamp,
 "A Tribute to the Artist," in Andrew Carnduff
 Ritchie, *Charles Demuth*, exh. cat. (New York:
 Museum of Modern Art, 1950), 17. Davis
 once alluded to an outing he made with
 Demuth to a dissolute speakeasy in New York;
 he did not specify whether it was a black or a
 white establishment. See Stuart Davis, inter-
 view by Emily Farnham, January 20, 1956, in
 Farnham, "Charles Demuth," 3: 972.
5 For Marshall's Hotel, see Jim Haskins and
 N. R. Mitgang, *Mr. Bojangles: The Biography
 of Bill Robinson* (New York: William Morrow,
 1988), 48; and Jervis Anderson, *This Was
 Harlem: A Cultural Portrait, 1900 –1950* (New

York: Noonday, 1982), 31. The Sissle quota-
 tion is in "Show Business," *Age*, October 23,
 1948, as cited in Anderson, *This Was Harlem*,
 16. Henry McBride, "An Underground Search
 for Higher Moralities," *New York Sun*, Novem-
 ber 25, 1917. For more on Barron Wilkins's
 place, see James Weldon Johnson, *Black
 Manhattan* (New York: Atheneum, 1972),
 74–75. Johnson describes it as a "professional
 club," while pointing out that some honky-
 tonks and professional clubs were quite similar.
6 *Marshall's* was published in A. E. Gallatin, ed.
 Charles Demuth (New York: William Edwin
 Rudge, 1927), unpaginated. The Caffins'
 observations are in Caroline Caffin and
 Charles H. Caffin, *Dancing and Dancers of
 Today* (1912; rpt., New York: Da Capo, 1978),
 255–56.
7 Tom Fletcher, *100 Years of the Negro in Show
 Business* (New York: Burdge, 1954), 193,
 quoted in Stearns and Stearns, *Jazz Dance*,
 96. Vernon Castle and Irene Castle, *Modern
 Dancing* (1914; rpt., New York: Da Capo,
 1980), 177.
8 Hartley, "The Twilight of the Acrobat," in
 Adventures in the Arts, 158. The essay first
 appeared in *Seven Arts* 1 (January 1917). The
 remark about audiences who like acrobats
 is in [Gilbert Seldes], "The Rath Brothers in
 Silhouette," *Vanity Fair* 19 (January 1923): 56.
9 Marsden Hartley, "Vaudeville," in *Adventures
 in the Arts*, 168. The essay first appeared in
 Dial 68 (March 1920). Caffin, *Vaudeville*, 182.
 Gilbert Seldes, *The Seven Lively Arts* (New
 York: Harper and Brothers, 1924), 270.

CHAPTER 7

EDWARD HOPPER AND THE THEATER OF THE MIND: VISION, SPECTACLE, AND THE SPECTATOR

ROBERT SILBERMAN

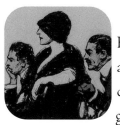Edward Hopper (1882–1967) objected to being described as an Ashcan school painter—and with good reason. He did study with Robert Henri, the unofficial leader of the group, and he did paint New York scenes. Yet he presents an alternative to the image of the city, and in particular its entertainments, offered by artists such as William Glackens and Everett Shinn, who delighted in the exuberant depiction of roof gardens and vaudeville shows. Hopper, like a figure in one of his works, always seems alone, artistically speaking, and this is nowhere so evident as in his theater paintings.[1]

In 1907 John Sloan, another major figure among the Ashcan artists and someone Hopper admired and even wrote about, painted *Movies, Five Cents*. It shows a full house, and members of the audience smile as they watch a couple kissing on the screen. In contrast, when Hopper painted *Solitary Figure in a Theatre* (c. 1902–4, fig. 7.1) a few years earlier he showed a figure in silhouette sitting alone in the front row, reading what is presumably the program. The stage curtain is down. Already in this small grisaille oil sketch, executed when the artist was only in his twenties, the hallmarks of Hopper's signature style are unmistakable: he creates a strong sense of isolation and introspection, using the theater not as a showcase of spectacle but as a backdrop for an interest in the spectator.

Hopper's distinctive approach to the theater is equally apparent when he shows an exterior. Sloan painted the outside of a movie house in *Movies* (1913), depicting the small theater front as a brilliantly lit attraction, a magnet drawing young and old alike to its exotic charms; the marquee announces the feature "A Romance of the Harem." In an early commercial illustration, *A Theater Entrance* (c. 1906–10, fig. 7.2), Hopper does show the outside of a theater as a place of sociability, with couples conversing and a figure moving

7.1 Edward Hopper, *Solitary Figure in a Theatre*, c. 1902–4. Oil on board, 12^{1}/$_{2}$ x 9^{3}/$_{16}$ in. (31.8 x 23.3 cm). Whitney Museum of American Art, New York, Josephine N. Hopper Bequest

smoothly up the stairs to the entrance. But that convivial tone is exactly what marks this as an early effort, not in keeping with his more characteristic work.

The only theater exterior Hopper executed during his mature period, *The Circle Theatre* (1936, fig. 7.3), shows the massive form looming over an all but deserted street under a subdued sky. A subway entrance largely obscures the marquee and entrance, and the two darkened lobby doors we can see indicate that the theater is not open for business. One of the most intense elements in the painting is the visual exclamation point presented by the red glow of a traffic light at the lower right. The theater is the nominal subject of the painting and its central presence, but it is incorporated into an ensemble of forms. Except for lively bits of signage that play across the facade, the mood of this cityscape has nothing in common with the energy and activity that Sloan, or a later painter such as Reginald Marsh, in his raucous *Twenty Cent Movie* (1936), associates with the social role of moviegoing and movie theaters in modern urban life.

Henri advised Hopper (and his other students) to go to the theater, and Hopper and his wife, Jo, were avid movie- and theatergoers. Hopper admitted, "When I don't feel in the mood for painting I go to the movies for a week or more. I go on a regular movie binge!" Apart from two important exceptions, *Girlie Show* (1941) and *The Two Comedians* (1965), his approach to movies, plays, and burlesque emphasized the spectators rather than the spectacle, psychology rather than performance. In *Girlie Show* a redheaded, big-bosomed stripper moves to center stage, holding her skirt in her hands so that it trails behind her like a streamer; for once the sexual, voyeuristic undercurrent in Hopper's work is made explicit. And in *The Two Comedians*, Hopper's bittersweet final painting (which Frank Sinatra owned), the artist and his wife are depicted as commedia dell'arte performers taking a bow—the only time he included himself and Jo together in one of his images. But Jo Hopper was the model for all the central female characters in his paintings, including the stripper. And Hopper himself was in a sense always the main character in his work, whether through a male surrogate or as the implied observer whose perception defines the scene.[2]

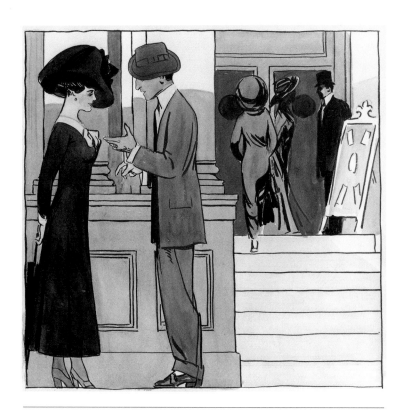

7.2 Edward Hopper, *A Theater Entrance*, c. 1906–10. Ink and watercolor on paper, 19 9/16 x 14 3/4 in. (49.7 x 37.5 cm). Whitney Museum of American Art, New York, Josephine N. Hopper Bequest

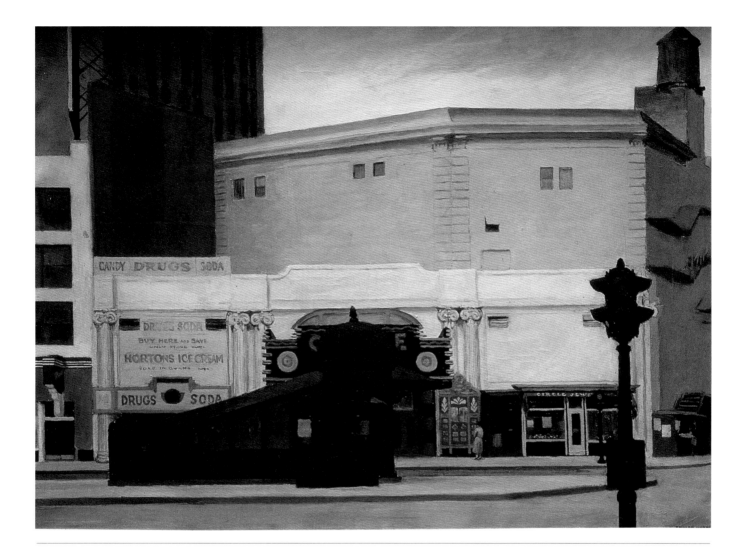

Hopper's paintings all suggest a fascination with drama. But their drama is not only a human one with human actors; it is also a drama of the mind, arising from the relationship between the observer and the world. It uses people and places, light and shadow, form and color, to establish a visual spectacle that is at once poetic in its emphasis on mood and philosophical in its reflexive concern with the act of seeing. Because Hopper is so engaged with the relationship between observer and observed, with the drama that is shown and the drama that is only suggested, his images of movies and theaters, though relatively few, occupy a special place in his work.

For Hopper, theaters are at once public and private. Like the diners, automats, cafeterias, and other restaurants that also figure prominently in his work, they are places where members of the lonely crowd can find refuge. Hopper wrote of a 1916 Sloan etching of the back room at McSorley's saloon

7.3 Edward Hopper, *The Circle Theatre*, 1936. Oil on canvas, 27 x 36 in. (68.6 x 91.4 cm). Private collection

ROBERT SILBERMAN

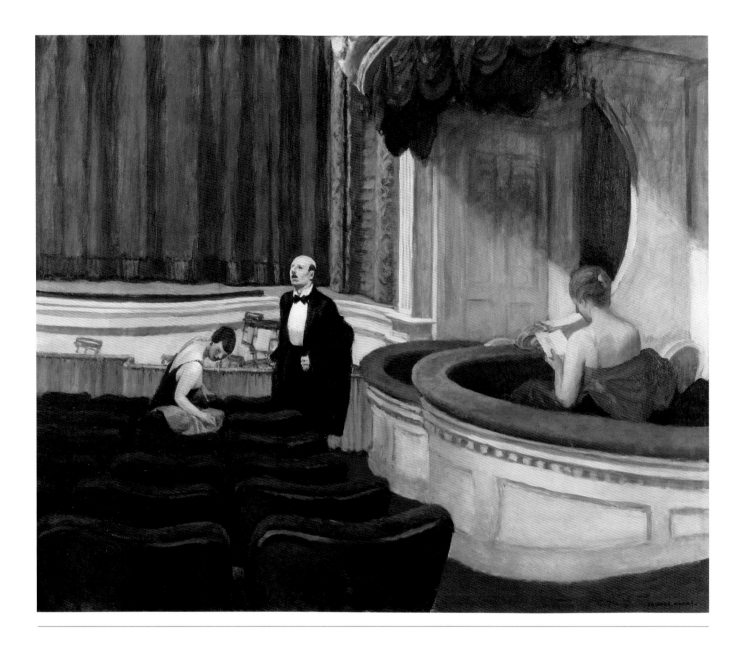

7.4 Edward Hopper, *Two on the Aisle*, 1927. Oil on canvas, 40 1/8 x 48 1/4 in. (101.9 x 122.6 cm). Toledo Museum of Art, Ohio, Purchased with funds from the Libbey Endowment, Gift of Edward Drummond Libbey

in New York that it captures "a brooding and silent interior in this vast city of ours." Hopper's theaters, though much larger interior spaces, convey the same sense of being sealed off from the outside world. He makes them appear as hushed realms that are closer to museums or libraries than places filled with music and speech. In his most famous theater painting, *New York Movie* (1939), the female usher is lost in her thoughts while the few individuals in the audience are lost in the image on the screen. This division within the painting indicates the central duality in Hopper's art, where individuals are usually characterized by either an outward look, which promises an escape

from self in visual spectacle, or a more inward, meditative gaze, which suggests an existential isolation.[3]

What is missing in either case is sociability and social interaction, expressions of a genuinely communal life. Of the mature theater paintings, *Two on the Aisle* (1927, fig. 7.4) and *First Row Orchestra* (1951, fig. 7.5) depict a pre-show moment of quiet, with early-bird couples taking their seats or waiting for the play to begin. With no grand anticipation, as might be the focus of a painting devoted to the moment when the curtain goes up, these images emphasize a subdued moment of expectation, just hinting at a transition, like *Shakespeare at Dusk* (1935), a painting of Central Park at sunset, or Hopper's many other cityscapes and landscapes set at dawn and dusk. But in Hopper's crepuscular vision nature is infused with color, whereas an image such as *Two on the Aisle* is as low-key in its hues as in its mood, with the dominant color, gray, enlivened only by some orange-red, gold, and green in the decor and women's clothing. Somber rather than satirical in the manner of Hopper's friend Guy Pène du Bois, *Two on the Aisle* still offers a bit of activity, with the couple being seated; and even *First Row Orchestra* presents two couples in the front row and two more individuals in the second row. *Intermission* (1963, fig. 7.6), however, a late work that appears as a companion piece and coda for the earlier works, hearkens back to *Solitary Figure*, executed more than a half-century earlier. It fixes not on the rising emotion before the play but on the stasis in the middle, with a theatergoer sitting alone in a first-row aisle seat, looking calmly at the stage. (A second figure appeared in a preparatory sketch but was not included in the painting.) There is no sense of people leaving for

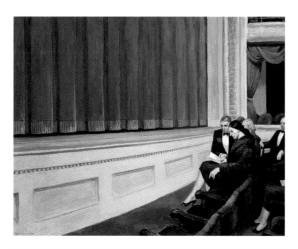

7.5 Edward Hopper, *First Row Orchestra*, 1951. Oil on canvas, 31 1/8 x 40 1/8 in. (79.1 x 101.9 cm). Hirshhorn Museum and Sculpture Garden, Smithsonian Institution, Washington, D.C., Gift of the Joseph H. Hirshhorn Foundation, 1966

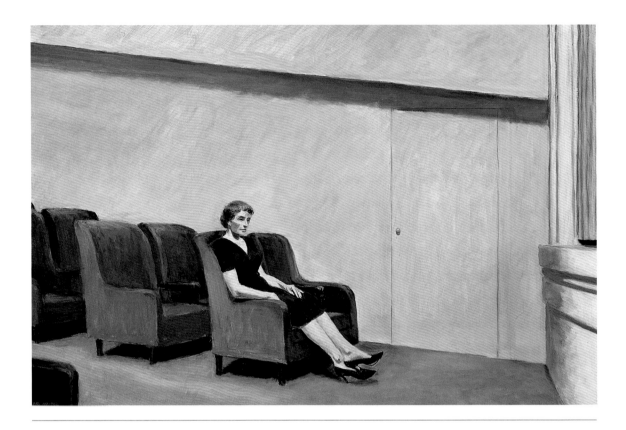

7.6 Edward Hopper, *Intermission*, 1963. Oil on canvas, 40 x 60 in. (101.6 x 152.4 cm). Private collection, courtesy Fraenkel Gallery, San Francisco

a burst of convivial chatter in the lobby or rushing back in for the next act—just a concentrated form of suspension.

The only person in *Intermission* is a typical Hopper figure, engaged in the prototypical Hopper activity: looking. *Two on the Aisle* and *First Row Orchestra* include women engaged in another characteristic Hopper activity, reading. The *Solitary Figure*, the woman in *Hotel Room* (1931) with her timetable, the woman in *Compartment C, Car 293* (1938) with her magazines, and many other Hopper figures are occupied with newspapers, books, or other reading materials. The reading in the theater paintings may be explicable as a preparatory act, a perusal of the playbill as background for the play, or maybe just as a means of whiling away some time. Yet the theater as depicted is not a place of shared experience, especially not shared pleasure of the kind so visible in the work of artists such as Shinn. In Hopper, the audience as a collective entity barely exists.

In *The Balcony* (1928, fig. 7.7; also known as *The Movies*), a drypoint from the pivotal period when Hopper's printmaking helped him develop his mature painting style, the artist exploits the steep diagonal of the stairs up in

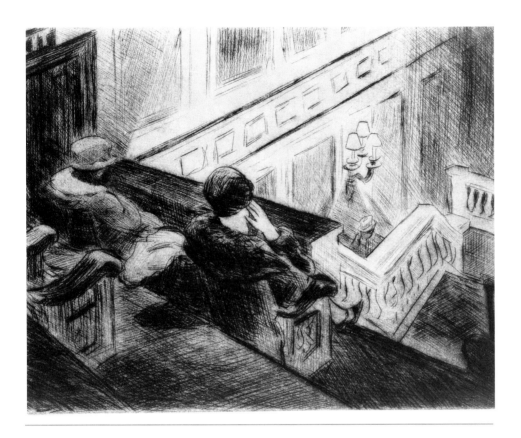

the balcony and depicts two seated spectators, with another making an exit below. But once again he does not show the object of their attention, the screen or stage; his focus is upon the spectators, not the spectacle, and on the architectural drama to be found in the vertiginous upper reaches of the theater. In *The Sheridan Theatre* (1937, fig. 7.8) the figures of three women are visible, but they are relatively small. Their faces are either turned away (the woman in the foreground) or indecipherable (the two women at left), and their body language is relatively uncommunicative. The women on the left appear to be chatting or lounging, passing the time. The painting depicts a dynamic, exotic space, with swooping balconies creating a Piranesian layered view and lighting fixtures that are weird glowing excrescences, so that the whole is suffused with a sense of strangeness as well as a sense of quiet fostered by the lack of activity. The stage—in this case, the screen at the front of the theater—is invisible.

The inwardness of many characters in Hopper's theater paintings and in his other works represents the painterly mode that the art historian Michael Fried has called "absorptive."[4] Fried pairs absorption with an antithesis that he

7.7 Edward Hopper, *The Balcony* or *The Movies*, 1928. Drypoint, 7⅞ x 9⅞ in. (20 x 25.1 cm). Philadelphia Museum of Art, The Harrison Fund

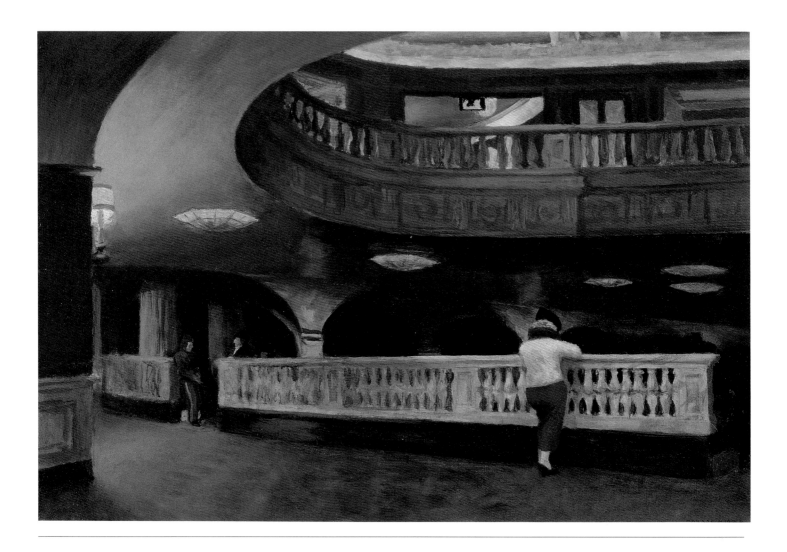

7.8 Edward Hopper, *The Sheridan Theatre*, 1937. Oil on canvas, 17 1/8 x 25 1/4 in. (43.5 x 64.1 cm). The Newark Museum, New Jersey

calls, significantly enough, "theatricality." *Western Motel* (1957, fig. 7.9) is one of the few Hopper paintings with theatricality in the Friedian sense, a direct acknowledgment of the viewer by the figure in the painting. The year before, in *Hotel Window*, he had painted a woman looking not at the viewer but out a hotel lobby window into the street. The woman in *Western Motel* has her back to the window as she faces the observer. Her expression is neither aggressive nor welcoming; it is clear-eyed and uninflected, and it recalls that of the nude in Edouard Manet's *Olympia* (1863), the classic instance of a female subject confronting the viewer, and a figure Hopper once copied in a sketchbook. This pointed theatricality prevents the viewer from being an unnoticed and unself-conscious voyeur and makes the painting a key demonstration of the significance of the act of looking within Hopper's art.

The gaze outward and the gaze inward are complementary and suggest a complex reflexivity underlying all of Hopper's theater paintings. It has become a commonplace in the literature about the artist to consider the significance of what is often called the theatrical and the cinematic aspects of his art. Those terms can encompass the influence of theater and film upon Hopper and the influence of Hopper upon theater and film, as well as the filmlike and theaterlike aspects of his work. Comparisons between Hopper's paintings and movie stills, and between Hopper and a stage director, have been especially popular, although like the broader relationships between Hopper, theater, and film, such comparisons are not always handled adequately. Questions of influence aside, one way to assess the importance of his theater paintings is to consider the representation of theater- and moviegoing as reflexive images of art. In that light, the parallel between the figures in the paintings and the viewers of the paintings reveals a fundamental ambivalence toward vision and visual display, whether theatrical or pictorial.[5]

In a situation where spectators should be absorbed in spectacle, Hopper's theatergoers are frequently shown with a less-than-outward gaze. Even when they are shown actively watching, the spectators often do not remain the focus of attention. In *New York Movie* (1939, fig. 7.10) the actual moviegoers are minor figures, scarcely more than silhouettes, while the usher, though standing off to one side, is awarded preeminence. The sliver of film screen on the

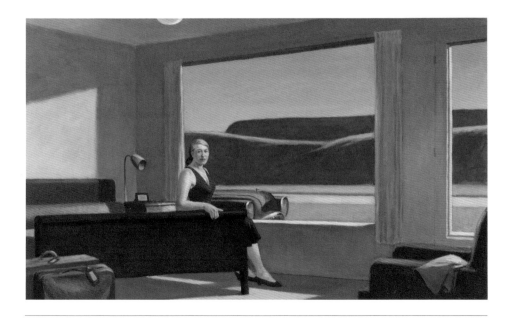

7.9 Edward Hopper, *Western Motel*, 1957. Oil on canvas, 30¹/₄ x 50¹/₈ in. (76.8 x 127.3 cm). Yale University Art Gallery, New Haven, Connecticut, Bequest of Stephen Carlton Clark, B.A. 1903

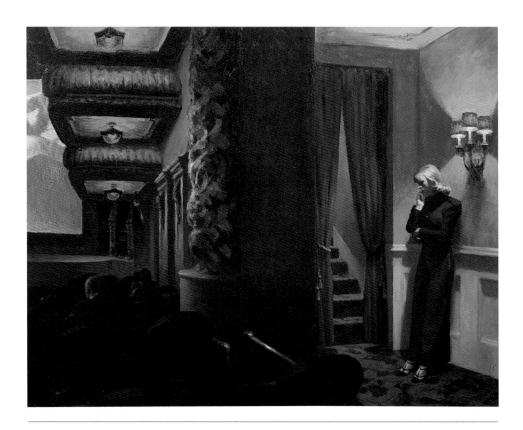

7.10 Edward Hopper, *New York Movie*, 1939. Oil on canvas, 32 1/4 x 40 1/8 in. (81.9 x 101.9 cm). The Museum of Modern Art, New York, Anonymous Gift

far-left edge of the painting reveals only a glimpse of some gray-and-white forms that are apparently snow-covered peaks. Such a bland, distant view is no match for the usher in her blue uniform with red piping, shown full-length, blond and pensive, in the illumination of the wall lamps above her and set off by the red curtains of the doorway to the balcony.[6]

Hopper's emphasis on the spectator rather than on the spectacle might be regarded as a subtle form of irony, like the photographer Henri Cartier-Bresson's tactic of focusing on the parade-watchers, not the parade. Here again, Hopper's early commercial illustrations present a model that is modified in his mature work. In contrast to the people in *Two on the Aisle* and *First Row Orchestra*, the figures in *At the Theater* (c. 1916–22, fig. 7.11) form a cohesive group and are entirely engaged in watching a performance. But as in so many other Hopper works, what they are looking at is outside the frame—an element he said he considered "very forcibly."[7] A standard element in many of his nontheater paintings is the figure looking at something beyond our field of vision. Our attention is on the individual, but his or her attention is aimed

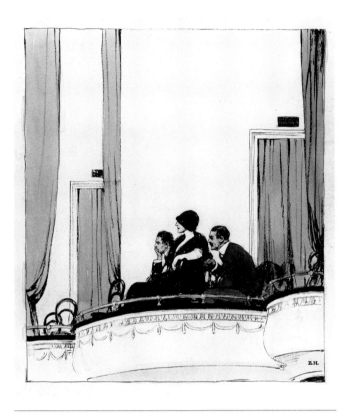

7.11 Edward Hopper, *At the Theater*, c. 1916–22. Wash and ink on paper, 18¹/₂ x 14⁷/₈ in. (47 x 37.8 cm). Whitney Museum of American Art, New York, Josephine N. Hopper Bequest

7.12 Edward Hopper, *Office in a Small City*, 1953. Oil on canvas, 28 x 40 in. (71.1 x 101.6 cm). The Metropolitan Museum of Art, New York, George A. Hearn Fund, 1953

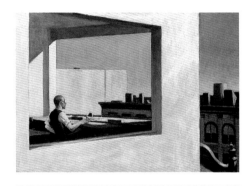

elsewhere. This redirection of attention is frequently from indoors to outdoors or from darkness to light. In *Pennsylvania Coal Town* (1947) a man raking in the front yard looks off toward the sun, which we cannot see. In *Office in a Small City* (1953, fig. 7.12) we look through one window at a man sitting at a desk looking out another window. In *People in the Sun* (1960), a small group of people seated in neatly arranged lawn chairs face the sun, except for one man who reads a book; here again, the sun is beyond the frame. They are not sunbathing in the usual manner, for they are fully clothed; they are, in effect, attending a nature theater. In such works the basic principle of the theater paintings holds true: whether outside in the theater of light and nature or inside in the theater of stages and screens, the act of looking is central, but it is governed by a principle of indirection and redirection. Hopper simultaneously draws us in and frustrates our desire to see what the figures in the image are looking at.

Hopper's paintings offer scenes without scenarios, introducing narratives full of suggestion but lacking explanation. His pictorial presentation relies on

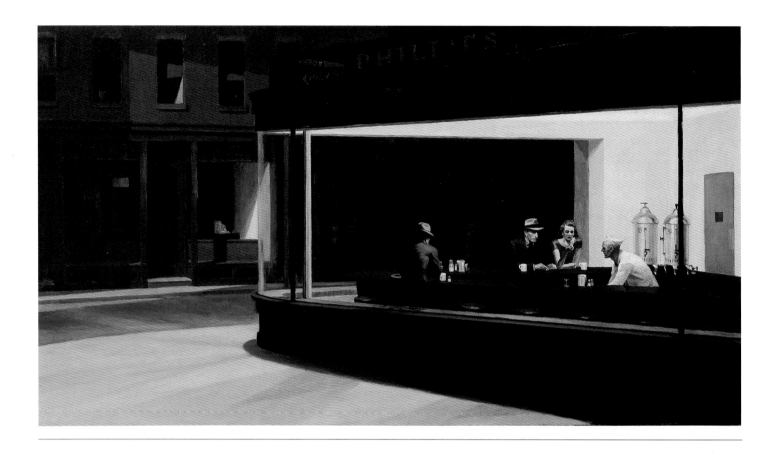

7.13 Edward Hopper, *Nighthawks*, 1942. Oil on canvas, 33⅛ x 60 in. (84.1 x 152.4 cm). The Art Institute of Chicago, Friends of American Art Collection

a fundamental device, the picture frame, to establish a boundary for the field of vision—much like a proscenium or the edge of a motion picture screen. In his own way, Hopper shares the general concern among modernists with framing devices. He emphasizes a variety of frames within the picture frame to control the visual, spatial, and psychological relationship between the observer and the observed. In *Nighthawks* (1942, fig. 7.13) the large expanse of the glass diner window opens up the scene to view, framing the group within, at once linking and separating interior from exterior. Instead of the invisible "fourth wall" that opens a proscenium stage to the view of the audience, we are given a glass window, a sign of urban modernity but, more important, a means of establishing, simultaneously, intimacy and detachment, visual clarity and physical distance. In *First Row Orchestra* and *Two on the Aisle*, as in *Solitary Figure*, the theater curtain is closed, sealing off the stage and forcing attention to the audience. By contrast, *New York Movie* is a divided image in which the screen is included, if only partially visible. That double movement, of opening and closing, inviting sight and blocking it, is a fundamental Hopper tactic. It is evident even in the landscapes and architectural paintings that contain no

humans. In *House by the Railroad* (1925), for example, the subject that is the center of attention is brightly illuminated on the outside, but its interior is sealed off, visually inaccessible.

The double vision in Hopper's art—of absorption and theatricality, closure and openness—reflects not two complementary attitudes toward the world but one. Hopper was no theoretician, although he was well read and his writings demonstrate great thoughtfulness. His major oils show him to be uninterested in straightforward mimesis (with the possible exception of *Early Sunday Morning* [1930], *Lighthouse at Two Lights* [1929], and some other architectural and landscape paintings). Instead, he combined observation with imagination and memory, the outward gaze and the inward look. His mature art is philosophical in that it is meditative, not historical or expansively narrative, not a record or re-creation of events. Unlike Constantine Guys, celebrated by Charles Baudelaire in a famous 1863 essay as the exemplary painter of modern life, Hopper is relatively uninterested in momentary, spontaneous actions, the passing scene, and the crowd. He is interested, rather, in a particular kind of inaction and a particular kind of poetry arising from the moments in nature and human behavior when time appears stretched out, suspended.[8]

The constant dialogue in Hopper's work between interior and exterior is a reflection of his central dilemma: how can art reconcile the claims of observation and introspection, vision and thought? The doorways and windows that provide openings for vision, and the deep perspectives that extend vision, like the rows of seats marching down toward the stage in the theater paintings, lead only to the closed theatrical curtains. The storefronts in his major cityscape *Early Sunday Morning* are, at once, the object of sight and a barrier halting any view of what lies behind the facade, while in several rural landscapes, such as *Road and Trees* (1962), a dark line of trees blocks any view of the horizon. At the center of his art is a fundamental ambivalence built upon the insurmountable separation between the seer and the seen, the self and the world. Yet by presenting images that suggest what might be called thoughtful looking, Hopper engages the viewer of his paintings in a drama for the eye that is also a drama of the mind.

Hopper's paintings are about the drama of seeing. The images of actual theaters are central to his engagement with the world, because his art is a visual one. The author Leonard Michaels, in a freewheeling meditation on Hopper and the movies entitled (after a line from Wallace Stevens) "The

Nothing That Is Not There," writes that Hopper's movie theaters are palaces of desire. Whether in the graphic directness of *Girlie Show* or in the more subtle allure of *New York Movie*, with its complex links between darkness, decor, the female figure, and the act of looking, the sexuality is unmistakable. Yet his erotics include not only the pleasures of sexuality but also the pleasures of seeing—and the limitations of seeing, the frustration of the desire to see all, the inadequacy of the visual. The gap between desire and satisfaction, the power of representation and the fact that it is based upon illusion and absence constitute the tragic side of what Michaels calls Hopper's "erotico-metaphysics." In *New York Movie*, the image being projected on the screen is like the shadows on the wall of the cave in Plato's *Republic*, a seductive image capable of attracting humans but not to be confused with the actual world. Thus Michaels writes of the "Byzantine phantasmagoria" of the movie palace, "where people go for a shot of desire and confuse it with life."[9]

Hopper did not confuse art with life. He knew that to see a painting of a woman was not to be in her physical presence. Yet he also knew that the power of art and the imagination to engage individuals is a real power. As the painter Eric Fischl has observed about *New York Movie*, Hopper speaks to "the duality of experience. . . . It's about the reality of fantasy and the fantasy of reality."[10] In *New York Movie*, the most complex of his theater paintings, Hopper depicts the theater as a dream palace. The combination of the inward daydreaming on the right (with the usher) and the outward look at a fantasy world on the left (with the movie audience) suggests a merging, so that the painting appears as an illustration of two forms of escapism. It is as if the image of the usher presents boredom and daydreaming simultaneously as the source of cinematic fantasy and a reaction to it. To paraphrase Goya, the sleep of reason breeds movies; movies and art arise from boredom, fantasy, projection. The gaze of the person viewing the painting completes the set of linkages, for the viewer is, like the moviegoers, visually involved with an artistic image, projecting him- or herself into it, and yet, like the usher, detached from it. The painting is at once a window and a mirror, opening up a view of the world and reflecting back the viewer's own position as an observer.

The German sociologist Georg Simmel, in his landmark essay on urban existence, "The Metropolis and Mental Life," argued that the psychology of the city is defined by "the intensification of . . . stimulation," a constant bombardment of sensation.[11] That is not Hopper's city, nor is it Hopper's world. Not

for him the electric splendor of Broadway, Times Square, or Coney Island. Not for him the energy of the crowd, whether rushing to work, jostling in a Lower East Side street market, or getting caught up in the ferocious intensity of a boxing arena. Vaudeville, burlesque, and the motion picture shows are the epitome of Simmel's urban experience, popular pleasures delivered with high spirits and high energy in a concentrated form. But Hopper's paintings offer an alternative view of the theater, the modern city, and modern life.

Hopper's art acknowledges the new emphasis on visual experience in urban culture that occurred during his lifetime, whether in the culture of consumption and shop-window display or in the development of movies as a new form of visual spectacle. His paintings emphasize the constant presentation of spectacle and appeal to spectatorship in theaters, in the theater of the street, and throughout the modern city. But the sidewalks in his paintings are not filled with window shoppers, and the theaters are not packed with people. Hopper's chosen moments and moods generally run counter to the excited celebration of urban culture and popular entertainments found in the work of many of his contemporaries. Yet his paintings offer not so much a reaction against modernity as a depiction of fundamental effects of modernity that are often experienced but not often represented: isolation, inwardness, and an ambivalence toward spectacle.

Edward Hopper's long career roughly coincided with the period that began with the rise of the movies at the turn of the twentieth century and ended with the dominance of television—a medium he never depicted—by the 1960s. The continuing popularity of his art can no doubt be explained in many ways. For some, it may go no deeper than a nostalgia for diners, movie palaces, and lighthouses. Hopper said that the greatness of art made Molière as modern as Ibsen. Perhaps now we must say that Hopper is as modern as Warhol or whichever contemporary artist has most recently gained notoriety by employing the most advanced "new media." For by concentrating on the psychological, even philosophical, aspects of theatergoing and the "erotico-metaphysics" of sight, Hopper fashioned a personal approach to the act of seeing that remains compelling in an age when Simmel's discussion has been updated in descriptions of contemporary existence as "a society of the spectacle" characterized by "a frenzy of the visible."[12]

Notes

1 Gail Levin, *Edward Hopper: An Intimate Biography* (New York: Knopf, 1995), 138. This is the standard biographical work, though unsatisfactory in its interpretation of the relationship between Edward and Jo Hopper. For Hopper's art, see Gail Levin, *Hopper: Catalogue Raisonné* (New York: Norton, in association with the Whitney Museum of American Art, 1995). See also Deborah Lyons, ed., *Edward Hopper: A Journal of His Work* (New York: Norton, in association with the Whitney Museum of American Art, 1997).

2 Hopper quotation from Levin, *Hopper: Art and Artist*, 58. On *Girlie Show*, see Vivien Green Fryd, "Edward Hopper's *Girlie Show*: Who Is the Silent Partner?" *American Art* 14, no. 2 (summer 2000): 52–75. On the notion of the implied observer, see Silberman, "Edward Hopper." Robert Hobbs, *Edward Hopper* (New York: Abrams, 1987), also discusses what he calls the implied or assumed observer. Fairman, "Landscape of Display," deals with John Sloan's work in relation to questions of spectacle and spectatorship but with an emphasis on commodity culture and people on display.

3 For Hopper on Sloan, see Edward Hopper, "John Sloan and the Philadelphians," *Arts* 11 (April 1927): 168–78, quotation on 174. For *New York Movie*, see Pamela N. Koob, *Edward Hopper's New York Movie*, exh. cat. (New York: Bertha and Karl Leubsdorf Art Gallery, Hunter College, 1998).

4 For Fried's argument, see Michael Fried, *Absorption and Theatricality: Painting and Beholder in the Age of Diderot* (Berkeley: University of California Press, 1980).

5 See, for example, Levin, "Edward Hopper"; Erika Doss, "Edward Hopper, *Nighthawks*, and *Film Noir*," *Post Script* 2, no. 2 (winter 1983): 14–36; and Bryan Robertson, "Hopper's Theater," *New York Review of Books*, December 16, 1971, 38–40. Brian O'Doherty, in what remains the finest text yet written on the artist, "Edward Hopper," in *American Masters: The Voice and the Myth in Modern Art* (New York: Dutton, 1974), remarks that "his best works appear like freeze-frames from a lifelong movie. Hopper's viewpoint, framing, and lighting frequently appropriate movie and theater conventions" (34). Others have been less suggestive and less precise, to my mind pushing the analogy between Hopper and a stage director beyond the breaking point, and not considering the relation between a movie still and a painting in a convincing fashion. I had not read the film scholar Lucy Fischer's "Savage Eye" until after the present essay was substantially completed. Her discussion of spectatorship, voyeurism, and moviegoing overlaps at some points with mine, but otherwise her comments have a different emphasis and perspective.

6 The identification as snow-covered peaks is from a Jo Hopper ledger entry in which she mentions "snowy mountain tips." Lyons, *Edward Hopper*, 50. Given the darkened theaters, grisaille might seem the perfect method. But obviously Hopper uses color. Certain colors, including red, are often sexual markers in his work—where sensuousness crosses into sensuality as in the peach or pink chemises worn by the women in *Night Windows* (1928), *Morning Sun* (1952), and *Excursion into Philosophy* (1959), the red nipples and hair in *Girlie Show*, the provocative red dress in *Carolina Morning* (1955), and the red curtains and "garnet" lighting fixtures (Jo Hopper's term) in *New York Movie*. Sometimes, of course, red is just red. Levin has made some important comments on the artist's debt to Degas (see especially Levin, "Edward Hopper"). But Hopper, after the c. 1904–6 painting of a group of musicians in an orchestra pit, rarely shows the onstage drama and, except for some sketches, never takes a backstage position. The perspective is that of an audience member. I suspect that just as Hopper thought it a bad idea to paint flowers, because the beauty was already in them and there was nothing to add, he was, with the exceptions noted, not interested in painting theater performances, as opposed to the other aspects of the theatrical experience or the dramatic tableaux he depicted in nontheatrical settings.

7 Quoted in O'Doherty, "Edward Hopper," 34. There were other early variations on this same motif: in an ink sketch of a woman with opera glasses from 1899; in a cover for the March 1921 issue of *Tavern Topics* magazine that closely resembles *At the Theater*; in an illustration study entitled *Ibsen* (c. 1900–1906), which



Of course, as a painter Hopper had a professional interest in observation. In that sense his spectator figures, whether in the theater, in an office or apartment looking out a window, or outdoors gazing into the sunlight, are all surrogates, caught up in the visual world. What is not shown, however, is any kind of direct or metaphorical representation of the artist engaged in painting, apart from a few watercolors that depict Jo at work, and the two theatrical exceptions mentioned above: *Girlie Show*, an image of art as self-exposure, and *The Two Comedians*, where the performance is over and what we see is the final bow, Hopper's farewell to art.

shows four people in a theater, including a
woman with opera glasses; and in a pencil-
and-wash work, *Ibsen: At the Theater* (c.
1900–1906), which features three people, a
couple looking toward the stage and a man in
the row behind them looking toward the viewer.

8 On the complex subject of Hopper's combina-
tion of observation, imagination, and memory,
the best interpretation remains O'Doherty,
"Edward Hopper." For Baudelaire on Guys, see
"The Painter of Modern Life," in Charles
Baudelaire, *The Painter of Modern Life and
Other Essays*, trans. and ed. Jonathan Mayne
(London: Phaidon, 1964), 1–40.

9 Leonard Michaels, "The Nothing That Is Not
There," in Deborah Lyons and Adam D.
Weinberg, *Edward Hopper and the American
Imagination*, ed. Julie Grau, exh. cat. (New
York: Whitney Museum of American Art, in
association with W. W. Norton, 1995), 1–8;
quotation on p. 2.

10 Quoted in Gail Levin, "Edward Hopper: His
Legacy for Artists," in Lyons and Weinberg,
*Edward Hopper and the American
Imagination*, 121.

11 Georg Simmel, "The Metropolis and Mental
Life," in *The Sociology of Georg Simmel*, ed.
and trans. Kurt H. Wolff (1903; rpt., New York:
Free Press, 1950), 410.

12 Michel de Certeau, *The Practice of Everyday
Life*, trans. Steven Rendall (Berkeley: University
of California Press, 1984), xxi; Guy Debord,
The Society of the Spectacle (Detroit: Red and
Black, 1977).

CHAPTER 8

EVERETT SHINN AND THE INTIMATE SPECTACLE OF VAUDEVILLE

SYLVIA YOUNT

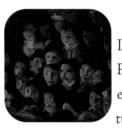In an 1899 article for *Scribner's Magazine*, Edwin Milton Royle aptly and amusingly characterized vaudeville as an essential element of America's vibrant new consumer culture: "The vaudeville theatre belongs to the era of the department store and the short story. It may be a kind of lunch-counter art, but then art is so vague and lunch is so real."[1] The contemporary interpretation of vaudeville as "real" entertainment suggests its particular appeal to a number of early twentieth-century modernists, from the Ashcan school (William Glackens, Robert Henri, George Luks, Everett Shinn, and John Sloan) to the Stieglitz circle (Charles Demuth), all of them inveterate theatergoers.

Although these artists showcased various aspects of the vaudeville experience in their work, none emphasized to the same degree as Shinn the sense of community that was forged through the intimate exchange between performer and spectator. A marked theatricality runs throughout the life and career of Everett Shinn (1876–1953), and his contribution to the Ashcan group lies in his portrayal of the city as "dramatic spectacle." In both pastel and oil depictions of the street and stage, he addressed the nature of public urban encounters and the possibilities for contact among disparate groups at the turn of the twentieth century. In this essay I examine Shinn's lifelong theatrical interests in light of his reputation as an urban realist. I also consider how the artist's fascination with the vaudeville audience in relation to the performer distinguished his art from that of his contemporaries.

As consumerism became the defining force in early twentieth-century urban America, a new concept of social life as role and performance emerged. Experiences of spectacle, or publicly consumed displays, permeated the marketplace in its various forms—namely, the press, the department store, and popular entertainment. Shinn's enthusiastic response to the urban spectacle encompassed all of these subjects, from fires (fig. 8.1) and street incidents (fig.

8.2) to shopping (fig. 8.3) and vaudeville. In these works, he employed dramatic and modern pictorial devices to cast common occurrences as street theater and to highlight the interchange between "performer" and "spectator." In effect, this relationship became the underlying subject of Shinn's art, which helps to explain its extraordinary appeal to his contemporaries.[2]

New York at the beginning of the twentieth century was characterized by its physical scale and social diversity. Such factors helped to create the potentially alienating, depersonalized effects of modernity bemoaned by such writers as the German sociologist Georg Simmel, while they forced urbanites to seek new sources of community. Increasingly, the consumer marketplace provided networks of social interaction as it fostered a common identity among the city's heterogeneous populations.[3]

Shinn's renderings of these new modes of urban experience in decidedly theatrical terms spoke to both specialized and general audiences who had come to associate social reality with spectacular artifice, a condition of modern times that privileged observation over direct involvement. Through his vaudeville images in particular, he explored the dynamic union of performer, artist, and viewer engaged in the acts of seeing, being seen, and "seeing to be seen" that constituted the ultimate urban game.

Shinn's experiences with popular entertainment were multifaceted. From his early student days at the Pennsylvania Academy of the Fine Arts, where he participated in the burlesques that were so popular with the Henri circle,

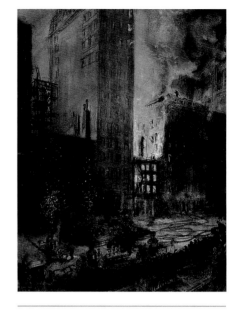

8.1 (above) Everett Shinn, *Fire on 24th Street*, 1907. Pastel on paper, 23¼ x 18 in. (59.1 x 45.7 cm). Cheekwood Museum of Art, Nashville, Tennessee

8.2 (below left) Everett Shinn, *Night Life, Accident*, 1908. Pastel, watercolor, and gouache on paper, 13 x 17¼ in. (33 x 43.8 cm). Private collection, courtesy of Guggenheim, Asher Associates, Inc.

8.3 Everett Shinn, *Window Shopping*, 1903. Pastel, 15 x 19 in. (38.1 x 48.3 cm). Private collection

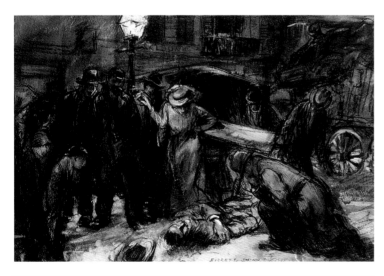

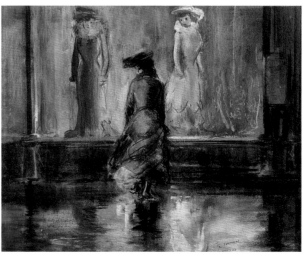

to his later move to New York, where he cofounded the Waverly Street Players (an amateur troupe comprised of Shinn, Glackens, and their wives, among others) and the first Little Theater in Greenwich Village, Shinn maintained an active interest in all aspects of the theater. His friendships with the actresses Julia Marlowe and Elsie de Wolfe, the playwright Clyde Fitch, and the impresario David Belasco (which led to a 1906 commission to paint eighteen decorative murals for Belasco's Stuyvesant Theatre on Broadway, now the Belasco Theatre) had a decisive impact on the young artist's career. Moreover, his absorption in the theatrical milieu eventually led to six years of work as an art director in New York's burgeoning motion picture industry. Hired by Goldwyn Pictures in 1917, Shinn moved on to Inspiration Pictures in 1920, ending his movie career, in 1923, at William Randolph Hearst's Cosmopolitan Pictures.[4]

Like his Ashcan colleagues, Shinn developed his dramatic aesthetic largely through early training as an artist-reporter. Adept at so-called memory-sketching, he conveyed the immediacy and excitement of this journalistic

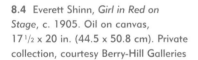

8.4 Everett Shinn, *Girl in Red on Stage*, c. 1905. Oil on canvas, 17 1/2 x 20 in. (44.5 x 50.8 cm). Private collection, courtesy Berry-Hill Galleries

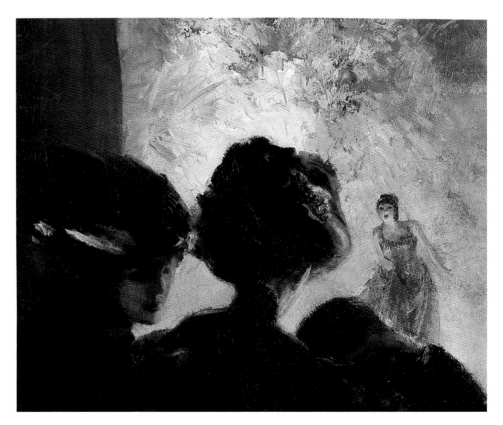

style, which paralleled the rapid pace of urban life, through an agitated line of graphic shorthand. Unlike Glackens and Sloan, he was more interested in capturing the overall effect of street life than with rendering individual characterizations and distinct narratives. Given his attention to artistic spontaneity in both style and content, it is not surprising that Shinn found pastel to be far more suitable than oil for depicting the frenetic character of urban happenings. Pastel became a transitional medium for the artist—as well as the vehicle for early celebrity—in his move from reportorial sketches, produced for newspapers and magazines, to paintings, intended for the art market. After 1903 Shinn's interpretation of the dramatic spectacle increasingly moved from its incarnation on the street to its realization on the stage. That he executed most of these scenes of urban amusements in oil rather than pastel suggests a rise in artistic ambitions as well as a desire to invest his depictions of urban fellowship with greater weight.

In 1900 Shinn had visited France and England, where he became acquainted with the *café-chantant* and cockney music hall images of Edgar Degas and Walter Sickert. These unconventional urban subjects may well have inspired Shinn's production of theater pictures, yet important distinctions exist between his work and that of his European predecessors.

Contemporary critics found affinities between Shinn and Degas, an artist whom Shinn greatly admired (while in Paris, he rented a studio across the street from Degas's Latin Quarter residence), in the use of pastel to chronicle modern entertainments as well as in the pictorial devices of unusual perspectives and vantage points. Yet the artists' emphases were different. Shinn underlined through formal means the subtle interactions between performer and audience that created a shared experience. Degas utilized the audience more as a compositional element, finding only detachment and isolation in the theater crowd.[5]

In a work like *Girl in Red on Stage* (c. 1905, fig. 8.4), probably inspired by Shinn's memories of French amusements, he explored the connection between a singer and two women spectators—boldly silhouetted against the glowing stage lights and freely painted backdrop—through an exchange of overt and implied glances, while introducing the viewer as a participant in the scene. Although the contrast between the monochromatic massing of the spectators and the colorful site of the staged attraction underscores the different roles of the participants within the theater, Shinn emphasized the

8.5 Everett Shinn, *Theatre Box*, 1906.
Oil on canvas, 16¹/₈ x 20¹/₈ in.
(41 x 51.1 cm). Albright-Knox Art
Gallery, Buffalo, New York, Gift of
T. Edward Hanley, 1937

8.6 Everett Shinn, *At the Hippodrome*,
c. 1900. Charcoal on paper, 14 x 20 in.
(35.6 x 50.8 cm). Private collection,
courtesy D. Wigmore Fine Art, Inc.

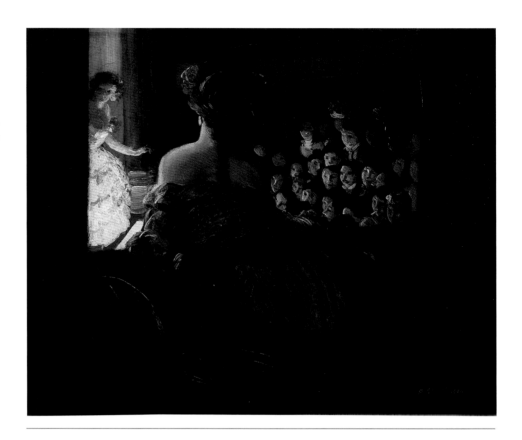

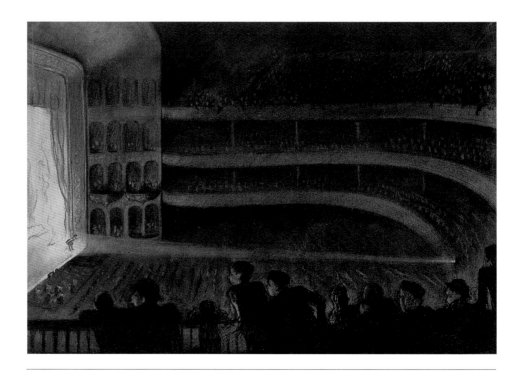

potential erasure of distance between the spectacle and its viewers through extreme spatial compression and asymmetrical cropping.

In *Theatre Box* (1906, fig. 8.5), one of eight dramatic "glimpses of stage life" featured two years later in the landmark exhibition of works by the group known as the Eight at New York's Macbeth Galleries—an exhibition that furthered the public identification of Shinn as an "insurgent modernist"—he employed a similar pictorial design to comment on the active role of the audience in the depicted spectacle and to highlight the intended intimacy of the theatrical experience. In effect, there are four lines of vision operating in this image: they belong to the stage performer; to the prominently placed woman patron; to the viewer, positioned behind her in the private box; and to the crowd of spectators gathered at the front of the house. The single seated figure seems to function as a reflection of the performer, suggesting their mutually desired personal contact and exchange. By compressing the interior space and framing the scene from the fragmentary perspective of the theater box rather than the proscenium, Shinn addressed the concentrated attentiveness associated with modern spectacle.[6]

This interest in the theme of audiences raptly observing and being observed is even more clearly articulated in two images of London's Hippodrome, the famous English circus cum music hall. *At the Hippodrome* (c. 1900, fig. 8.6), one of the artist's first theater scenes, showcases the sweep of the balconies, the grandeur of the stage, and the working-class men and boys in the upper gallery involved in watching the show. The presence of the artist-viewer is implied by the curious figure at right, who stares fixedly out of the composition. (Given the drawing's freshness and immediacy, it is likely that Shinn executed it on the spot.) The sole performer onstage seems inconsequential in relation to the vast audience, despite being dramatically spotlit by a beam that extends from the back of the theater. By reducing the "cube" of theatrical space to a fragmentary diagonal at the far left of the picture and expanding the arena of representation, Shinn emphasized the complete involvement of audience and actor.

Shinn produced the image for which he is best known, *The Hippodrome, London* (fig. 8.7), in New York in 1902, although he probably conceived it earlier, during his London stay. Here, in even more pronounced terms than in the drawing, he depicted the audience as the main performers in the spectacle. The trapeze artist, who shares the spotlight with the balcony dwellers and is

8.7 Everett Shinn, *The Hippodrome, London*, 1902. Oil on canvas, 26 3/8 x 35 3/16 in. (66.9 x 89.3 cm). The Art Institute of Chicago, Friends of American Art Collection, The Goodman Fund

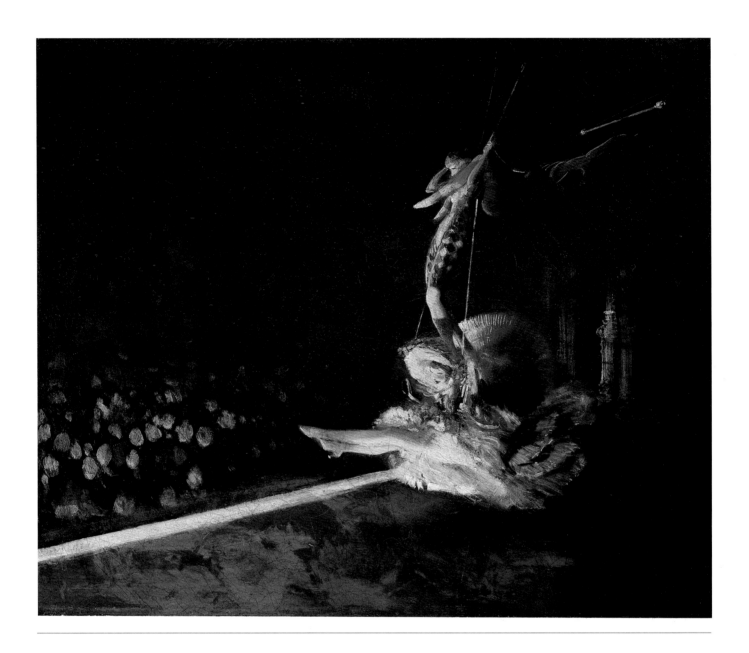

8.8 Everett Shinn, *Trapeze, Winter Garden*, 1903. Oil on canvas, 19¹/₂ x 23¹/₈ in. (49.5 x 58.7 cm). Private collection, Washington, D. C.

cleverly reflected by a mirror in the upper-center of the composition, seems to distract only a few faces, while the majority look down at the assumed larger gathering of theatergoers on the main floor, the unseen stage activity, or out at the artist-viewer. The visual dialogue of attention and distraction that forms the subject of the work suggests the multiple points of interest that constituted the modern spectacle. Shinn's lower vantage point implies that he, too, is less attracted to the "official" performance than to the diverse social texture of the spectators, many of whom vie for the viewer's attention.

Interestingly, in *Trapeze, Winter Garden* (1903, fig. 8.8), one of Shinn's New York vaudeville images, he reversed this vantage point and reduced the audience to mere dabs of paint, highlighting the energetic aerial act with vivid strokes of color. Yet by depicting the scene from stage left, Shinn trained his focus on the exchange between performer and spectator. Coupled with the authenticity of his urban subject matter, the artist's fragmentary glimpse, gestural and seemingly spontaneous handling of paint, uneven treatment of figures, and dramatic cropping in both works would have identified his imagery as modern to contemporary eyes.

Significantly, Shinn's Hippodrome images evoke the precedent of Walter Sickert, one of the leading exponents of English modernism. It was Sickert who, in the 1880s, first introduced "rough and tumble" music halls as a contemporary theme in British painting. His theater interiors range from Degas-inspired compositions in which the stage, orchestra pit, and audience are presented in sharply receding planes to representations that omit the stage and focus on the audience. Shinn, whose Hippodrome charcoal closely parallels the latter type of composition, may have become acquainted with his work while in Paris or earlier through certain progressive art publications that circulated in the States.[7]

Although Shinn continued to depict European entertainments on his return to New York, most of his theater imagery treats the distinctly American amusement of vaudeville. In effect, Shinn chose the novelty of vaudeville to explore the novelty of urban society as personified by the audience of the spectacle. The artist's numerous depictions of the popular entertainment suggest that it was inside the theater, more so than on the street, where he discovered the potential for cultural exchange within the city. Indeed, Shinn visualized the fluid social dynamic of modern life, in which private and public spheres frequently overlapped, through his acute attention to the intimacy and cohesion achieved in the vaudeville house.

All the New York theaters whose names Shinn included in his titles— Old Proctor's Fifth Avenue, Keith's New Union Square, the Olympic, the Winter Garden—were downtown vaudeville houses, as opposed to the more exclusive uptown Broadway venues, like Belasco's Stuyvesant Theatre. The Philadelphia art critic Helen Henderson, unlike many later observers, recognized this distinction in her review of Shinn's 1903 exhibition *Paris and New York Types* at M. Knoedler and Company in New York. Noting that it was the

artist's attention to the "artificial life of the folk at the cheaper theaters and concert halls" that made him "a modern of moderns," she was struck by Shinn's unusual approach to his stage subjects—"always from behind the scenes"— and by his emphasis on the audience in the images. "Of this novel view of the stage in its relation to the audience Mr. Shinn has made a special study," Henderson wrote.[8] Given that Shinn was an urban realist by inclination and reputation, his interest in vaudeville may be ascribed to the role it played in New York's turn-of-the-century consumer culture as well as to its authentically modern character.

Vaudeville emerged during the 1870s and 1880s as an important source of amusement for city dwellers. By 1905, according to some accounts, it had become the most popular form of entertainment in America, spreading from major urban centers to virtually every region in the country. By offering its varied audience a little of everything—from humorous skits and song-and-dance numbers to acrobatics, magic acts, and motion pictures—the vaudeville theater moved beyond its early promise of cheap thrills and immediate gratification to function as a vehicle for uniting divergent groups of city people and providing opportunities for communication and fellowship among pleasure-seeking strangers.[9]

As Robert W. Snyder notes in *The Voice of the City*, his cultural history of the entertainment, most turn-of-the-century Americans defined vaudeville as cleaned-up variety theater made tasteful for middle-class women, men, and children by shrewd entrepreneurs. One of the first showmen to promote "clean vaudeville" successfully was Tony Pastor. The relocation of his theater from the Bowery to Union Square in 1881 established him as New York's premier vaudeville impresario of the period.[10]

By ensuring that the ticket prices were high enough to keep out the "riffraff"—25 cents to $1.50—Pastor (and others who followed him, such as Frederick F. Proctor and B. F. Keith) sought to elevate vaudeville sufficiently to attract the middle class, while maintaining its appeal to the uneducated working class. As a result, the vaudeville theater established itself as one of the more egalitarian cultural institutions of the day. By the turn of the century, Pastor's polite vaudeville had taken hold in most theaters and become a popular family entertainment for members of the middle and working classes alike.[11]

Vaudeville's widely held appeal to contemporary visual artists and writers, including the apostle of American realism William Dean Howells, was par-

tially rooted in the "representations of life" it served to its audience.[12] It was in great measure this interrelationship of realism, mass consumerism, and spectacle that captivated Shinn's artistic sensibility. The novelty, variety, and speed of the "continuous" vaudeville performance, which echoed the tempo of modern urban life—as well as its particularly democratic aesthetic of visual economy, immediate sensation, and direct engagement (discussed in Robert C. Allen's essay in this book)—presented itself as an ideal subject for the artist's quick stroke.

Shinn responded to the variety of the vaudeville program by portraying both the big song-and-dance numbers as well as the "dumb" acts, those primarily silent routines that ranged from acrobatic and animal performances to magical illusionists, "living pictures," and puppetry. In *The Orchestra Pit, Old Proctor's Fifth Avenue Theatre* (c. 1906–7, fig. 8.10), Shinn presented the seventh act (note the placard at left) on a standard nine-act program. This was typically a top-billed sketch or a song-and-dance number that required the full stage. Taking a cue from Degas, Shinn depicted the performers—three women musicians and dancers—from the fragmented viewpoint of an orchestra member, or, more accurately, from the first row of the main-floor seats. The performers' gazes may be interpreted as being directed at the prominently positioned musician, at an unseen audience member, or at the viewer outside the picture itself. The beckoning look of the compressed dancer at right, whose bent posture emphasizes her direct appeal to the spectator and compels immediate attention, reveals how the strongest of Shinn's vaudeville images break through the proverbial "fourth wall" that separates audience from actor, bestowing on the viewer—both inside and outside the painting—a key role in the scene. This circularity of glances conveys the vital excitement that the act of looking created in the vaudeville house. Set within an architectural framework that allowed and even encouraged audience members to stare at one another, at the orchestra, and at the stage performer, vaudeville provided spectators with many different points of attraction.

The conflation of viewpoints in *Old Proctor's* suggests Shinn's fascination with the intimate relationship that existed between artist and audience in the vaudeville theater as well as the role of the pit orchestra in this important exchange. As Caroline Caffin wrote in *Vaudeville* (1914), one of the first book-length studies of the entertainment, "We must not forget the vaudeville orchestra, which does such gallant work in augmenting our delight in each

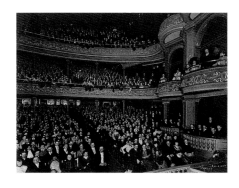

8.9 Ted Mark's Big Sunday Night Concert, American Theatre, New York, 1901–2. Silver gelatin print. The Byron Collection, Museum of the City of New York

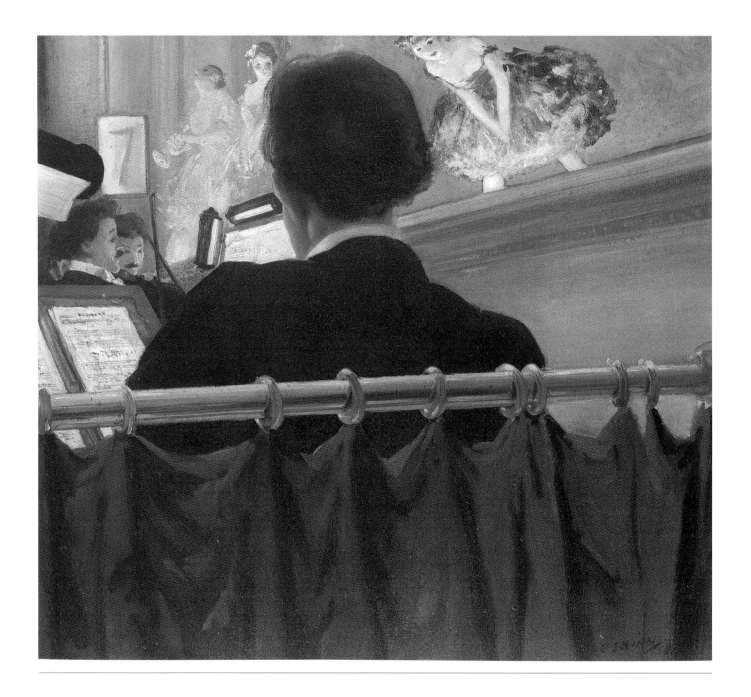

8.10 Everett Shinn, *The Orchestra Pit, Old Proctor's Fifth Avenue Theatre*, c. 1906–7. Oil on canvas, 17 7/16 x 19 1/2 in. (44.3 x 49.5 cm). Mr. and Mrs. Arthur G. Altschul, New York

and every one of the many turns." She observed that the conductor "will often be expected to join in some dialogue with the comedian or to interrupt some specialty, or 'fill in,' in one way or another, in the many efforts to bring actor and audience into personal relation."[13]

In *Concert Stage* (1905, fig. 8.11), Shinn utilized a similar compositional design to examine this three-way relationship but kept his primary focus on the performer, who returns the viewer's gaze. The depicted moment of atten-

tion and distraction suggests the beginning or end of a turn (note the implied arrival, or departure, of two spectators at left), in which the performer attempts in the space of a few minutes to connect with the audience, individually or collectively, while the orchestra plays. Shinn later described this picture as "my personality plus the forgotten vaudeville performer which inspired it," alluding to the connection between actor and artist, performer and spectator, that was central to vaudeville's popularity and so consistently visualized in his work.[14]

Shinn's attention to the vaudeville audience implies a keen understanding of its special role in the performance. As the drama critic Mary Cass Canfield observed at the time, "The audience becomes part of the show and enjoys it. And there is community art for you."[15] The "community art" of vaudeville dictated that performers speak and sing directly to the audience, enlisting it in the spectacle. In *The Monologist* (1910, fig. 8.12), Shinn highlighted this interplay by choosing a backstage vantage point, behind the comedian, and thereby inverting the conventional roles of performer and observer. The rapt attention of the audience suggests an investment in the spectacle that belies the brightly lit divide of the proscenium and recasts the spectator as the subject of the work.

8.11 Everett Shinn, *Concert Stage*, 1905. Oil on canvas, 16¹/₂ x 20 in. (41.9 x 50.8 cm). Norton Museum of Art, West Palm Beach, Florida, Bequest of R. H. Norton

8.12 Everett Shinn, *The Monologist*, 1910. Pastel on paper, 8¹/₄ x 11³/₄ in. (21 x 29.9 cm). Wichita Art Museum, Kansas, The Roland P. Murdock Collection

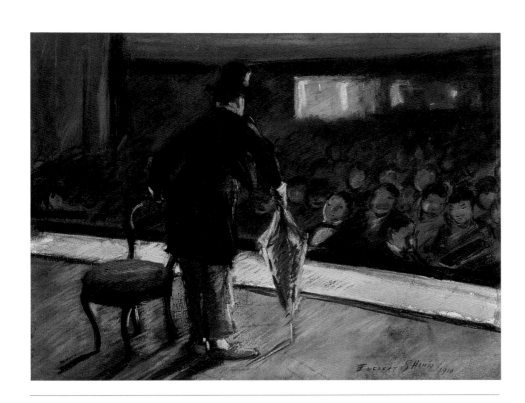

Caffin took a similar interest in the mutual relation between the spectator and the spectacle itself. Her shrewd observations focused on the active power of the vaudeville "consumer": "Vaudeville is *Your* show. It is there because it is what is wanted by the average of you. If you want it differently you only have to make the demand loud enough, large enough, persistent enough. For these figures you see on the stage are but a reflection of what you, the creator want. . . . More or less truly it throws upon its screen the current sentiment of the day. We cannot escape from its influence."[16]

Shinn distinguished his theater representations from those of his modern colleagues by emphasizing the intricate relationship between performance and observation that shaped the vaudeville experience and, in the process, captured the essence of the entertainment. Certain images of the period expressed the stately, almost iconic presence or spirited grace of individual performers. For example, in Henri's *Salome* (1909, fig. 8.13) and Demuth's *Acrobats* (1919, fig. 8.16) the spectator is implied rather than represented. Glackens's numerous depictions of vaudeville also differed from Shinn's. They tended either to be Degas-inspired distant views in which performer and audience were disconnected, such as *Hammerstein's Roof Garden* (c. 1901, fig. 8.17), or to be overtly narrative, such as *I'm so glad you found me. Oh, take me away!* (c. 1901, fig. 8.18), which illustrated the 1901 short story "A Vaudeville Turn" in *Scribner's Magazine.*[17] By contrast, Shinn eschewed narrative for spectacle in his vaudeville views, echoing and reinforcing the fractured, nonlinear nature of the entertainment.

Vaudeville, an institution that occupied a major place in early twentieth-century urban culture, offered Shinn an opportunity to explore through a modern pictorial syntax moments of animated display and communal understanding in a rapidly changing, often unintelligible world. That the intimate exchange between performer and spectator—and, in broader terms, between fine art and popular culture—which constituted Shinn's subject continues to resonate for us today attests to America's deeply rooted fascination with spectacle in its many forms.

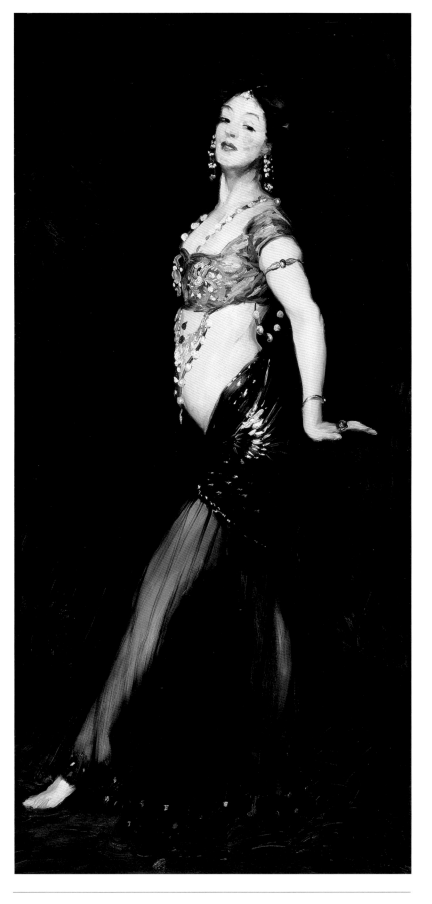

8.13 Robert Henri, *Salome*, 1909. Oil on canvas, 77½ x 37 in. (196.9 x 94 cm). The John and Mable Ringling Museum of Art, The State Art Museum of Florida, Museum purchase

8.14 Eva Tanguay, *New York Star*, May 8, 1909. Theatre Collection, Museum of the City of New York

8.15 Orval Hixon, *Portrait of Ruth St. Denis*, 1918. Silver gelatin print, 11 x 8½ in. (27.9 x 21.6 cm). Spencer Museum of Art, University of Kansas, Gift of Orval Hixon. Best known as a modern-dance pioneer and Martha Graham's teacher, St. Denis also worked as an exotic dancer in vaudeville.

8.16 (below) Charles Demuth, *Acrobats*, 1919. Watercolor and pencil on paper, 13 x 7 7/8 in. (33 x 20 cm). The Museum of Modern Art, New York, Gift of Abby Aldrich Rockefeller

8.17 (below center) William J. Glackens, *Hammerstein's Roof Garden*, c. 1901. Oil on canvas, 30 x 25 in. (76.2 x 63.5 cm). Whitney Museum of American Art, New York, Museum purchase

8.18 (below right) William J. Glackens, *I'm so glad you found me. Oh, take me away!* c. 1901. Charcoal, wash, and Chinese white on paper, 17 3/8 x 11 1/2 in. (44.1 x 29.2 cm). Prints and Photographs Division, Library of Congress

8.19 Everett Shinn, *Footlight Flirtation*, 1912. Oil on canvas, 29 1/2 x 36 1/2 in. (74.9 x 92.7 cm). Mr. and Mrs. Arthur G. Altschul, New York

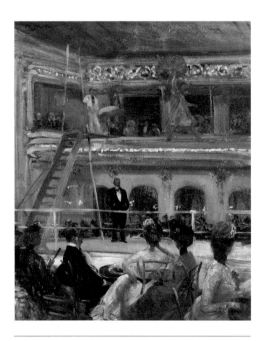

Notes

1 Edwin Milton Royle, "The Vaudeville Theatre," *Scribner's Magazine* 26 (October 1899): 495.

2 For an extended analysis of Shinn's oeuvre in terms of urban spectacle, see Yount, "Consuming Drama."

3 As the art historian Jonathan Crary has noted, following the argument of the French cultural theorist Guy Debord, spectacle became the "primary simulation of cohesion and unification within twentieth-century modernity." See Crary, *Suspensions of Perception*, 184.

4 DeShazo, *Everett Shinn*, 71–97, 113–19.

5 Writing in 1906, the critic and collector A. E. Gallatin referred to Shinn as one of the modern masters of pastel, noting that "he has learnt to see things from Degas' point of view." See Gallatin, "Studio-Talk," *International Studio* 30 (November 1906): 84–87.

6 "Insurgent modernist" was the term used by an unidentified critic, quoted by Ferber, "Stagestruck," 63. For more on the Macbeth Galleries exhibition that featured the work of the Eight, see Milroy, *Painters of a New Century*. For an analysis of the late nineteenth-century transformation in perception and attention that coincided with the rise of new forms of spectacle, see Crary, *Suspensions of Perception*.

7 For a discussion of Sickert in the context of culturally specific notions of modernity and modernism, see David Peters Corbett, "Seeing into Modernity: Walter Sickert's Music Hall Scenes, c. 1887–1907, and English Modernism," *Modernism/Modernity* 7, no. 2 (2000): 285–306. See also Wendy Baron, *Sickert* (London: Phaidon, 1973).

8 Helen W. Henderson, "Philadelphia Artists Exhibiting in New York," *Philadelphia North American*, March 11, 1903.

9 The New York journalist Hartley Davis claimed that vaudeville's golden age occurred between 1900 and 1920. See "In Vaudeville," *Everybody's Magazine* 13 (August 1905): 231–40, rpt. Stein, *American Vaudeville*, 97–106.

10 Snyder, *Voice of the City*, 17–25.

11 As Snyder has observed, Pastor succeeded by "taking vaudeville out of the Bowery without entirely taking the Bowery out of vaudeville" (ibid., 13). See also May, *Screening Out the Past*, 33.

12 Quoted in Stein, *American Vaudeville*, 77.

13 Caffin, *Vaudeville*, 92–94.

14 Everett Shinn to Ralph H. Norton, February 14, 1940, curatorial file, Norton Museum of Art, West Palm Beach, Fla. For a related discussion of other vaudeville imagery by Shinn and his Ashcan colleagues, see Snyder and Zurier, "Picturing the City," in Zurier, Snyder, and Mecklenburg, *Metropolitan Lives*, 157–63.

15 Mary Cass Canfield, "The Great American Art," *New Republic* 32 (November 22, 1922): 355.

16 Caffin, *Vaudeville*, 226.

17 Cyrus Townsend Brady, "A Vaudeville Turn," *Scribner's Magazine* 30 (September 1901): 351–55. Glackens was even better versed in the work of European modernists than his younger colleague Shinn. Thus it is not surprising that his *Scribner's* illustration closely parallels Sickert's earlier oil *Little Dot Hetherington at the Bedford Music Hall* (1888–89, private collection).

CHAPTER 9

CITY, STAGE, AND SCREEN:
JOHN SLOAN'S URBAN THEATER

REBECCA ZURIER

John Sloan's favorite view, from his eleventh-floor studio on Sixth Avenue in Greenwich Village, was not the panorama of the skyline but the activities of his neighbors on the rooftops below. He invited a visitor to look down from his studio window and explained: "It is all the world. Work, play, love, sorrow, vanity, the schoolgirl, the old mother, the thief, the truant, the harlot. I see them all down there without disguise. These wonderful roofs of New York bring to me all of humanity."[1]

Such images as *Red Kimono on the Roof* (fig. 9.1)—painted in 1912, the year Sloan moved to the Sixth Avenue studio—depict the rooftops as a stage where people perform unself-consciously for the artist's delight. A woman pinning up laundry from a basket is dressed in red with not-quite-matching high heels, almost in costume, unaware of the viewer's gaze yet naturally flamboyant. An admiring critic described the work as if the figure were a character performing a role and each object was a prop: "The very clothespin in her mouth is eloquent of her competent and rather saucy personality."[2]

These pictorial comparisons of strangers to actors and urban spaces to stage sets are typical for John Sloan (1871–1951), who depicted scenes from New York's streets and other city locales in hundreds of paintings, drawings, and prints in the early decades of the twentieth century. His vibrant images, rendered in an active line as if snatched from the flow of the streets, suggest pulsing human activity seen by a desiring eye. *Red Kimono* conveys some of the random aspects of lives observed in a modern city. The fleshy figure, feet firmly planted in her red shoes, anchors a composition that rushes off toward two vanishing points at once: the clotheslines and retaining walls along the roof appear to converge past the upper-right corner of the canvas, while a vista of roofs, water towers, and buildings extends to the left. The tilting rooftop is seen from a viewpoint, looking down from an upper-story window, that desta-

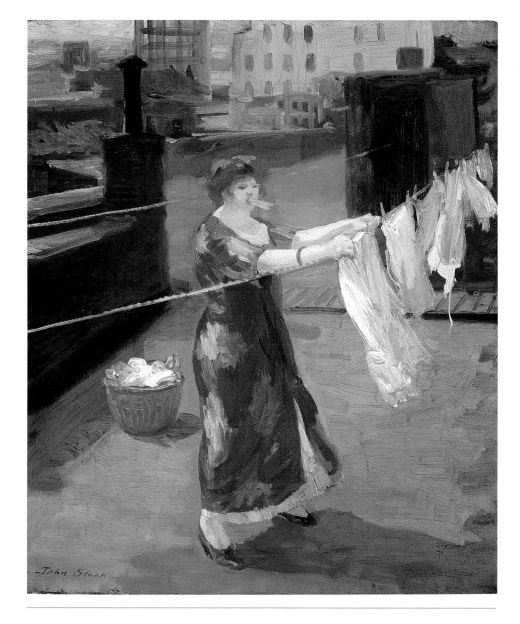

9.1 John Sloan, *Red Kimono on the Roof*, 1912. Oil on canvas, 24 x 20 in. (61 x 50.8 cm). Indianapolis Museum of Art, James E. Roberts Fund

bilizes New York City's foursquare grid.[3] Sloan's apparently hasty brushwork suggests a breeze in the air but also the rapid transcription of a casual, hurried observer of a city on the move.

Sloan is seldom considered a pioneer or modern artist. In fact, he is more often termed a romantic realist who sentimentalized or "euphemized" the shock of the early twentieth-century metropolis.[4] Yet his art offers insights into many of the predicaments of modern urban life, in which relationships were often determined by scopic impressions rather than firsthand knowledge; commerce redefined both culture and public space; women enjoyed new freedoms; and sensuality became more frank. Sloan's art positions viewers

looking out from a skyscraper, the back row of a movie theater, in the harsh light of a nighttime marquee—all viewpoints new to the twentieth century and defining emblems for its modernity. His brushwork itself brought to his subjects an intense presence quite distinct from the aestheticizing distance of earlier American impressionist paintings of urban subjects.

Sloan's images, however, are not modernist in the sense of the experiments in pictorial language that evoked the rapid, kaleidoscopic discontinuity of a vaudeville turn. Instead, they offer fresh versions of an impulse to narrate the city that continued from nineteenth-century realist literature and that later informed feature-length movies. They enact a complex back-and-forth between the modernist conception of the fragmented city and a desire to order that randomness, to find coherence amid the city's dynamic flux yet acknowledge that comprehension is only partial. In Sloan's rooftop or side-walk scenarios, temporary connections make momentary dramas amid strangers in the metropolis. They speak to the artist's own experience as a newcomer to the metropolis, as so many New Yorkers were in his day.

Depictions of people in theaters account for only a small part of Sloan's oeuvre, but the idea that urban public life itself had become a form of specta-cle resonates through most of his work.[5] Theatricality here is not solely a mat-ter of rapid-fire sensation and spectacular effects but rather an analogy for day-to-day interchanges in a city. The streets were his theater in which, the art implies, city dwellers participate as both actors and audience. The figure of the theatergoer becomes a stand-in for the urban spectator or for the artist him-self. Sloan's urban scenes thus contributed to the general discourse on specta-torship in everyday life at the turn of the twentieth century.

Sloan was himself an active theatergoer. The diaries he kept between 1906 and 1912 record visits to, and comments on, performances nearly every week. His tastes reveal a wide-ranging curiosity and indicate the cornucopia of entertainment on view in Manhattan at that time: from Annette Kellerman's diving act at Oscar Hammerstein's Victoria Roof Garden to Donizetti's *Lucia di Lammermoor* at the Gould Grand Opera House to five-cent movies. Sloan's viewing habits encompassed both the highbrow and the lowbrow, sometimes in conflict with each other. Although he wrote most appreciatively of finely acted drama, when left to his own devices (and a limited budget) he quickly repaired to one of the city's "cheap amusements." With tickets provided by col-leagues in the literary world, Sloan and his first wife, Dolly, attended musical

programs at Carnegie Hall and watched Isadora Duncan perform. ("She dances a symbol of human animal happiness as it should be, free from the unnatural trammels," he wrote ecstatically in 1909.) On special occasions, or with out-of-town guests, they went to plays, such as Arthur Schnitzler's *The Reckoning*. But more often they took in light comedies, such as Grace George in *Divorçons* and Maude Adams in *What Every Woman Knows*. With local friends, including the painter Robert Henri, they attended vaudeville or "variety shows." (He mentioned with pleasure a turn by the Scottish character actor Harry Lauder in 1907, as well as performances by Spanish dancers and aquatic displays.) And occasionally—when his wife was away—Sloan visited a "leg show" at Miner's Eighth Avenue burlesque theater, where his disapproval of the "pretty coarse" entertainment did not prevent him from paying a return visit.[6]

Most often the diaries mention movies, either at the large Keith's and Gane's theaters on Broadway or at several of the smaller theaters located in his neighborhood when he lived on Twenty-third Street between Sixth Avenue and Madison Square. In earlier days in Philadelphia, Sloan had written a review of one of the first silent movies, Thomas Edison's *The Kiss* (1896, fig. 9.2), for the little magazine *Chap Book*; he had been horrified by the "emphasized vulgarity" of such an inappropriate subject magnified and sustained on a screen. By the time he settled in New York, however, the films and his attitudes toward them had apparently changed. As with his theatergoing, Sloan's tastes in film oscillated between high and low. He noted with interest the so-called actuality films of a Mexican bullfight or the "cinematograph pictures" of the heavyweight boxer Jack Johnson's 1909 victory over Stanley Ketchel. "Wonderful to have this event repeated," he wrote. "Some day the government will wake up to the necessity of establishing a library of Biograph films as history." His highest praise was reserved for full-length French dramas: "Saw a very fine film, 'Tragedy of Meudon,' Pathé Frères Film d'Art," he noted in 1909. "A splendid production makes the American made film look silly and worse than amateurish by comparison. The pantomime acting done by the French is so much better." Although Sloan consistently dismissed American movies as banal, he watched them constantly. He would complain of seeing "several very stupid sets of films," but he sat through them all the same. In the years when he lived and worked on Twenty-third Street, "five cents worth of theatricals at our familiar 6th avenue picture show," or at one of several movie

9.2 *The Kiss*, 1896. Film Stills Archive, The Museum of Modern Art, New York

REBECCA ZURIER

9.3 John Sloan, *Movies, Five Cents*, 1907. Oil on canvas, 23 ¹/₂ x 31¹/₂ in. (59.7 x 80 cm). Private collection

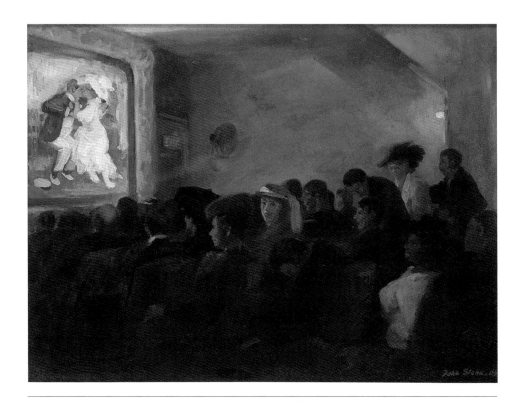

houses across the street from his apartment, became a regular part of his routine. His diaries made no apologies for the penchant: "Passed the wet evening being cheaply amused—15 cents each!"[7]

What drew Sloan to the movies? Spectacle, compelling stories, novelty, distraction, fine acting, the sheer visual pleasure of seeing images on the screen? The diaries are not very helpful on this score. Yet if the art he produced is any evidence, part of the appeal seems to have been in watching the audience. In Sloan's city paintings, theater and film offer a sanctioned and concentrated view into the drama that really interested him as both artist and urbanite: looking at people in cities. As in a novel with omniscient narration, the screen and proscenium remove any taint of voyeurism from the prospect of staring into, and speculating upon, the lives of strangers. Sloan's depictions of movies construct images that emphasize the human activity of the audience, as if the film itself should be of only minor interest to the viewer.

Movies, Five Cents (1907, fig. 9.3) shows a new urban space, the storefront nickelodeon. Sloan made it after several visits to a "five cent show of Kinematograph pictures on 6th Avenue. Think it might be a good thing to paint."[8] The canvas, rendered in muted tones, shows the hazy interior of a small, crowded theater. The foreground directs our attention not to the screen

but rather to the individual responses of audience members. Areas of more distinct brushwork reveal two people talking. A couple stand to make room for a woman entering late. Another woman smiles out at the viewer, while yet another touches her chest as if moved by the performance. Irrespective of the small projected image vaguely indicated in grisaille on the screen to the left, the painting suggests a sensual, bodily warmth generated by the audience united in the dark.

The painting dates from 1907, a particular juncture in the history of American cinema—before New York City police temporarily shut down all of Manhattan's theaters at the end of 1908, an action that was followed the next year by the establishment of the National Board of Review. Cheap downtown theaters were not yet governed by the middle-class codes of respectability that discouraged people from talking and moving about during performances, and only a few critics were expressing concern over the deleterious phenomenon of the "mass audience." Writers at that time debated whether the "nickel madness" was a mind-numbing hazard, a sweet escape, or a means to enlarge the horizons of naïve workers, especially for immigrants with little command of English who could readily enjoy silent movies. In an article on her visit to a theater in New York's Italian neighborhood near Bleecker and Carmine streets (the site of several of Sloan's paintings of movie theaters), the journalist and labor activist Mary Heaton Vorse remarked on how audience members conversed with each other as well as talked to the figures on the screen. She described the scene as a communal rite, similar to gatherings she had observed in Tuscan hill towns. Sloan, too, depicted movies as sites of sociality. Like Edward Hopper, he presented the theater as a metaphor for urban life. Yet his vision of the city, unlike Hopper's, was one not of "existential isolation" but of conversation.[9]

It is not surprising that *Movies, Five Cents* depicts a "nickel dump" rather than Keith's New Union Square Theater on Broadway. The lowbrow appealed to Sloan on several levels. Through a complicated mixture of literary interest in the lives of the "common people" and a Whitmanesque embrace of ordinary Americans, a class awareness that disdained the idle rich and a personal revolt from the bourgeoisie, Sloan could admire the seeming lack of inhibition among the lower classes without exactly identifying with them.[10] In his pictorial dramas, working-class New Yorkers, arrayed in cheap finery and devoid of deference, appear even more flamboyant than the ostentatious rich

and more likely to return our gaze. Yet the same innate theatricality that makes them worthy of attention also serves to separate them from us. Like the theater's artificial intimacy—or the artist's studio window—this social distance allowed the artist to imagine himself as simultaneously both in and out of the scene, participating in it while commenting upon it.

Sloan's rare images of uptown theaters and his own social peers were considerably less animated. His monotype *The Theater* (1909, fig. 9.4) emphasizes the ornate hall rather than the stage, which is seen from afar. It deploys a viewpoint that sends the eye gliding over the audience politely seated in rows rather than homing in on individuals. And although Sloan's diary praised an outdoor performance of Shakespeare's *As You Like It* on the Columbia University campus as "fine, the night, the trees, the quiet crowd of audience and the players with soft light on the stage—very handsome sight," his painting of the scene, *Coburn Players* (1910), is a respectfully restrained study in green and gold. Like his verbal description, it emphasizes a "handsome sight" rather than the human interest that enlivens his images of movies. Perhaps the behavior of the respectably "quiet crowd of audience" failed to engage Sloan as much as did the bumptious viewers at the local nickelodeon.[11]

The painting *Movies* (1913, fig. 9.5) returns to the themes of the audience as performers and of both making and looking at art as forms of urban viewing. Here one need not even go inside the theater in order to enjoy the show. Crude lettering and the pale, acid colors of a small illuminated facade call out to the viewer as posters and the glare of new electric lighting attract passersby. Rectangular shapes frame a series of figural groups, setting up the canvas itself as a kind of screen. The intricate flirtations and negotiations of people on the sidewalk outside the theater become the drama of interest.[12]

Sloan's pictorial narrative compares with the staging of film and theater, with focused lighting and framing devices that isolate certain characters from the random flow of people on the street. Each figure's action indicates some form of desire and visual attraction. Two women in black make eye contact with a pair of men moving offstage at the right, while a third man stands between the groups, taking in the scene. One woman reaches out to grasp her companion, a gesture that repeats the linked arms of a cluster of children who stare at the display of brightly lit posters. An older sister in that group grabs the toddler's collar as if to restrain him from running into the theater. Near the entrance, a doughty couple stand in deliberation, the woman protectively

9.4 John Sloan, *The Theater*, 1909. Monotype, 7½ x 9 in. (19.1 x 22.8 cm). The Cleveland Museum of Art, Gift of Mr. and Mrs. Ralph L. Wilson in memory of Anna Elizabeth Wilson

holding her husband's elbow. The building's brightly lit marquee attracts our eye. The painting becomes a frame in a film, with the roughly lettered posters drawing us in.

The painting's artful composition contrasts with the actual street scenes used as backdrops in such films as D. W. Griffith's *Romance of a Jewess* (1908, fig. 9.6) that render the city as much more chaotic. Like Griffith, Sloan used eye contact as a narrative device; where a film director could emphasize the actors' eyes with heavy makeup, Sloan applied paint. Instead of employing close-ups, as Griffith was starting to do by this time, he relied on costume (the important actors wear black, with white collars that call attention to their faces), accents of color, and telling gestures as well as gazes to connect the figures within the image. His abbreviated brushwork precisely renders slight gestures while pulling figures closer to the surface of the canvas and thus into our space.

Sloan's storytelling devices must work on several levels at once, because unlike film, the painting's narrative all takes place within a single frame and denouements are left open-ended. Where in Griffith's *The Italian Barber* (1911, fig. 9.7) a significant glance exchanged between the hero and a girl at a newsstand serves to propel a story—moved along by title cards—of love and eventual betrayal, in Sloan's work the act of viewing becomes the drama in itself. He presents his figures not with the preternaturally sharp focus of a camera but in smudges and smears and half-indicated lettering that provide the makings of a story without the clarification of an ending.

For all the modernity of these brief exchanges and chance encounters between strangers, Sloan's narrative images of urban life offer a counterpoint to vaudeville's frenetic and random pace. They remind us that Sloan also was a serious reader of nineteenth-century novels. As in the fiction of Honoré de Balzac and Thomas Hardy, the storytelling impulse interjects cohesion and pause into modern city life. In *Sixth Avenue and Thirtieth Street, New York City* (1907, fig. 9.8), Sloan creates a human drama out of a momentary incident: a woman, slightly dazed, stops to cross a street and passersby react. With artful devices, he arranges the figures in a temporary tableau and directs the viewer to notice such significant details as the sign on a nearby saloon, the "growler" (pitcher) of beer in the woman's hand, the elaborate costumes and makeup that identify two women on the corner as prostitutes. The title's reference to an intersection at the heart of a well-known red-light district conveys further

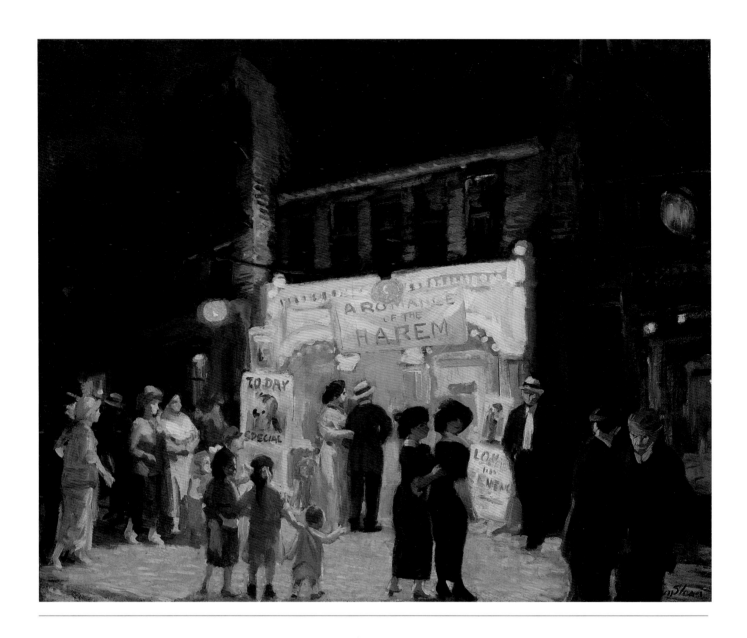

9.5 John Sloan, *Movies*, 1913. Oil on canvas, 19⁷/₈ x 24 in. (50.5 x 61 cm). Toledo Museum of Art, Ohio, Museum Purchase Fund

9.6 D. W. Griffith, *Romance of a Jewess*, 1908. Courtesy of Murray Glass and Em Gee Film Library

9.7 D. W. Griffith, *The Italian Barber*, 1911. Motion Picture, Broadcasting, and Recorded Sound Division, Library of Congress

information while rooting the work in a particular locale. As the woman in white raises a hand to cover her chest, her vulnerable gesture contrasts with the scornful stares of the well-dressed female onlookers, themselves the objects of gazes from ogling men. With its suggestive title and shorthand plot, Sloan's painting prefigures the "eight million stories in the naked city" conceit that loomed large for filmmakers in decades to come.[13]

Staged on the city streets amid the implied traffic of passersby, Sloan's scenes of urban theater break down the customary "fourth wall" separating the audience from the stage. The viewer thereby becomes one with the person on the street and has the opportunity to participate vicariously in the scene.[14] This vision of the city as communal theater contrasts with the more common image of urban anomie promulgated in modern times. The vision has its limits, however. In contrast with his hero Walt Whitman, who proclaimed, in "Song of Myself," "This is the city and I am one of the citizens," John Sloan displays something less than a sense of commitment to the fellow city dwellers he observes. Compelling as he may find these characters, there is an air of distance in his depictions; the comradeship they evoke is never total. Still, Sloan's sidewalk scenarios continue to absorb modern viewers with dramas that have long outlasted the stage plays of his time.

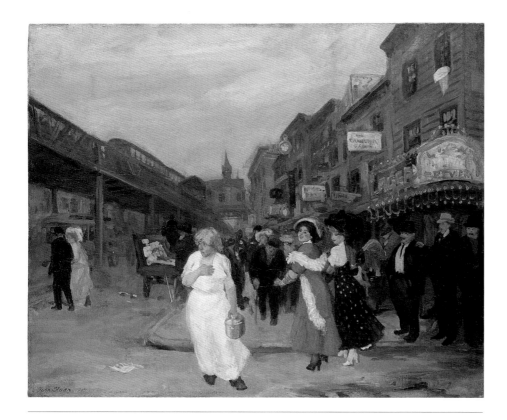

9.8 John Sloan, *Sixth Avenue and Thirtieth Street, New York City*, 1907. Oil on canvas, 26¼ x 32 in. (66.7 x 81.3 cm). Philadelphia Museum of Art, Gift of Mr. and Mrs. Meyer P. Potamkin

Notes

1 The editor and critic Mary Fanton Roberts reported that Sloan made this remark in a conversation she had with him "some years ago . . . as we looked out of his window" of the Greenwich Village studio in "John Sloan: His Art and Its Inspiration," *Touchstone* 4 (February 1919): 362. Sloan moved from an apartment-studio on Twenty-third Street to Greenwich Village in 1912. At the time Roberts and Sloan talked, the artist lived on Perry Street and maintained a studio in a tall building on lower Sixth Avenue.

2 "An Interesting Little Show of Interpretations of New York Life by a Group of Good Painters," review of the Folsom Gallery exhibition *Interpretations of New York, New York Sun*, October 27, 1912.

3 A similar point about the modernity of the paintings Georgia O'Keeffe made in her studio high up in the Shelton Hotel during the 1920s is argued in Anna Chave, "Who Will Paint New York? 'The World's New Art Center' and the New York Paintings of Georgia O'Keeffe," *American Art* (winter–spring 1991): 86–107.

4 H. Barbara Weinberg uses the term *euphemized* in Weinberg, Bolger, and Curry, *American Impressionism*. See also Corn, "The New New York."

5 This theme will be explored at greater length in Rebecca Zurier, *Picturing the City: Urban Vision and Representation in the Art of the Ashcan School* (Berkeley: University of California Press, forthcoming). For a view that emphasizes consumption rather than urban behavior, see Fairman, "Landscape of Display."

6 See *John Sloan's New York Scene: From the Diaries, Notes, and Correspondence, 1906–1913*, ed. Bruce St. John (New York: Harper and Row, 1965), diary entries for July 5, 1909 (Annette Kellerman at Hammerstein's), and June 22, 1907 (*Lucia di Lammermoor*). Sloan notes visits to Carnegie Hall in the entries for March 26, 1908 (symphonic concert), and January 18, 1911 (song recital). For his comment about Isadora Duncan, see the entry for November 16, 1909, and for other descriptions of her performances, the entries for February 15 and March 2, 1911. Sloan received many tickets to classical music and theatrical performances from Mary Fanton Roberts, editor and art critic for the *Craftsman* magazine. For theater, see the diary entries for August 19, 1907 (*Divorçons*), and December 31, 1909 (Maude Adams). He describes vaudeville in the entries for November 11, 1907 (Harry Lauder at New York Theatre), November 12, 1906 ("Creole dancer" at Proctor's), August 21, 1909 (Spanish dancer at Miner's Eighth Avenue Theater), and March 22, 1907 ("spectacular show" and water act at the Hippodrome). Sloan mentions burlesque in the diary entries for May 17, 1907, and August 5, 1909, as well as May 13, 1908 ("pretty coarse"). See also his visit to Koster and Bial's cellar, "a rather shabby low resort," recorded in the entry for August 17, 1909.

7 According to notes by his second wife, Helen Farr Sloan, the artist wrote an unsigned review of *The Kiss* that appeared in the July 15, 1896, issue of the *Chap Book*. I am grateful to Robert Hunter for showing me this reference. Miriam Hansen analyzes the impact of *The Kiss* in Hansen, *Babel and Babylon*, 35–36; the film is also treated in Robert C. Allen's essay in this book. Sloan mentions watching actuality films in *Sloan's New York Scene*, diary entries for October 29, 1909 (Johnson-Ketchel bout); August 19, 1908; June 3, 1909; and August 21, 1909. For French films, see the entry for August 7, 1909 (Pathé Frères). He comments on cheap American films in the diary entries for April 23, 1908 ("stupid sets of films"), July 16, 1907 ("five cents worth"), and April 4, 1911 ("cheaply amused").

8 *Sloan's New York Scene*, diary entry for June 29, 1907.

9 For film censorship in the early 1900s and the creation of the National Board of Review, see May, "Rescuing the Family: Urban Progressivism and Modern Censure," in *Screening Out the Past*, 43–59; and Daniel Czitrom, "The Politics of Performance: From Theater Licensing to Movie Censorship in Turn-of-the-Century New York," *American Quarterly* 44 (December 1992): 525–53. The composition of early film audiences has been a topic of much scholarly debate in recent years. See, for example, the summary in Stokes and Maltby, *American Movie Audiences*, 2–5, and Robert C. Allen's essay in this book. Magazine articles on film audiences from the period include Barton Currie, "The Nickel Madness," *Harper's Weekly* 51 (August 24, 1906), and Mary Heaton Vorse, "Some Picture Show Audiences," *Outlook* 98 (June 24, 1911): 441–47. Vorse and Sloan became colleagues on the staff of *The Masses* in 1912. I am grateful to Gerald McFarland for showing me the Vorse article, which he treats at greater length in his forthcoming social history of artists and immigrants in pre–World War I Greenwich Village. For Edward Hopper, see the essay by Robert Silberman in this book. Hopper wrote appreciatively of Sloan in "John

Sloan and the Philadelphians," *Arts* 11 (April 1927): 168–78.

10 *Sloan's New York Scene*, diary entry for January 16, 1908 ("common people"). The topic of Sloan's attitude toward the working class is treated more thoroughly in Rebecca Zurier, *Art for The Masses: A Radical Magazine and Its Graphics, 1911–1917* (Philadelphia: Temple University Press, 1988).

11 *Sloan's New York Scene*, diary entry for July 30, 1910. Mary Fanton Roberts gave the Sloans the tickets for this performance. The painting, now in the collection of the Dayton Art Institute, Dayton, Ohio, is reproduced and discussed in Elzea, *Sloan's Oil Paintings*, 1: 171.

12 For more on the sexual politics of *Movies*, see the discussion of this painting in Zurier, Snyder, and Mecklenburg, *Metropolitan Lives*, 172–73.

13 Sloan's reading will be analyzed at length in Zurier, *Picturing the City*. See the discussions of *Sixth Avenue and Thirtieth Street* in Suzanne Kinser, "Prostitutes in the Art of John Sloan," *Prospects* 9 (1995): 23–54; and Timothy J. Gilfoyle, *City of Eros: Prostitution, New York City, and the Commercialization of Sex, 1790–1920* (New York: Norton, 1992), 279–82. Jules Dassin directed the realistic drama *Naked City* (1948), which was shot on location in New York and based on a true story. It spawned a popular 1960s TV series of the same title.

14 Here I depart from the interpretation of city as theater, with its assumption of a detached viewer, presented in Boyer, "City and Theater," 73–112.

CHAPTER 10

"A COMPANY OF GHOSTS, PLAYING TO SPECTRAL MUSIC":

GESAMTKUNSTKINO AND THE FUTURE OF DIGITAL CINEMA

WALTER MURCH

If only we could stop that gentleman in the top hat leaving the Metropolitan Opera—no, no, *him*, the one with the fur collar—and ask about the performance of Richard Wagner's *Tannhäuser* he has just attended. Perhaps, if he was agreeable, we could walk with him up Broadway and let the conversation go where it might, for this is New York in December 1899, and one's thoughts are naturally turned toward the impending twentieth century.

What about the stunning production that he has just seen? Truly unbelievable! And perhaps a word about the future of opera, specifically Wagner's concept of *Gesamtkunstwerk* (Total Artwork), the ultimate fusion of music, drama, and image? What wonders will audiences be seeing a hundred years from now, in 1999?

As he stops to consider, one cannot help but glance over his shoulder at the sight of dozens of people in the shop behind him, mostly men, mostly young, mostly immigrants, with their heads plunged into some kind of mechanism, their right hands cranking madly away, in a kind of trance. We have stopped by chance in front of an amusement arcade, and the men inside are operating Kinetoscopes, watching images of young ladies disrobing over and over again before their very eyes.

Well, as our fur-collared friend is excitedly anticipating a century of high culture and operatic triumphs to make those of the nineteenth century pale in comparison, we—we time travelers who know the truth—cannot help suppressing a smile. Imagine our new acquaintance's astonishment and repugnance at being told that the noisy and offensive contraptions behind him would shortly transform themselves into the dominant art form of the twentieth century and stage their own assault on the citadel of Total Artwork; and that although his beloved operas would still be performed in 1999, and lav-

ishly, most would be reworkings of the nineteenth century's preserved-in-amber canon, the West's own version of Japanese Kabuki.

Of course, we won't disappoint him with our news from the future, which would seem like typical ravings from the kind of strange-looking creatures that he usually takes pains to avoid. What is New York coming to these days? Good-bye. Nice talking with you.

————

The astonishing fact is that the man with the fur-collared coat might have been Thomas Edison himself, universally known at the time as the inventor of motion pictures. Or if not Edison, it might have been Louis Lumière, co-inventor (with his older brother, Auguste) of the Cinématographe, the first motion picture projector. It is strange to realize that neither of these pioneers of cinema had much confidence or interest in the theatrical potential of film. Both certainly believed that there was a curiosity factor to be exploited: everyone would want, at least once, to see these electric shadows move. And Edison strongly believed in the educational and archival value of film. But both he and the Lumière brothers felt that the initial flash of curiosity in moving pictures would inevitably fade away. The practical Edison, for his part, could not abide the idea of projecting films for large audiences; surely there was more

10.1 American Entertainment Co., c. 1900. Poster. American Museum of the Moving Image, Astoria, New York

money to be made in marketing his one-person Kinetoscope! And Lumière, the originator of public projection, went so far as to call cinema an invention without a future.[1]

Yet it is possible that Lumière could have been right: there sometimes *are* inventions without a future—inventions ahead of their time or orphaned outside their appropriate culture. The Aztecs, for instance, invented the wheel but did not know how to use it except as a toy. The ancient Greeks did the same with the steam engine. So there is not only the invention itself to consider but also the cultural and economic context that surrounds it: all three have to mesh for the invention to "take," and despite Lumière's gloomy prognosis, with film it happened that they meshed spectacularly well.

From out of Broadway's shadows a second figure now steps forward and beckons us into the Kinetoscope arcade (fig. 10.2). We follow him past the wildly cranking young men and come upon two machines standing unused near the back of the room. Their operating price was too high (twenty-five cents) and the subject matter (Niagara Falls) could not compete with the disrobing young women. But our new friend, William Kennedy Laurie Dickson, looks proudly and paternally at these Kinetophones of his—machines that played motion pictures and sound together, thirty years before the "official" invention of sound film.

From 1887 to 1895, W. K. L. Dickson was a key figure at Thomas Edison's West Orange, New Jersey, laboratory: 35mm sprocketed film, the rotating-shutter mechanism, the Kinetoscope, the famous Black Maria studio, the Kinetograph—all of these were the partial or sole creations of Dickson, who as a young man of twenty-one had almost forced his way into Edison's lab in 1881 with the crusading purpose of persuading Edison to pursue the invention of motion pictures.

Edison had warily taken Dickson on, tested him for several years in the comparative purgatory of an ore-extraction project, and then finally set him to work on motion pictures in 1887. The Dickson-Edison collaboration was intense and productive, but in 1895 there were terrible arguments and Dickson was fired. We inquire, discreetly, as to the reasons for the disagreement, but Dickson demurs. He is too busy with his work for the American Mutoscope and Biograph Company—commonly known as Biograph—to dwell on the past.

10.2 Automatic Vaudeville (exterior view), 48 East Fourteenth Street, c. 1903–5. Silver gelatin print. The Byron Collection, Museum of the City of New York

What, then, about the future? Does Mr. Dickson share the reservations of Lumière and Edison? He smiles, "You mean to ask, What is the future of the Kinetograph?" And we sense that this question was at the heart of the disagreement with Edison. "Ask rather, from what conceivable phase of the future it can be debarred!"

As he enthusiastically elaborates, his figure begins fading away, and without much warning we find ourselves transported back to the New York of December 1999, holding a copy of *History of the Kinetograph, Kinetoscope, and Kineto-phonograph* (1895), the brief book Dickson wrote with his sister, Antonia (fig. 10.3). We skip through its pages, and the printed words continue in the tones of his eloquent voice:

> To the final development of the kinetographic stage ... no limitations can possibly be affixed. ... No imperfections will mar the illusion. The rich strain of a Seidl or Damrosch orchestra, issuing from a concealed phonograph, will herald the impending drama, and attune the hearts of the expectant throng. The curtain will rise, exposing some one of the innumerable phases of pictorial art, some soft English pastoral or cosy interior of a mansion, some fastness in the Alps or Himalayas, some tempestuous ocean scene. ... The actors will enter singly and in groups. ... The tones will be instinct with melody, pathos, mirth, command, every subtle intonation which goes to make up the sum of vocalism: the clang of arms, the sharp discharge of artillery, the roll of thunder, the boom of ocean surges ... all these effects of sight and sound will be embraced in the kinetoscopic drama, and yet of that living breathing, moving throng, not one will be encased in a material frame. A company of ghosts, playing to spectral music. ...
>
> Not only our own resources but those of the entire world will be at our command, nay, we may even anticipate the time when sociable relations will be established between ourselves and the planetary system, and when the latest doing in Mars, Saturn and Venus will be recorded by enterprising kinetographic reporters.[2]

We look up from the book to see that the newly released *Star Wars: Episode I—The Phantom Menace* is playing at a theater just up the street. So Dickson

10.3 W. K. L. Dickson and Antonia Dickson, Title page, *History of the Kinetograph, Kinetoscope and Kineto-Phonograph*, 1895. Rare Book and Special Collections Division, Library of Congress

the technician also was a visionary, and the history of cinema in the twentieth century has proven him right. Strolling by the theater's marquee, however, we discover that certain things are changing: *The Phantom Menace* is being projected digitally, without film.

Dickson's sprocketed 35mm celluloid, which serviced the arrival of sound, of color, of wide screen, of Dolby Stereo—film itself, the physical medium that carried all these inventions uncomplainingly on its shoulders—is, at the beginning of the twenty-first century, about to put down its burdens and slip away. In a few years it will most likely become a historical curiosity, like parchment or vellum.

As astonishing as it is to see digitally projected images—as clear or clearer than 35mm film, with none of the scratches, dirt, or jitter that infect even the most pristine of prints—the truth is that for fifteen years the film industry has been steadily turning digital from the inside out. The triumphs of digital visual effects, of course, were already well known before their apotheosis in *Jurassic Park* (1993), *Titanic* (1997), *The Matrix* (1999), *Toy Story 2* (1999), and *The Phantom Menace*. But the arrival of digital projection will trigger the final capitulation of the two last holdouts of the nineteenth century's mechanical-analog legacy. Projection, at the end of the line, is one; the other is the original photography that begins the whole process. The movie industry, currently, is a digital sandwich between slices of analog bread.

In the almost-immediate future, then—when both projection and original photography are digitized—the entire technical process of filmmaking will be digital from start to finish, and the whole technical infrastructure will telescope in upon itself with great suddenness. Some of the consequences of this we can foresee; others are unpredictable. But it is likely that this transformation will be complete in fewer than ten years.

Bereft of the physical medium of film, what will *cinema*—the habit of seeing motion pictures in a theatrical setting, so vividly and accurately visualized by Dickson—what will *cinema* be like in the digital future? Will it perhaps ossify into the twenty-first century's version of grand opera? Tuxedo-clad crowds attending yet another projection of 160-year-old *Casablanca*, unimaginably enhanced by some technological grandson of today's digital wizardry? Or perhaps cinema will have disappeared completely, overrun by some technical-social upheaval as unimaginable to us as the Kinetoscope's ultimate transformation was in 1899. (The parallels between the young men cranking their

10.4 "Take Your Girlie to the Movies (If You Can't Make Love at Home)," 1919. Sheet music cover. Celeste Bartos International Film Study Center Special Collections, The Museum of Modern Art, New York

10.5 "If That's Your Idea of a Wonderful Time, Take Me Home," words and music by Irving Berlin, 1914. Sheet music cover. Sam DeVincent Illustrated American Sheet Music Collection, Archives Center, National Museum of American History, Smithsonian Institution, Washington, D.C.

Kinetoscopes in the amusement arcade and teenage boys today locked in their rooms with Lara Croft are striking.)

Of course, as soon as we pose these questions, we know it is silly even to attempt an answer. But it is December 1999, after all—the end of a millennium. Why not?

Underlying all these speculations about cinema in the twenty-first century is a more specific question: Is the impending digitization of the art and industry of cinema something that will be artistically healthy in the long run, or does cinema in some mysterious way depend on the material medium of film?

Even to glimpse an answer to such a question, we need to find some analogous development in the past. The one that seems closest is the transformation that began during the fifteenth century when the older technique of applying pigments to wet plaster—fresco—was gradually replaced by painting in oil colors on canvas.

Some of the greatest, if not *the* greatest triumphs of European art were done in fresco, the painstaking process whereby damp plaster is stained with various pigments that, as they dry, bond chemically with the plaster and change color. One need only think of Michelangelo's frescoed ceiling of the Sistine Chapel, the pictorial equivalent of Beethoven's Ninth Symphony.

A great deal of advance planning needs to be done with fresco, and the variables—such as the consistency and drying time of the plaster—have to be controlled exactly. Artists needed a precise knowledge of the pigments and how they would change color as they dried. Once the pigment had been applied, no revisions were possible without applying another layer of plaster. Only so much work could be done in a day before the plaster applied that morning became too dry to absorb the pigments. Inevitably, cracks would form at the joins between subsequent applications of plaster. The arrangement of each day's subject matter had to be chosen carefully so as to minimize the damage from this cracking.

There was more, but it should be clear that for all of these reasons, fresco painting was an expensive effort involving many people and various interlocking technologies, overseen by the artist who took responsibility for the final product.

The invention of oil paint changed all this. The artist was freed to paint wherever and whenever he wanted. He did not have to create the work in its final location. The paint was virtually the same color wet as it would be dry. He did not have to worry unduly about cracking surfaces. And the artist

could paint over areas that he did not like, even to the point of reusing canvases for completely different purposes.

Although painting in oils remained collaborative for many decades, the innate logic of the new medium encouraged the artist to take more and more control of every aspect of the work, intensifying his personal vision. This was tremendously liberating, and the history of art from the fifteenth century to the present is a clear testimony to the creative power of that liberation—and some of its dangers, which found ultimate expression in the late nineteenth and early twentieth centuries, with the emergence of such solitary and tortured geniuses as Vincent van Gogh.

The nature of working with film has been more like painting in fresco than with oils. It is so heterogeneous, with so many technologies woven together in a complex and expensive fabric, that it is almost by definition impossible for a single person to control. There are a few solitary filmmakers (Jordan Belson comes to mind), but these are exceptional individuals, and the films they make are geared in their subject matter to allow creation by a single person.

By contrast, because of their mathematical commonality, digital techniques naturally *tend* to integrate with each other and thus to come under easier control by a single person.

So let's be as bold as Dickson was for his time and imagine a technical apotheosis taking place sometime in the next fifty years, when it somehow becomes possible for an individual to make an entire feature film, with virtual actors. Would this be a good thing?

If the history of oil painting is any guide, the broadest answer would be yes, with the obvious caution that we should keep a wary eye on the destabilizing effect of following too intently a hermetically personal vision. One need only to look at the unraveling of painting or classical music in the twentieth century to see the risks.

Let's go even further and force the issue to its ultimate conclusion by supposing the diabolical invention of a black box that could directly convert a single person's thoughts into a viewable cinematic reality. You would attach a series of electrodes to various points on your skull and simply *think* the film into existence. And as long as we are time traveling already, let us present this hypothetical invention as a Faustian bargain to the future filmmakers of the twenty-first century. If this box were offered to you by some mysterious cloaked figure in exchange for your eternal soul, would you take it?

The kinds of filmmakers who would accept, even leap, at the offer are driven by the desire to see their own vision on screen in as pure a form as possible. They accept present levels of collaboration as the evil necessary to achieve this vision. Alfred Hitchcock, I imagine, would be one of them, judging from his well-known description of the creative process: "I wish I didn't have to shoot the picture. When I've gone through the script and created the picture on paper, for me the creative job is done, and the rest is just a bore."[3]

The kind of filmmakers who would reject the offer are interested foremost in the collaborative *process* of filmmaking and in seeing a detailed vision mysteriously *emerge out of* that process, rather than being imposed from the beginning. Francis Ford Coppola's colorful description of his role sums it up: "I specialize in being the ringmaster of a circus that's inventing itself."[4]

The paradox of cinema is that it is most effective when it seems to fuse two contradictory elements—the general and the personal—into a kind of *mass intimacy*. The work itself is unchanging, aimed at an audience of millions,

and yet, when it works, it seems to speak to each member of the audience in a powerfully personal way. The origins of this power are mysterious, but I believe they come from two of the primary characteristics of motion pictures: it is a theater of thought; and it is intensely collaborative.

Film is a dramatic construction in which, for the first time in history, the characters can be *seen to think* at even the subtlest level, and these thoughts can then be choreographed. Sometimes the thoughts are almost physically visible, moving across the faces of talented actors like clouds across the sky. This is made possible by two techniques that lie at the foundation of cinema itself: the close-up, which renders such subtlety visible; and the cut, the sudden switch from one image to another, which mimics the acrobatic nature of thought itself.

And collaboration may be the very thing, if properly encouraged, that allows the work to speak in the most developed way to the largest number of people. Every person who works on a film brings his or her own perspective to bear on the subject, and if these perspectives are properly orchestrated by the director, the result will be a multifaceted and yet integrated complexity that will have the greatest chance of catching and sustaining the interest of the audience, which is itself a multifaceted entity in search of integration.

None of this, however, addresses the other salient fact about cinema: it is by definition a theatrical, communal experience for the audience as well as the authors, but one in which the play remains the same each time it is shown. Instead, it is the audience's reactions that change.

Pessimism about the future of cinema overlooks the perennial human urge, at least as old as language itself, to leave the home and assemble in the firelit dark with like-minded strangers to listen to stories. The cinematic experience is a re-creation of this ancient practice of theatrical renewal and bonding in modern terms, except that the flames of the Stone Age campfire have been replaced by the shifting images that are telling the story itself. The images dance the same way every time the film is projected, but they kindle different dreams in the mind of each beholder: the experience of cinema is a fusion of the permanency of literature with the spontaneity of theater.

The new century has just turned, and the digital revolution has not yet swept the field. But when it does it will be many years before Mephistopheles arrives to tempt us with his electrode-studded black box. There will be collaboration in motion pictures, grudging or not, for years to come. But it seems

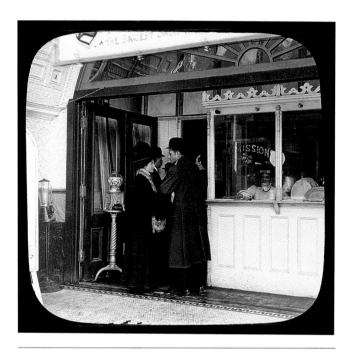

10.8 Illustrated song slide for unknown song, n.d. Marnan collection, Minneapolis

that if we are searching for the darker shadows that digital technologies might cast, we should look in the direction of anything that encourages a solitary monolithic vision and discourages developed complexity, both at the beginning, in the production of film, and at the end, in its theatrical enjoyment.

And because we are here to draw conclusions, I will come down on the affirmative side and say that cinema, very much as W. K. L. Dickson imagined it a century ago, *will* be with us a hundred years from now—different, of course, but still cinema. Its persistence will be fueled by the unchanging human need for stories in the dark, and its evolution will be sparked by the technical revolutions now just getting under way. We are perhaps now where painting was in 1499. So we have a few good centuries ahead of us, if we are careful.

Beyond that, who knows? Let's meet again in 2099 and have another look around.

Notes

This essay was originally published, in somewhat different form, in the *New York Times*, May 2, 1999.

1 Louis Lumière to Félix Mesguich, 1896, as quoted in Georges Sandoul, *Lumière et Méliès*, ed. Bernard Eisenschitz (Paris: Éditions Pierre Lherminier, 1985), 108.

2 W. K. L. Dickson and Antonia Dickson, *History of the Kinetograph, Kinetoscope, and Kineto-phonograph* (New York: A. Bunn, 1895), 50–51.

3 Quoted in Donald Spoto, *The Dark Side of Genius: The Life of Alfred Hitchcock* (Boston: Little, Brown, 1983), 492.

4 Quoted in Michael Goodwin and Naomi Wise, *On the Edge: The Life and Times of Francis Coppola* (New York: William Morrow, 1989), 372.

SELECTED BIBLIOGRAPHY

Abel, Richard. *The Red Rooster Scare: Making Cinema American, 1900–1910.* Berkeley: University of California Press, 1999.

———, ed. *Silent Film.* New Brunswick, N.J.: Rutgers University Press, 1996.

Allen, Richard. *Projecting Illusion: Film Spectatorship and the Impression of Reality.* Cambridge: Cambridge University Press, 1995.

Allen, Robert C. "The Movies in Vaudeville: Historical Context of the Movies as Popular Entertainment." In Balio, *American Film Industry,* 57–82.

———. "Motion Picture Exhibition in Manhattan, 1906–1912: Beyond the Nickelodeon." *Cinema Journal* 18, no. 2 (spring 1979): 2–15.

———. *Vaudeville and Film, 1895–1915: A Study in Media Interaction.* New York: Arno, 1980.

———. *Horrible Prettiness: Burlesque and American Culture.* Chapel Hill: University of North Carolina Press, 1991.

Allen, Robert C., and Douglas Gomery, eds. *Film History: Theory and Practice.* New York: Knopf, 1985.

Ankerich, Michael G. *Broken Silence: Conversations with 23 Silent Film Stars.* Jefferson, N.C.: McFarland, 1993.

Austin, Bruce A. *Immediate Seating: A Look at Movie Audiences.* Belmont, Calif.: Wadsworth, 1989.

Balio, Tino, ed. *The American Film Industry.* Madison: University of Wisconsin Press, 1976.

Balzar, Richard. *Optical Amusements: Magic Lanterns and Other Transforming Images— A Catalog of Popular Entertainment.* Watertown, Mass.: Richard Balzar, 1987.

Barnes, John. *Precursors of the Cinema: Shadowgraphy, Panoramas, Diorama, and Peepshows Considered in Their Relation to the History of Cinema.* St. Ives, Cornwall: Barnes Museum of Cinematography, 1967.

Barth, Gunther. *City People: The Rise of Modern City Culture in Nineteenth-Century America.* New York: Oxford University Press, 1980.

Beck, Hubert. "Urban Iconography in Nineteenth-Century American Painting: From Impressionism to the Ashcan School." In *American Icons: Transatlantic Perspectives on Eighteenth- and Nineteenth-Century American Art,* ed. Thomas W.

Gaehtgens and Heinz Ickstadt, 319–47. Santa Monica, Calif.: Getty Center for the History of Art and Humanities, 1992.

Belton, John, ed. *Movies and Mass Culture*. New Brunswick, N.J.: Rutgers University Press, 1996.

Bender, Thomas. "Metropolitan Life and the Making of Public Culture." In Mollenkopf, *Power, Culture, and Place*, 261–71.

Berman, Marshall. *All That Is Solid Melts into Air: The Experience of Modernity*. New York: Simon and Schuster, 1982.

Bernardi, Daniel, ed. *The Birth of Whiteness: Race and the Emergence of U.S. Cinema*. New Brunswick, N.J.: Rutgers University Press, 1996.

Bowser, Eileen. *The Transformation of Cinema, 1907–1915*. Berkeley: University of California Press, 1990.

Boyer, Christine M. "The City and the Theater." In *The City of Collective Memory: Its Historical Imagery and Architectural Entertainments*, 73–127. Cambridge: MIT Press, 1994.

Braden, Donna. *Leisure and Entertainment in America*. Dearborn, Mich.: Henry Ford Museum and Greenfield Village, 1988.

Brockman, C. Lance. *The Twin City Scenic Collection: Popular Entertainment, 1895–1929*. Exh. cat. Minneapolis: University Art Museum, University of Minnesota [now Frederick R. Weisman Art Museum], 1987.

Bronner, Simon J., ed. *Consuming Visions: Accumulation and Display of Goods in America, 1880–1920*. New York: Norton, 1989.

Buchloh, Benjamin, Serge Guilbaut, and David Solkin, eds. *Modernism and Modernity: The Vancouver Conference Papers*. Halifax: Press of the Nova Scotia College of Art and Design, 1983.

Butsch, Richard, ed. *For Fun and Profit: The Transformation of Leisure into Consumption*. Philadelphia: Temple University Press, 1990.

———. "Bowery B'hoys and Matinee Ladies: The Regendering of Nineteenth-Century American Theater Audiences." *American Quarterly* 46 (September 1994): 374–405.

———. *The Making of American Audiences: From Stage to Screen, 1750–1990*. Cambridge: Cambridge University Press, 2000.

Caffin, Caroline. *Vaudeville*. New York: Mitchell Kennerly, 1914.

Card, James. *Seductive Cinema: The Art of Silent Film*. New York: Knopf, 1994.

Charney, Leo. "In a Moment: Film and the Philosophy of Modernity." In Charney and Schwartz, *Cinema and the Invention of Modern Life*, 279–94.

———. *Empty Moments: Cinema, Modernity, and Drift*. Durham: Duke University Press, 1998.

Charney, Leo, and Vanessa R. Schwartz, eds. *Cinema and the Invention of Modern Life*. Berkeley: University of California Press, 1995.

Corn, Wanda M. "The New New York." *Art in America* 61 (July–August 1973): 58–65.

———. *In the American Grain: The Billboard Poetics of Charles Demuth*. Poughkeepsie, N.Y.: Vassar College, 1991.

———. "The Artist's New York: 1900–1930." In *Budapest and New York: Studies in Metropolitan Transformation, 1870–1930*, ed. Thomas Bender and Carl E. Schorske, 275–308. New York: Russell Sage Foundation, 1994.

———. *The Great American Thing: Modern Art and National Identity, 1915–1935*. Berkeley: University of California Press, 1999.

Crary, Jonathan. *Techniques of the Observer: On Vision and Modernity in the Nineteenth Century*. Cambridge: MIT Press, 1990.

———. "Modernizing Vision." In *Poetics of Space: A Critical Photographic Anthology*, ed. Steve Yates, 85–97. Albuquerque: University of New Mexico Press, 1995.

———. *Suspensions of Perception: Attention, Spectacle, and Modern Culture*. Cambridge: MIT Press, 1999.

Cripps, Thomas. *Slow Fade to Black: The Negro in American Film, 1900–1942*. New York: Oxford University Press, 1977.

Crow, Thomas. "Modernism and Mass Culture in the Visual Arts." In *Modern Art in the Common Culture*, 3–37. New Haven: Yale University Press, 1996.

Cutrer, Emily Fourmy. "A Pragmatic Mode of Seeing: James, Howells, and the Politics of Vision." In *American Iconology: New Approaches to Nineteenth-Century Art and Literature*, ed. David C. Miller, 259–75. New Haven: Yale University Press, 1993.

Czitrom, Daniel J. "American Motion Pictures and the New Popular Culture, 1893–1918." In *Media and the American Mind: From Morse to McLuhan*, 30–59. Chapel Hill: University of North Carolina Press, 1982.

———. "The Redemption of Leisure: The National Board of Censorship and the Rise of Motion Pictures in New York City, 1900–1920." *Studies in Visual Communication* 10, no. 4 (fall 1984): 2–6.

Davis, Michael Marks. *The Exploitation of Pleasure: A Study of Commercial Recreations in New York City*. New York: Russell Sage Foundation, 1911.

DeCordova, Richard. *Picture Personalities: The Emergence of the Star System in America*. Urbana: University of Illinois Press, 1990.

DeShazo, Edith. *Everett Shinn, 1876–1953: A Figure in His Time*. New York: Potter, 1974.

Douglas, Ann. *Terrible Honesty: Mongrel Manhattan in the 1920s*. New York: Farrar, Straus, and Giroux, 1995.

Dreiser, Theodore. *Sister Carrie*. New York: Doubleday, Page, 1900.

———. *The Genius*. New York: John Lane, 1915.

Elsaesser, Thomas, with Adam Barker, eds. *Early Cinema: Space, Frame, Narrative*. London: British Film Institute, 1990.

Elzea, Rowland. *John Sloan's Oil Paintings: A Catalogue Raisonné*. 2 vols. Newark: University of Delaware Press; and London: Associated University Presses, 1991.

Elzea, Rowland, and Elizabeth Hawkes. *John Sloan: Spectator of Life*. Exh. cat. Wilmington: Delaware Art Museum, 1988.

Erenberg, Lewis A. *Steppin' Out: New York Nightlife and the Transformation of American Culture, 1890–1930*. Westport, Conn.: Greenwood, 1981.

Ewen, Stuart, and Elizabeth Ewen. *Channels of Desire: Mass Images and the Shaping of American Consciousness*. New York: McGraw-Hill, 1982.

Fairman, Deborah. "The Landscape of Display: The Ashcan School, Spectacle, and the Staging of Everyday Life." *Prospects* 18 (1993): 205–35.

Fell, John L., ed. *Film Before Griffith*. Berkeley: University of California Press, 1983.

———. "Cellulose Nitrate Roots: Popular Entertainment and the Birth of Film Narrative." In Leyda and Musser, *Before Hollywood*, 39–44.

Ferber, Linda S. "Stagestruck: The Theater Subjects of Everett Shinn." In *American Art Around 1900: Lectures in Memory of Daniel Fraad*, ed. Doreen Bolger and Nicolai Cikovsky, Jr., 51–67. Washington, D.C.: National Gallery of Art, 1990.

Fischer, Lucy. "The Savage Eye: Edward Hopper and Cinema." In *A Modern Mosaic: Art and Modernism in the United States*, ed. Townsend Ludington, 334–56. Chapel Hill: University of North Carolina Press, 2000.

Fox, Richard Wrightman, and T. J. Jackson Lears, eds. *The Culture of Consumption: Critical Essays in American History, 1880–1980*. New York: Pantheon, 1983.

Friedberg, Anne. *Window Shopping: Cinema and the Postmodern*. Berkeley: University of California Press, 1993.

———. "Cinema and the Postmodern Condition." In *Viewing Positions: Ways of Seeing Films*, ed. Linda Williams, 59–83. New Brunswick, N.J.: Rutgers University Press, 1995.

Friedman, Lester D., ed. *Unspeakable Images: Ethnicity and the American Cinema*. Urbana: University of Illinois Press, 1991.

Frisby, David. *Fragments of Modernity: Theories of Modernity in the Work of Simmel, Kracauer, and Benjamin*. Cambridge: Polity, 1985.

Fuller, Kathryn H. *At the Picture Show: Small-Town Audiences and the Creation of Movie Fan Culture*. Washington, D.C.: Smithsonian Institution Press, 1996.

———. "Viewing the Viewers: Representations of the Audience in Early Cinema Advertising." In Stokes and Maltby, *American Movie Audiences*, 112–28.

George-Graves, Nadine. *The Royalty of Negro Vaudeville: The Whitman Sisters and the Negotiation of Race, Gender, and Class in African American Theater, 1900–1940.* New York: St. Martin's, 2000.

Gerdts, William H., and Jorge H. Santis. *William Glackens.* New York: Abbeville; and Fort Lauderdale, Fla.: Museum of Art, 1996.

Gilbert, Douglas. *American Vaudeville: Its Life and Times.* New York: McGraw-Hill; and London: Whittlesay, 1940.

Gomery, Douglas. *Shared Pleasures: A History of Movie Presentation in the United States.* Madison: University of Wisconsin Press, 1992.

Gottschild, Brenda Dixon. *Waltzing in the Dark: African American Vaudeville and Race Politics in the Swing Era.* New York: St. Martin's, 2000.

Grover, Kathryn, ed. *Hard at Play: Leisure in America, 1840–1940.* Amherst: University of Massachusetts Press; and Rochester, N.Y.: Strong Museum, 1992.

Gunning, Tom. "The Non-Continuous Style of Early Film, 1900–1906." In *Cinema, 1900–1906: An Analytical Study*, ed. Roger Holman, 219–30. Brussels: Fédération Internationale des Archives du Film, 1982.

———. "The Cinema of Attraction: Early Film, Its Spectator, and the Avant-Garde." *Wide Angle* 8, nos. 3–4 (1986): 63–70.

———. "An Aesthetic of Astonishment: Early Film and the (In)Credulous Spectator." *Art and Text* 34 (spring 1989): 31–45.

———. *D. W. Griffith and the Origins of American Narrative Film: The Early Years at Biograph.* Urbana: University of Illinois Press, 1991.

———. "Now You See It, Now You Don't: The Temporality of the Cinema of Attractions." *Velvet Light Trap* 32 (fall 1993): 3–12.

Handel, Leo A. *Hollywood Looks at Its Audience: A Report of Film Audience Research.* Urbana: University of Illinois Press, 1950.

Hansen, Miriam Bratu. "Early Silent Cinema: Whose Public Sphere?" *New German Critique* 29 (spring–summer 1983): 147–84.

———. "Benjamin, Cinema, and Experience: 'The Blue Flower in the Land of Technology.'" *New German Critique* 40 (winter 1987): 179–224.

———. "Adventures of Goldilocks: Early Cinema, Consumerism, and Public Life," *Camera Obscura* 22 (1990): 51–72.

———. *Babel and Babylon: Spectatorship in American Silent Film.* Cambridge: Harvard University Press, 1991.

———. "Decentric Perspectives: Kracauer's Early Writings on Film and Mass Culture." *New German Critique* 54 (fall 1991): 47–76.

———. "America, Paris, the Alps: Kracauer (and Benjamin) on Cinema and Modernity." In Charney and Schwartz, *Cinema and the Invention of Modern Life*, 362–402.

Harris, Neil. "A Subversive Form." In Leyda and Musser, *Before Hollywood*, 45–49.

———. *Cultural Excursions: Marketing Appetites and Cultural Tastes in Modern America.*

Chicago: University of Chicago Press, 1990.

Hartley, Marsden. *Adventures in the Arts: Informal Chapters on Painters, Vaudeville, and Poets*. 1921; rpt., New York: Hacker Art Books, 1972.

Hartmann, Sadakichi. "The Esthetic Significance of the Motion Picture." *Camera Work* no. 38 (April 1912): 19–21.

Harvey, David. "Time-Space Compression and the Rise of Modernism as a Cultural Force." In *The Condition of Postmodernity: An Enquiry into the Origins of Cultural Change*. Oxford: Blackwell, 1989.

Haskell, Barbara. *Charles Demuth*. Exh. cat. New York: Whitney Museum of American Art, in association with Harry N. Abrams, 1987.

———. *The American Century: Art and Culture, 1900–1950*. Exh. cat. New York: Whitney Museum of American Art, in association with W. W. Norton, 1999.

Havig, Alan. "The Commercial Amusement Audience in Early Twentieth-Century American Cities." *Journal of American Culture* (spring 1982): 1–19.

Henderson, Amy, and Dwight Blocker Bowers. *Red, Hot, and Blue: A Smithsonian Salute to the American Musical*. Exh. cat. Washington, D.C.: National Portrait Gallery and National Museum of American History, in association with the Smithsonian Institution Press, 1996.

Henderson, Mary C. *The City and the Theatre: New York Playhouses from Bowling Green to Times Square*. Clifton, N.J.: James T. White, 1973.

———. *Broadway Ballyhoo: The American Theater Seen in Posters, Photographs, Magazines, Caricatures, and Programs*. New York: Abrams, 1989.

Higashi, Sumiko. *Cecil B. DeMille and American Culture: The Silent Era*. Berkeley: University of California Press, 1994.

Hills, Patricia. *Turn-of-the-Century America: Paintings, Graphics, Photographs, 1890–1910*. Exh. cat. New York: Whitney Museum of American Art, 1977.

Holland, Charlie. *Strange Feats and Clever Turns: Remarkable Specialty Acts in Variety Vaudeville and Sideshows at the Turn of the 20th Century as Seen by Their Contemporaries*. London: Holland and Palmer, 1998.

Jay, Martin. "Scopic Regimes of Modernity." In *Vision and Visuality*, ed. Hal Foster, 2–23. Seattle: Bay Press, 1988.

Jenkins, Henry. *What Made Pistachio Nuts? Early Sound Comedy and the Vaudeville Aesthetic*. New York: Columbia University Press, 1992.

Johnson, Helen Armstead. "Blacks in Vaudeville: Broadway and Beyond." In *American Popular Entertainment: Papers and Proceedings of the Conference on the History of American Popular Entertainment*, ed. Myron Matlaw, 77–95. Westport, Conn.: Greenwood, 1979.

Johnson, Stephen Burge. *The Roof Gardens of Broadway Theatres, 1883–1942*. Ann Arbor: UMI Research Press, 1985.

Jowett, Garth S. "The First Motion Picture Audiences." *Journal of Popular Film* 3 (winter 1974): 39–54.

Kattwinkel, Susan. *Tony Pastor Presents: Afterpieces from the Vaudeville Stage*. Westport, Conn.: Greenwood, 1998.

Kern, Stephen. *The Culture of Time and Space, 1880–1918*. Cambridge: Harvard University Press, 1983.

Kibler, M. Alison. *Rank Ladies: Gender and Cultural Hierarchy in American Vaudeville*. Chapel Hill: University of North Carolina Press, 1999.

Koszarski, Richard. "Offscreen Spaces: Images of Early Cinema Production and Exhibition." In Leyda and Musser, *Before Hollywood*, 13–37.

————. *An Evening's Entertainment: The Age of the Silent Feature Picture, 1915–1928*. New York: Scribner's; Toronto: Collier Macmillan Canada; and New York: Maxwell Macmillian International, 1990.

Laurie, Joseph. *Vaudeville: From the Honky-Tonks to the Palace*. New York: Holt, 1953.

Leach, William R. "Strategists of Display and the Production of Desire." In Bronner, *Consuming Visions*, 99–132.

————. *Land of Desire: Merchants, Power, and the Rise of a New American Culture*. New York: Pantheon, 1993.

Lears, T. J. Jackson. *No Place of Grace: Antimodernism and the Transformation of American Culture, 1880–1920*. New York: Pantheon, 1981.

Leja, Michael. "Modernism's Subjects in the United States." *Art Journal* 55 (summer 1996): 65–72.

Levin, Gail. *Edward Hopper: The Art and the Artist*. Exh. cat. New York: Norton, in association with the Whitney Museum of American Art, 1980.

————. "Edward Hopper: The Influence of Theater and Film." *Arts Magazine* 55 (October 1980): 123–27.

————. *Edward Hopper: A Catalogue Raisonné*. New York: Norton, in association with the Whitney Museum of American Art, 1995.

Levine, Lawrence W. *Highbrow, Lowbrow: The Emergence of Cultural Hierarchy in America*. Cambridge: Harvard University Press, 1988.

Leyda, Jay, and Charles Musser, eds. *Before Hollywood: Turn-of-the-Century Film from American Archives*. Exh. cat. New York: American Federation of the Arts, 1986.

Ludington, Townsend, ed. *A Modern Mosaic: Art and Modernism in the United States*. Chapel Hill: University of North Carolina Press, 2000.

Lynes, Russell. *The Lively Audience: A Social History of the Visual and Performing Arts in America, 1890–1950*. New York: Harper and Row, 1985.

Lyons, Deborah, ed. *Edward Hopper: A Journal of His Work*. New York: Norton, in association with the Whitney Museum of American Art, 1997.

Marvin, Carolyn. *When Old Technologies Were New: Thinking About Electric Communication in the Late Nineteenth Century*. New York: Oxford University Press, 1988.

Mast, Gerald, ed. *The Movies in Our Midst: Documents in the Cultural History of Film in America*. Chicago: University of Chicago Press, 1982.

May, Lary. *Screening Out the Past: The Birth of Mass Culture and the Motion Picture Industry*. New York: Oxford University Press, 1980.

McConachie, Bruce A. "Pacifying American Theatrical Audiences, 1820–1900." In Butsch, *For Fun and Profit*, 47–70.

McCullough, Jack. *Living Pictures on the New York Stage*. Ann Arbor: UMI Press, 1983.

McLean, Albert F., Jr. *American Vaudeville as Ritual*. Lexington: University of Kentucky Press, 1965.

McNamara, Brooks. "The Scenography of Popular Entertainment." *Drama Review* 18, no. 1 (March 1974): 16–24.

———. *American Popular Entertainments: Jokes, Monologues, Bits, and Sketches*. New York: Performing Arts Journal Publications, 1983.

Merritt, Russell. "Nickelodeon Theatres, 1905–1914: Building an Audience for the Movies." In Balio, *American Film Industry*, 83–102.

Michelson, Annette, Douglas Gomery, and Patrick Loughney. *The Art of Moving Shadows*. Exh. cat. Washington, D.C.: National Gallery of Art, 1989.

Milroy, Elizabeth. *Painters of a New Century: The Eight and American Art*. Exh. cat. Milwaukee: Milwaukee Art Museum, 1991.

Moers, Ellen. *Two Dreisers*. New York: Viking, 1969.

Mollenkopf, John Hull, ed. *Power, Culture, and Place: Essays on New York City*. New York: Russell Sage Foundation, 1988.

Murch, Walter. Foreword to *Audio-vision: Sound on Screen*, by Michel Chion. Trans. and ed. Claudia Gorbman. New York: Columbia University Press, 1994.

———. *In the Blink of an Eye: A Perspective on Film Editing*. Los Angeles: Silman-James, 1995.

———. "A Digital Cinema of the Mind? Could Be." *New York Times*, May 2, 1999.

———. "Stretching Sound to Help the Mind See." *New York Times*, October 1, 2000.

Musser, Charles. "The Nickelodeon Era Begins: Establishing the Framework for Hollywood's Mode of Production." *Framework* 22–23 (autumn 1983): 4–11.

———. "Toward a History of Screen Practice." *Quarterly Review of Film Studies* 9, no. 1 (winter 1984): 58–69.

———. *The Emergence of Cinema: The American Screen to 1907*. New York: Scribner's, 1990.

———. *Before the Nickelodeon: Edwin S. Porter and the Edison Manufacturing Company*. Berkeley: University of California Press, 1991.

———. *Edison Motion Pictures, 1890–1900: An Annotated Filmography*. Washington, D.C.: Smithsonian Institution Press, 1997.

Musser, Charles, in collaboration with Carol Nelson. *High-Class Moving Pictures: Lyman H. Howe and the Forgotten Era of Traveling Exhibition, 1880–1920*. Princeton: Princeton University Press, 1991.

Naremore, James, and Patrick Brantlinger, eds. *Modernity and Mass Culture*. Bloomington: Indiana University Press, 1991.

Nasaw, David. "Cities of Light, Landscapes of Pleasure." In Ward and Zunz, *Landscape of Modernity*, 273–86.

———. *Going Out: The Rise and Fall of Public Amusements*. New York: Basic, 1993.

Neville, Henry. *The Stage: Its Past and Present in Relation to Fine Art*. New York: Garland, 1986.

Nye, David E. *Electrifying America: Social Meanings of a New Technology, 1880–1940*. Cambridge: MIT Press, 1990.

Nye, Russel. *The Unembarrassed Muse: The Popular Arts in America*. New York: Dial, 1970.

Peiss, Kathy Lee. *Cheap Amusements: Working Women and Leisure in Turn-of-the-Century New York*. Philadelphia: Temple University Press, 1986.

Pisano, Ronald. *Idle Hours: Americans at Leisure, 1865–1914*. Boston: Little, Brown, 1988.

Pratt, George C. *Spellbound in Darkness: A History of the Silent Film*. Greenwich, Conn.: New York Graphic Society, 1973.

Pumphery, Martin. "The Flapper, the Housewife, and the Making of Modernity." *Cultural Studies* 1 (May 1987): 179–94.

Rabinovitz, Lauren. *For the Love of Pleasure: Women, Movies, and Culture in Turn-of-the-Century Chicago*. New Brunswick, N.J.: Rutgers University Press, 1998.

Ramsaye, Terry. *A Million and One Nights: A History of the Motion Picture Through 1925*. New York: Simon and Schuster, 1926.

Robinson, David. *From Peep Show to Palace: The Birth of American Film*. New York: Columbia University Press, 1996.

Roeder, George H., Jr. "What Have Modernists Looked At? Experiential Roots of Twentieth-Century American Painting." *American Quarterly* 39, no. 1 (spring 1987): 56–83.

Rogin, Michael. "Making America Home: Racial Masquerade and Ethnic Assimilation in the Transition to Talking Pictures." *Journal of American History* 79 (December 1992): 1050–77.

Rosenzweig, Roy. *Eight Hours for What We Will: Workers and Leisure in an Industrial City, 1870–1920*. Cambridge: Cambridge University Press, 1983.

Schickel, Richard. *Intimate Strangers: The Culture of Celebrity*. Garden City, N.Y.: Doubleday, 1985.

Schivelbusch, Wolfgang. *Disenchanted Night: The Industrialization of Light in the Nineteenth Century*, trans. Angela Davies. Berkeley: University of California Press, 1988.

———. *Licht, Schein, und Wahn: Auftritte der elektrischen Beleuchtung im 20. Jahrhundert*. Berlin: Ernst and Sohn, 1992.

Schlereth, Thomas J. *Victorian America: Transformations in Everyday Life, 1876–1915*. New York: HarperCollins, 1991.

Sharpe, William, and Leonard Wallock, eds. *Visions of the Modern City: Essays in History, Art, and Culture*. Baltimore: Johns Hopkins University Press, 1987.

Signal, Daniel Joseph. "Towards a Definition of American Modernism." *American Quarterly* 39, no. 1 (spring 1987): 7–26.

Silberman, Robert. "Edward Hopper and the Implied Observer." *Art in America* 69, no. 7 (September 1981): 148–54.

Singer, Ben. "Modernity, Hyperstimulus, and the Rise of Popular Sensationalism." In Charney and Schwartz, *Cinema and the Invention of Modern Life*, 72–99.

Sklar, Robert. *Movie-Made America: A Cultural History of American Movies*. New York: Vintage, 1975.

Sklar, Robert, and Charles Musser, eds. *Resisting Images: Essays on Cinema and History*. Philadelphia: Temple University Press, 1990.

Slide, Anthony. *The Vaudevillians: A Dictionary of Vaudeville Performers*. Westport, Conn.: Arlington, 1981.

———. *The Encyclopedia of Vaudeville*. Westport, Conn.: Greenwood, 1984.

———. *The Big V: A History of the Vitagraph Company*. Metuchen, N.J.: Scarecrow, 1987.

Snyder, Robert W. *The Voice of the City: Vaudeville and Popular Culture in New York*. New York: Oxford University Press, 1989.

———. "Big Time, Small Time, All Around the Town: New York Vaudeville in the Early Twentieth Century." In Butsch, *For Fun and Profit*, 118–35.

———. "Immigrants, Ethnicity, and Mass Culture: The Vaudeville Stage in New York City: 1880–1930." In *Budapest and New York: Studies in Metropolitan Transformation, 1870–1930*, ed. Thomas Bender and Carl E. Schorske, 185–208. New York: Russell Sage Foundation, 1994.

———. "The Vaudeville Circuit: A Prehistory of the Mass Audience." In *Audiencemaking: How the Media Create the Audience*, ed. James S. Ettema and D. Charles Whitney, 215–31. Thousand Oaks, Calif.: Sage, 1994.

———. "City in Transition." In Zurier, Snyder, and Mecklenburg, *Metropolitan Lives*, 29–57.

Spehr, Paul C. *The Movies Begin: Making Movies in New Jersey, 1887–1920*. Exh. cat. Newark, N.J.: Newark Museum, 1977.

Staiger, Janet. "Class, Ethnicity, and Gender: Explaining the Development of Early American Film Narrative." *Iris* 11 (summer 1990): 13–25.

———. *Interpreting Films: Studies in the Historical Reception of American Cinema*. Princeton, N.J.: Princeton University Press, 1992.

Stansell, Christine. *American Moderns: Bohemian New York and the Creation of a New Century*. New York: Metropolitan Books, 2000.

Stein, Charles W., ed. *American Vaudeville as Seen by Its Contemporaries*. New York: Knopf, 1984.

Stokes, Melvyn, and Richard Maltby, eds. *American Movie Audiences: From the Turn of the Century to the Early Sound Era*. London: British Film Institute, 1999.

Studlar, Gaylyn. "The Perils of Pleasure? Fan Magazine Discourse as Women's Commodified Culture in the 1920s." In Abel, *Silent Film*, 263–97.

Susman, Warren I. *Culture as History: The Transformation of American Society in the Twentieth Century.* New York: Pantheon, 1984.

Sussman, Elisabeth, with John G. Hanhardt. *City of Ambition: Artists and New York, 1900–1960.* Exh. cat. New York: Whitney Museum of American Art, in association with Flammarion, 1996.

Taylor, William R. "The Launching of a Commercial Culture: New York City, 1860–1930." In Mollenkopf, *Power, Culture, and Place,* 107–33.

———. *In Pursuit of Gotham: Culture and Commerce in New York.* New York: Oxford University Press, 1992.

———, ed. *Inventing Times Square: Commerce and Culture at the Crossroads of the World.* New York: Russell Sage Foundation, 1991.

Thomas, David O. "From Page to Screen to Small-Town America: Early Motion Picture Exhibition in Winona, Minnesota." *Journal of the University Film Association* 33 (summer 1981): 3–13.

Toll, Robert C. *On with the Show: The First Century of Show Business in America.* New York: Oxford University Press, 1976.

Uricchio, William, and Roberta E. Pearson. *Reframing Culture: The Case of the Vitagraph Quality Films.* Princeton: Princeton University Press, 1993.

———. "Constructing an Audience: Competing Discourses of Morality and Rationalization During the Nickelodeon Period." *Iris* 17 (autumn 1994): 43–54.

Valentine, Maggie. *The Show Starts on the Sidewalk: An Architectural History of the Movie Theatre, Starring S. Charles Lee.* New Haven: Yale University Press, 1994.

Van Dyke, John Charles. *The New New York: A Commentary on the Place and the People.* New York: Macmillan, 1909.

Vardac, A. Nicholas. *Stage to Screen: Theatrical Method from Garrick to Griffith.* Cambridge: Harvard University Press, 1949.

Varnedoe, Kirk, and Adam Gopnik. *High and Low: Modern Art and Popular Culture.* Exh. cat. New York: Museum of Modern Art, in association with Harry N. Abrams, 1990.

———, eds. *Modern Art and Popular Culture: Readings in High and Low.* New York: Museum of Modern Art, in association with Harry N. Abrams, 1990.

Vaudeville. An American Masters special. Produced by Rosemary Garner. Written and directed by Greg Palmer. 112 min. WNET Television, 1997. Videotape.

Waller, Gregory A. "Another Audience: Black Moviegoing, 1907–1916." *Cinema Journal* 31, no. 2 (1992): 3–25.

———. *Main Street Amusements: Movies and Commercial Entertainment in a Southern City, 1896–1930.* Washington, D.C.: Smithsonian Institution Press, 1995.

Ward, David, and Olivier Zunz, eds. *The Landscape of Modernity: Essays on New York City, 1900–1940.* New York: Russell Sage Foundation, 1992.

Watson, Steven. *Strange Bedfellows: The First American Avant-Garde.* New York: Abbeville, 1991.

Wattanmaker, Richard J. "The Art of William Glackens." Ph.D. diss., New York University, 1972.

Weinberg, Barbara H., Doreen Bolger, and David Park Curry. *American Impressionism and Realism: The Painting of Modern Life, 1885–1915*. Exh. cat. New York: Metropolitan Museum of Art, in association with Harry N. Abrams, 1994.

Weintraub, Laural. "Fine Art and Popular Entertainment: The Emerging Dialogue between High and Low in American Art of the Early Twentieth Century." Ph.D. diss., City University of New York, 1996.

Weiss, Jeffrey. *The Popular Culture of Modern Art: Picasso, Duchamp, and Avant-Gardism*. New Haven: Yale University Press, 1994.

Wertheim, Arthur Frank. *The New York Little Renaissance: Iconoclasm, Modernism, and Nationalism in American Culture, 1908–1917*. New York: New York University Press, 1976.

Williams, Raymond. "Metropolitan Perceptions and the Emergence of Modernism." In *The Politics of Modernism*, 37–48. London: Verso, 1989.

Wong, Janay. *Everett Shinn: The Spectacle of Life*. Exh. cat. New York: Berry-Hill Galleries, 2000.

Yount, Sylvia. "Consuming Drama: Everett Shinn and the Spectacular City." *Smithsonian Studies in American Art* 6 (fall 1992): 87–109.

Zurier, Rebecca. "The Making of Six New York Artists." In Zurier, Snyder, and Mecklenburg, *Metropolitan Lives*, 59–83.

Zurier, Rebecca, Robert W. Snyder, and Virginia M. Mecklenburg. *Metropolitan Lives: The Ashcan Artists and Their New York*. Exh. cat. Washington, D.C.: National Museum of American Art, in association with W. W. Norton, 1995.

NOTES ON THE AUTHORS

Robert C. Allen is James Logan Godfrey Professor of American Studies, History, and Communication Studies, University of North Carolina. He is the author of *Vaudeville and Film, 1895–1915* (1980) and *Horrible Prettiness: Burlesque and American Culture* (1991), and co-editor (with Douglas Gomery) of *Film History: Theory and Practice* (1985).

C. Lance Brockman is a professor in the Department of Theater Arts and Dance, University of Minnesota. He was curator of the exhibition *The Twin City Scenic Collection: Popular Entertainment, 1895–1929* (1987) and wrote the accompanying catalogue.

Leo Charney is senior editor of the Walt Disney Internet Group. He is the author of *Empty Moments: Cinema, Modernity, and Drift* (1998) and co-editor (with Vanessa R. Schwartz) of *Cinema and the Invention of Modern Life* (1995).

Patricia McDonnell is curator at the Frederick R. Weisman Art Museum, University of Minnesota. Focusing on American early modernism, she has organized the exhibitions *Dictated by Life: Marsden Hartley and Robert Indiana* (1995) and *Marsden Hartley: American Modern* (1997), and she wrote the accompanying catalogues. American modernism also has been the subject of her essays for various scholarly journals and museum publications.

Walter Murch is a film editor and sound designer who has worked on such films as the *Godfather* trilogy, *Apocalypse Now*, *The English Patient*, and the restored version of Orson Welles's *Touch of Evil*. He has been nominated for eight Academy Awards and has won three. Recently, he worked with the Library of Congress to restore sound to the earliest attempt at synchronized image and sound: a seventeen-second film of W. K. L. Dickson playing the violin (1894–95).

David Nasaw is professor of history and American studies and director of the Center for the Humanities, City University of New York. He is the author of *Going Out: The Rise and Fall of Public Amusements* (1993).

Robert Silberman is a professor of art history and film studies, University of Minnesota. An active art critic, scholar, and curator, he has concentrated on such subjects as Edward Hopper, Alfred Hitchcock, American photography and film history, and the links between maps and art.

Laural Weintraub is a researcher for the New-York Historical Society and an instructor at the Fashion Institute of Technology, New York. Her 1996 dissertation for the City University of New York treated early twentieth-century American artists who portrayed popular entertainment.

Sylvia Yount is Margaret and Terry Stent Curator of American Art at the High Museum of Art, Atlanta. A specialist in late nineteenth- and early twentieth-century art, her publications include *To Be Modern: American Encounters with Cézanne and Company* (1996) and the essay "Consuming Drama: Everett Shinn and the Spectacular City" (*Smithsonian Studies in American Art*, fall 1992).

Rebecca Zurier is professor of art history at the University of Michigan. She co-organized (with Robert W. Snyder and Virginia M. Mecklenburg) the 1995 exhibition *Metropolitan Lives: The Ashcan Artists and Their New York*, at the National Museum of American Art, Washington, D.C. The accompanying catalogue won the College Art Association's Alfred H. Barr, Jr., Award. Her forthcoming book, *Picturing the City: Urban Vision and Representation in the Art of the Ashcan School*, will be published by the University of California Press.

INDEX

PHOTO CREDITS